KINFOLK

ISLANDS

JOHN BURNS

KINFOLK
ISLANDS

ARTISAN | NEW YORK

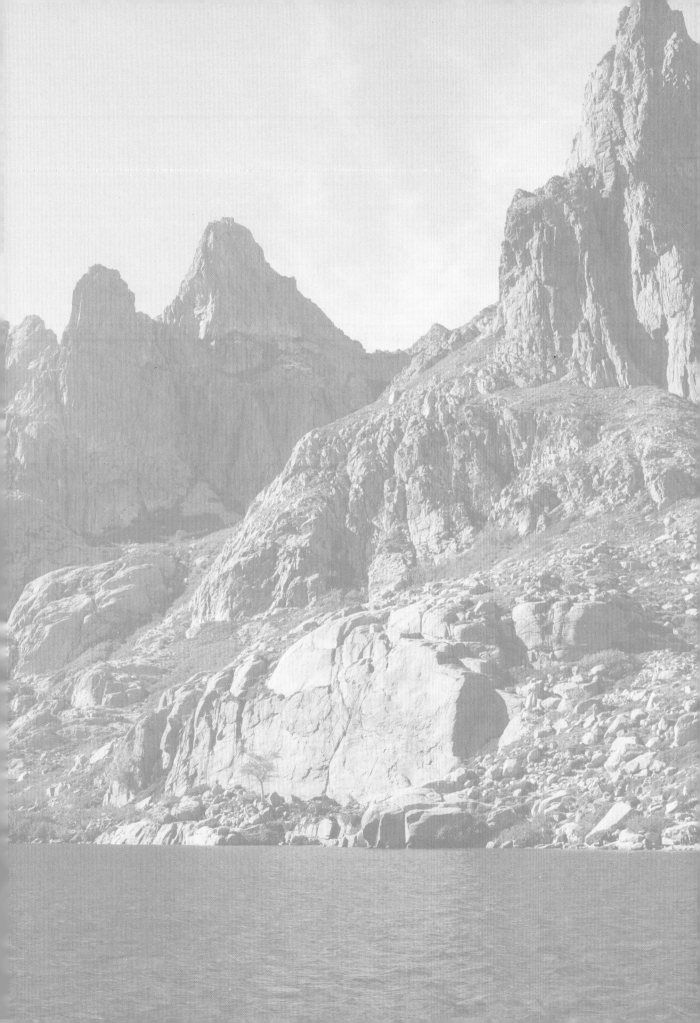

JOHN BURNS
Editor in Chief

STAFFAN SUNDSTRÖM
Art Direction & Book Design

HARRIET FITCH LITTLE
Editor

EDWARD MANNERING
Publishing Director

SUSANNE BUCH PETERSEN
Production Manager

LINN HENRICHSON
Illustrations

Selected Contributors

AMIRA ASAD

Amira is a journalist based
in Mexico City and the
co-founder of *LIFTA Volumes*.
Her writing has been published
in *The Guardian*, *Al Jazeera*
and *Vice*.

CONSTANTIN MIRBACH

Constantin is a German
photographer who works with
portraiture, documentary
and advertising. His work
has appeared in *Süddeutsche
Zeitung*, *Die Zeit* and *Monocle*.

CHARLES THIEFAINE

Charles is an independent
photographer and journalist
who lives between Paris
and Iraq. His work has been
featured in *The Washington
Post*, *Le Figaro* and *Libération*.

FERIDE YALAV-HECKEROTH

Feride is a writer based in
Istanbul and the author of
several travel guides,
including *The 500 Hidden
Secrets of Istanbul*.

FOR A FULL LIST OF CREDITS, SEE PAGE 251

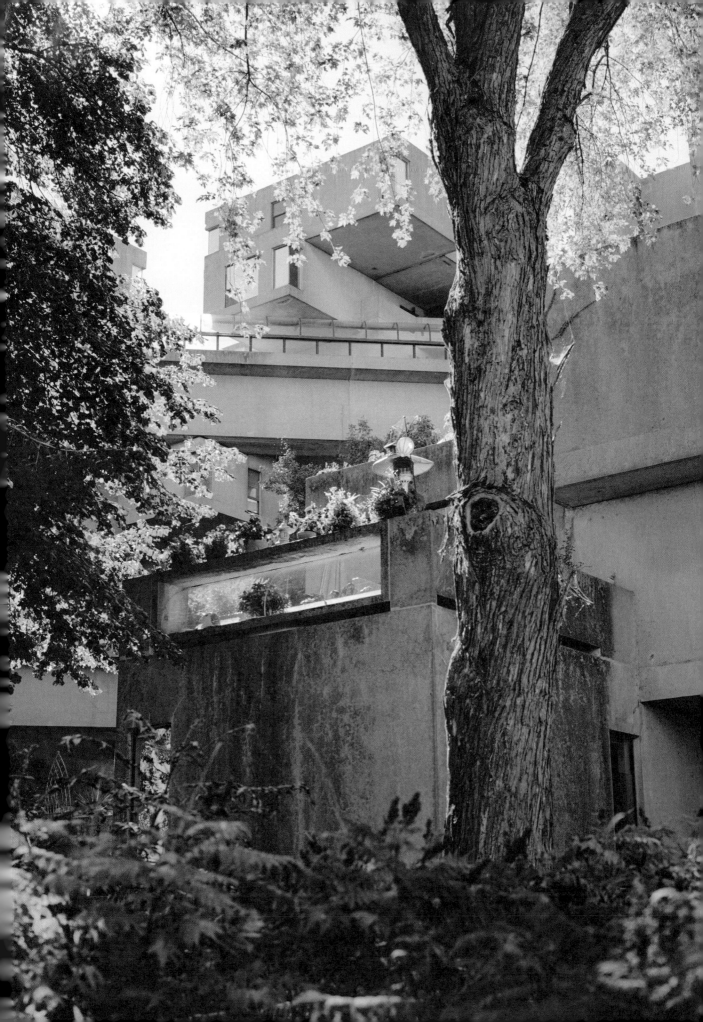

CONTENTS

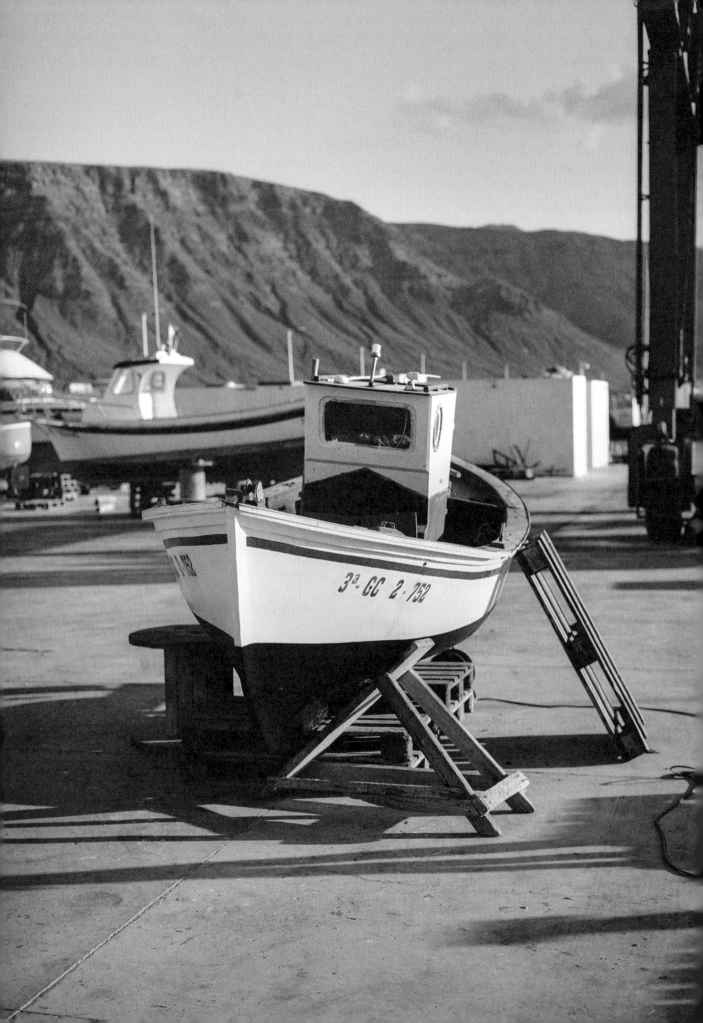

INTRODUCTION

The power islands hold over us is so established that there's even a word for it: islomania, a condition in which people find themselves irresistibly drawn to these small worlds. Cut off from the commotion of the mainland, surrounded by waves and the high drama of the elements, islands have been a Xanadu for centuries of writers' and explorers' most idyllic fantasies. Indeed, the concept of utopia was coined in relation to an island: Thomas More, writing in the 1500s, imagined Utopia as a crescent-shaped island protected from outsiders. Here, he believed, a harmonious and community-minded society could flourish.

Kinfolk Islands dips into more contemporary understandings of the appeal of island life. The stories in this book offer ideas for slow travel, featuring over eighteen islands that beckon you to escape, explore or unwind. Our talented writers and photographers have toured these destinations on their own terms, traversing jungles, deserts, cities and mountainsides to bring you a wealth of inspiration from five continents.

In our Escape chapter, we find bison grazing off the coast of Los Angeles, dragon's blood trees shading hillsides on the otherworldly Yemeni island of Socotra and psychedelic geology contributing to a bohemian outpost in the Strait of Hormuz. We stretch the definition of island to its boundaries in our Explore chapter, visiting islands that offer new perspectives on urban settings. In these pages, enjoy the coffee and culture of Montreal's beloved Mile End neighborhood, find respite from Colombo's chaos through modernist architecture and discover farm-to-table dining in Cuba's verdant Viñales Valley. Our Unwind chapter plants your feet firmly on the beach, as we venture to some of the world's most beautiful coastlines—from bougainvillea-fringed Mediterranean sands to rugged and remote Nordic shores.

For those of you who choose to use this book as a guide to your next adventure, our contributors have included practical tips and itineraries for every location. Equally, if you've got no immediate plans to set sail, and instead want to travel to utopias of your own imagining, we hope that *Kinfolk Islands* gives you the inspiration to do just that.

I

ESCAPE

SOCOTRA

An otherworldly, Arabian oasis

LOCATION	Arabian Sea
COORDINATES	12.46° N, 53.82° E
AREA	1,465 sq. miles (3,796 sq. km)
POPULATION	70,000
MAIN TOWN	Hadibu

Socotra doesn't do standard-issue sunsets. It seems to deal exclusively in extravagantly dramatic skies: colossal clouds painted a thousand mauves, an eerie bloodred moon and a dome of stars so full that it's hard to identify familiar constellations.

But then not much about Socotra is standard issue. It boasts exceptional biodiversity across an area the size of Rhode Island, with much of its flora found nowhere else on earth. The island's landscape feels untouched, witnessed only by its seventy thousand inhabitants and a handful of visitors each year. There are so few tourists because the journey to the island, which is technically part of Yemen but lies 220 miles (350 km) to the south in the Indian Ocean, closer to the coast of Somalia, can be forbiddingly complex to organize.

While mainland Yemen contends with civil war and famine, Socotra remains peaceful. Still, tourists will likely come up against the vagaries of Gulf politics; charter flights from Abu Dhabi, which are infrequent, can be canceled at short notice according to developments in Yemen's political situation. And a Socotri visa can be obtained only when booking a guided tour from travel agencies operating on the island. Despite the many

obstacles getting to the island presents, most visitors unanimously agree it's worth the effort.

Travelers accustomed to freedom and spontaneity might chafe against set itineraries and the near-constant presence of a tour guide, but once you arrive on the island, it's clear that it would be hard to explore any other way. There is little public transport, roads are unmarked and often perilous and there is no internet access or hotels outside the capital, Hadibu.

For most of the few-dozen tourists who visit Socotra each week, this is all part of the allure. The friendly local guides set up camp and handle cooking, coordinating itineraries with one another so that visitors feel they have the island's vast wilderness entirely to themselves. Most tourists choose to visit in the warm, dry months between January and May, avoiding the monsoons and cyclones that can dominate the rest of the year.

While itineraries can be adjusted according to a penchant for, say, camel trekking, hiking or snorkeling, the sites on the default tour packages are consistently sublime, with each day bringing a new surprise: the natural infinity pool on a cliff overlooking the Indian Ocean at Homhil Plateau; the towering dunes

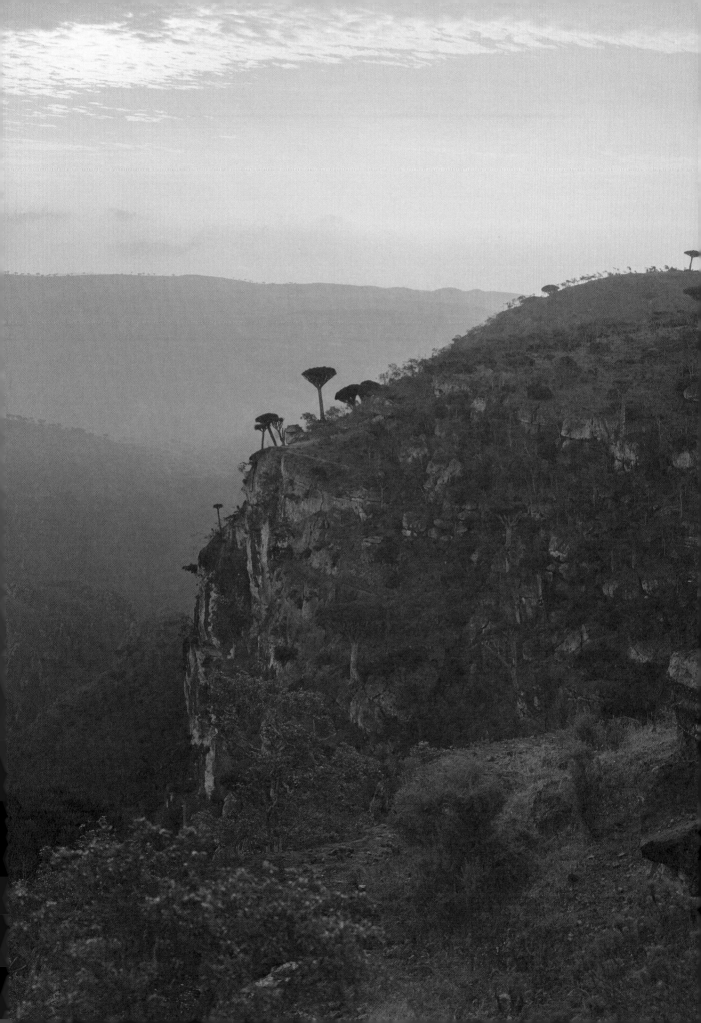

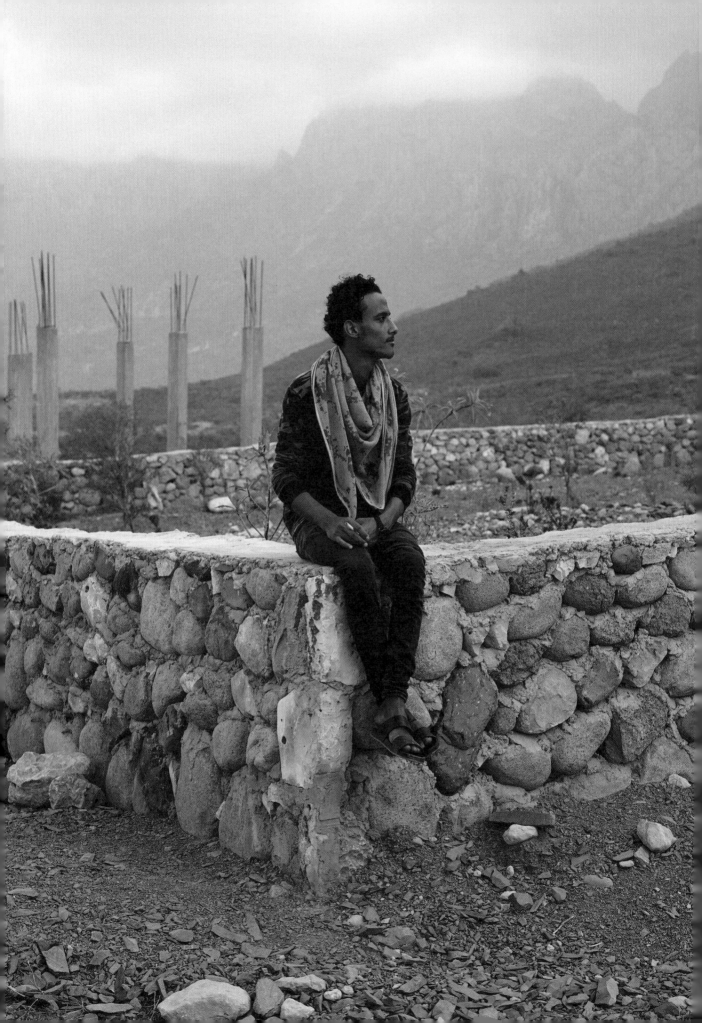

Socotra can currently be reached only via charter flight from Abu Dhabi. This can be arranged through your chosen tour guide company, with options including ISHKAR and Socotra Eco-Tours. The main city, Hadibu, has few tourist sites, so it will serve most visitors only as an occasional lunch or overnight spot while exploring the island via four-wheel-drive vehicle.

Learn about the extraction of resin from dragon's blood trees at Firmihin Forest. Climb the island's highest peak, Mount Skand, for impressive views of the Indian Ocean and the Arabian Gulf. Swim in the milky turquoise waters of the unspoiled Shoab Beach, accessible only by boat. While you will regularly be served fresh fish, seek out the delicious rainbow-colored lobster.

Most visitors to Socotra will camp, with tents and meals prepared by their guide and driver. There are hotel options in Hadibu, though most are basic aside from Summerland Hotel, one of the only places on the island to offer Wi-Fi. There are no banks or ATMs on the island; visitors must bring all money they need in cash—American dollars are accepted, alongside Yemeni rials.

Yemenis are known across the Arab world for their use of qat, a plant whose leaves, when chewed or infused, produce the effect of a mild stimulant. Though the plant doesn't grow in Socotra, it is exported daily from mainland Yemen via boat. All echelons of Yemeni society chew the plant, and they can be identified by the telltale bulge of plant mulch in the chewer's cheek.

 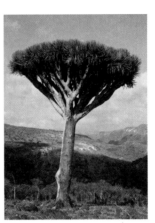

set against ominous black cliffs at Arher Beach; the mysterious depths of Hoq Cave, a cathedral of stalagmites hiding pictograms inscribed by travelers in the first century BCE.

For all its wind-sculpted rock and dramatic vistas, Socotra's primary draw is its unearthly flora. Many of its eight hundred species of plant, of which 37 percent are endemic, look as if they've come out of a science fiction movie. The specimens with the most personality are bottle trees, which have squat and bulbous trunks, just a few frail branches and, in February and March, bright pink flowers. They often squeeze out from boulders and cliffs and grow in such varied and eccentric shapes that it's hard to resist anthropomorphizing them.

But the symbol of Socotra is the endemic dragon's blood tree, with its distinctive mushroom-shaped crown of spiny leaves. Its name comes from the crimson resin that is extracted from it and used for dyes, lacquers and local medicine. Folklore tells that its Arabic name, dam al akhawain, which translates as "blood of the two brothers," references a murderous local tale similar to Cain and Abel, the first tree growing from the blood spilled on the earth.

These trees grow most profusely at Firmihin Forest in Diksam Plateau, where visitors will learn that the species is threatened both by escalating cyclones and by the island's huge population of goats, which eat saplings before they can mature. The species may be further endangered by the United Arab Emirates, which has recently been vying for political dominance in Socotra and allegedly exporting the trees to furnish private homes in Abu Dhabi. There are grassroots efforts to grow saplings in protected areas, but these young trees will take centuries to mature.

Beyond the goats, there are few mammals on the island to rival the botanical life (supposedly not even a single dog), but visitors are almost certain to see endangered Egyptian vultures, which turn up looking for scraps at every campsite, and a profusion of unusual aquatic creatures that can be spotted at Detwah Lagoon, where local self-proclaimed "cave man" Ellai will point out stingrays, squid, sea potatoes and his friend Mumduh the octopus.

Outside of the wilderness, Socotra is a blissfully sleepy place, with scattered villages and two tiny cities, Hadibu and Qalansiyah. Locals speak Yemeni Arabic and Socotri, a language that exists only orally. They have a rich poetic tradition, particularly during celebrations when men and women once competed in challenges of oratory. One local lullaby, translated by Miranda Morris, articulates the poetic beauty of Socotra's landscape and gestures to the symbiotic relationship its people have with the natural world to this day. "Wherever she goes may her goats be of the most lucky and blessed kind . . . for her eyes are huge rain clouds clustering around the peaks of the high Haghier mountains in the morning."

PREVIOUS PAGES, LEFT
Mohammed, pictured, is originally from Taiz—a city in southwest Yemen that was once known as the country's capital of culture but that has been all but destroyed over the course of the country's brutal eight-year civil war. (Mainland Yemen is currently in crisis and not safe for any form of tourism.) Mohammed moved to Socotra in 2021 and now works in a restaurant making juice.

BELOW & OPPOSITE
Bottle trees survive in very dry regions by storing water in their bulbous trunks. While other botanical species have been ravaged by the island's huge population of goats, bottle trees have been largely spared thanks to their poisonous sap. The graffiti carving (below) reads "God is above" in Arabic; most inhabitants of Socotra are Sunni Muslim.

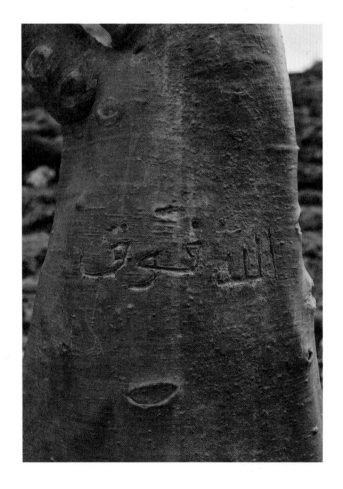

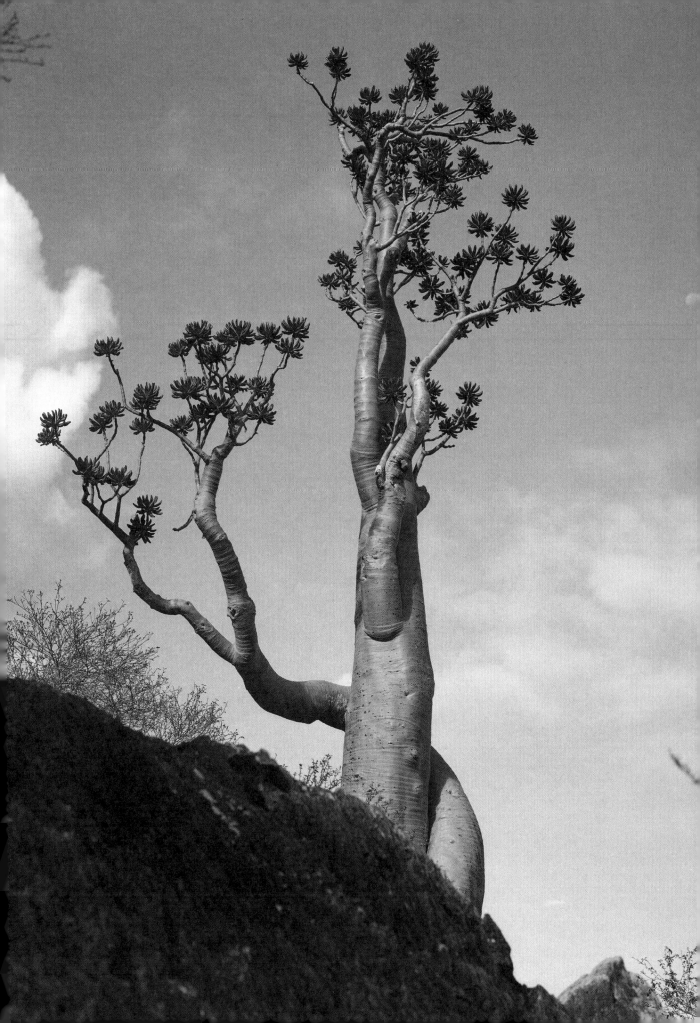

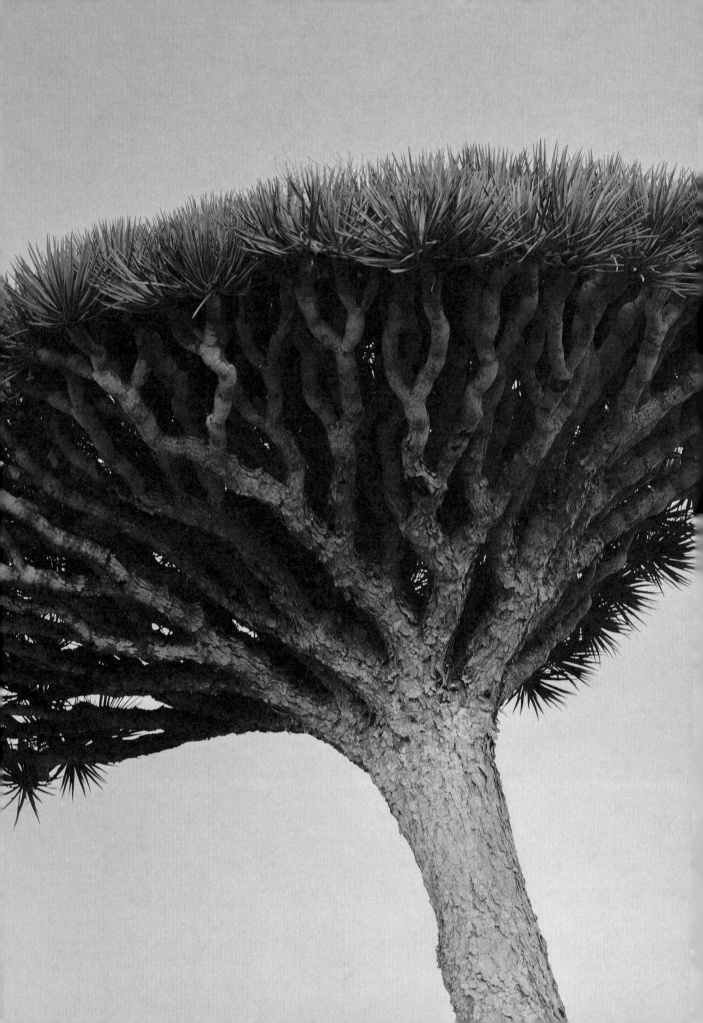

Dragon's blood trees are unique to
Socotra and have expertly adapted
to the climate. During the monsoon
season, the island experiences cloud
cover, light drizzle and mist, and
the dense tree canopy captures and
channels this moisture down toward
its roots (which are also shaded by
the canopy during periods of scorch-
ing heat). The island is sometimes
referred to as the "Galápagos of the
Indian Ocean" for its biodiversity.

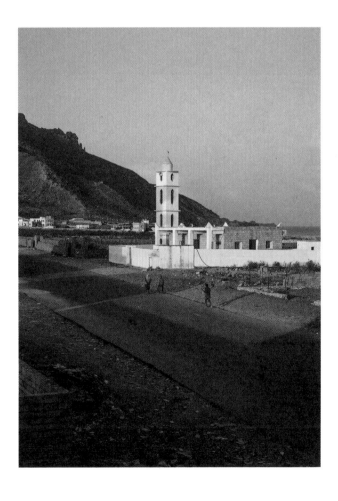

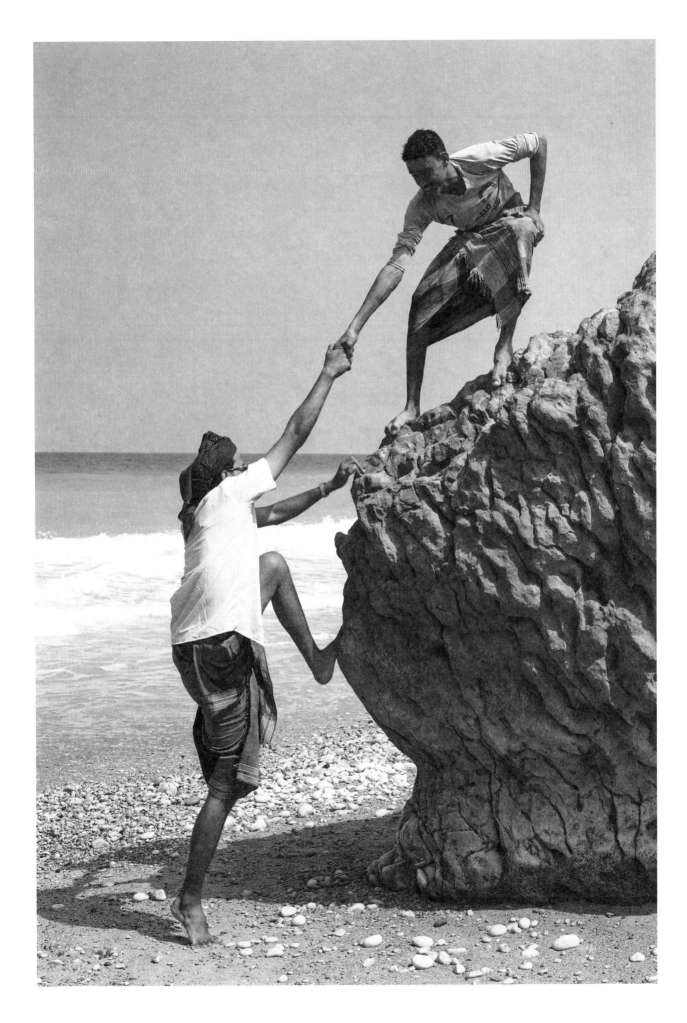

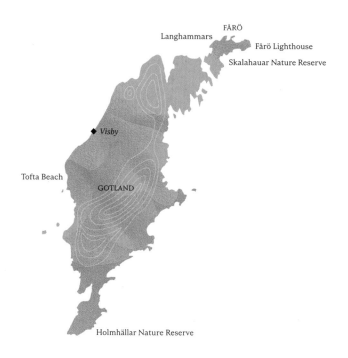

FÅRÖ
Langhammars
Fårö Lighthouse
Skalahauar Nature Reserve

◆ *Visby*

Tofta Beach
GOTLAND

Holmhällar Nature Reserve

GOTLAND & FÅRÖ

On the trail of Ingmar Bergman in Baltic Sweden

LOCATION	Baltic Sea
COORDINATES	57.47° N, 18.49° E
AREA	1,229 sq. miles (3,183 sq. km)
POPULATION	59,000
MAIN TOWN	Visby

At the easternmost tip of the Swedish island of Fårö, there stands a tall white lighthouse. It rises at the end of the road in the hamlet of Holmudden, beyond which lies the Baltic Sea and, farther still, Estonia. On a midwinter day, the water shifts from a dark, forbidding shade of green to bright emerald as the sun flits into view from behind the clouds. The breeze is stiff and bitingly cold. Standing amid the coastal pines of the Skalahauar nature reserve, it makes for a picture-perfect Nordic island scene.

For lovers of cinema, it's impossible to think of Fårö without thinking of the seminal Swedish director Ingmar Bergman. This is the place Bergman called home in the latter part of his life, and where he made the 1966 masterpiece *Persona*. In fact, he shot six features, a television series and two documentaries here. This being a small island, you're never far from one of Bergman's filming locations; a pilgrimage to Fårö is also a journey into his movies.

It's easy to imagine why Bergman wanted to center much of his life and work on Fårö. Like his films, both Fårö and the neighboring island of Gotland are defined by a stark, haunting beauty: the particular angle of the light, which is more piercing than on the mainland; the sea, welcoming and forbidding at the same time,

stretching to the horizon; the unusual limestone formations found along the rocky beaches, like hunchback trolls in the mist; and the sense of being in a kind of bucolic paradise, where people still make things with their hands (Gotland is known for its artisans) and sell them in their front yards. In his 1989 autobiography, *The Magic Lantern*, Bergman described how, when he first discovered Fårö, he had an intuitive sense that it was the place for him. "This is your landscape, Bergman," he wrote. "It corresponds to your innermost imaginings of forms, proportions, colors, horizons, sounds, silences, lights and reflections."

Fårö sits just north of Gotland, and the two islands can be reasonably grouped together in one trip. Although it is far larger and more populated, Gotland lodges in the psyche of visitors in much the same way. Many artists, writers and other creatives have arrived here for residencies—artists at the Baltic Art Center, writers at the Baltic Centre for Writers and Translators, both in the town of Visby—and found themselves making plans to stay. Even those without novels to finish find something here that draws them back year after year: Sweden has over 200,000 other islands, but this one is held particularly dear.

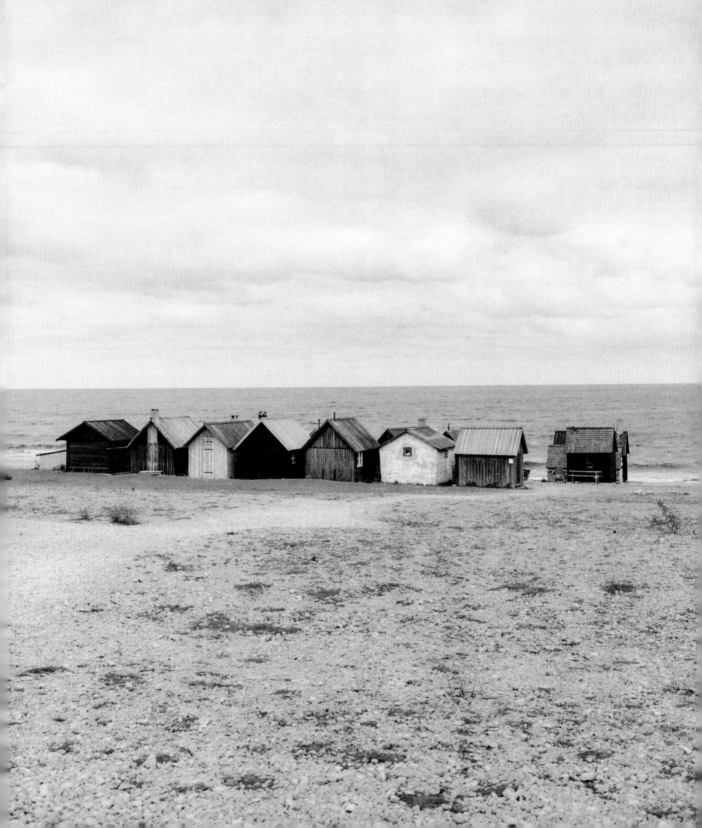

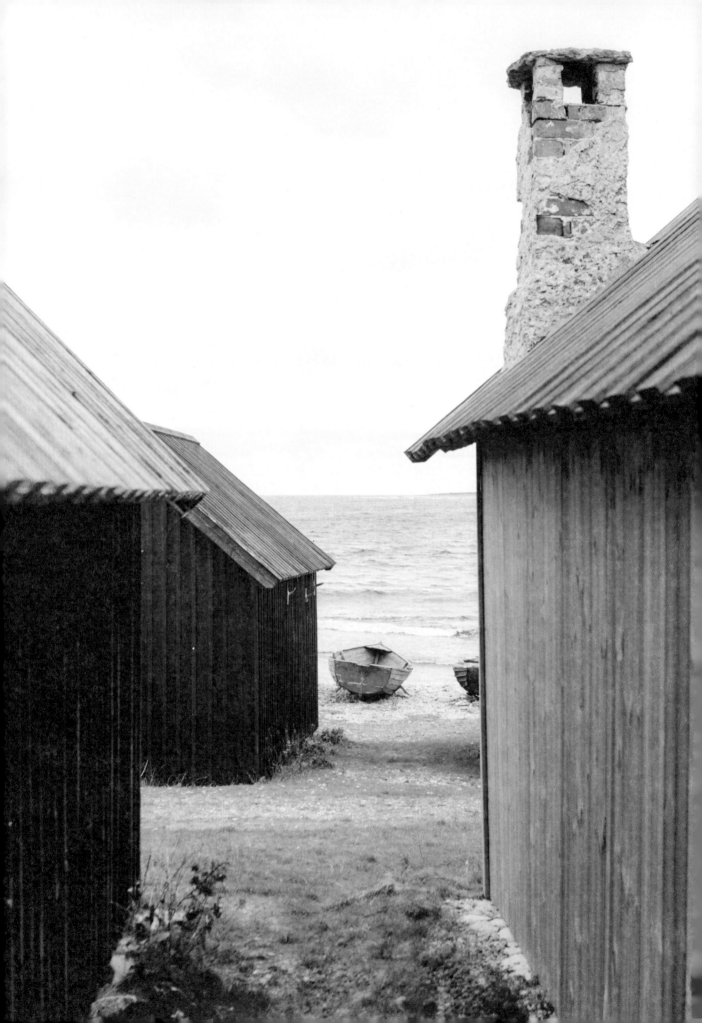

GETTING THERE

If touring by car, the Destination Gotland ferry from Nynäshamn (linked to Stockholm by commuter train) or Oskarshamn (farther south) takes around three hours to reach Gotland. For sheer convenience, there are thirty-minute flights from Bromma Stockholm Airport (flights occasionally depart from Gothenburg as well, more often in summer). All inbound transport arrives in Visby.

SEE & TOUR

In Fårö, head to the Gårdskrog at Stora Gåsemora for high-quality local food. In Gotland, visit Sysne Fish Shop on the eastern coast for fresh and smoked seafood. Tofta Beach is one of the most popular on Gotland; grab a local beer and take it down to the shore for a picnic, or climb around the limestone rock formations on a sunny day at Holmhällar Nature Reserve in the far south of Gotland.

STAY

Visby is the main town on Gotland and a pleasant place to spend time. Fabriken Furillen is a standout hotel on Gotland, offering a handful of beautifully designed rooms and cabins set in an old limestone quarry; the island has many other hotels, bed-and-breakfasts, camping sites and vacation rentals. Day trips to Fårö from Gotland are possible, but there are also accommodations on the island, at Stora Gåsemora.

WORTH KNOWING

Fårö was off-limits to non-Swedish citizens until 1998 because of sensitive military installations. Gotland remains a strategically important island in the Baltic Sea and home to Swedish military activity to this day. This could be in part because of its proximity to Russia; the island sits a little over 200 miles (322 km) as the crow flies from the Russian enclave of Kaliningrad.

 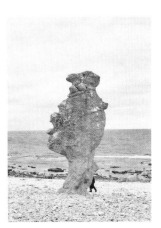

A flight to Visby from Bromma Stockholm Airport takes just thirty minutes; the ferry is a scenic three-hour alternative. During the busiest weeks of summer, you'll find Gotland full of life. There are beaches with golden sand, plus ice cream stands and alfresco lunches to be enjoyed. But it is during the off-season, when it's possible to not see a single person for hours, that the spirit of Bergman is most present.

To continue your Bergman safari, head for the free car ferry that runs between Fårösund, at the northern tip of Gotland, and Broa, in the southwest of Fårö. At the height of summer, when visitor numbers swell, the ferry runs every ten minutes, while off-season it usually leaves every half hour. A ten-minute drive from Broa, along an unnamed road, will lead you to the Bergman Center—a modern concrete cultural center that celebrates the director's life and work through exhibitions and a weeklong festival at the end of June (the center is open only between June and September). Visitors can enjoy a glass of wild yeast wine (there are several vineyards on Gotland) or a fresh lunch at the center's café, Törst, before visiting one of three barn-like movie theaters on the island.

There is a well-known photograph of the director on Fårö, walking along the rocky beach at Langhammars with a handful of tall, ice-age limestone formations—known as *rauk*—behind him. There are several nature reserves on both islands where these limestone columns can be seen, but Langhammars is home to perhaps the most famous (indeed, they feature on Swedish 200-kronor banknotes). The nearly 1,200-acre (486 km) reserve, set on a peninsula, is a good place for a long, contemplative walk along the coast.

Bergman sought answers to big questions in many of his films—no less weighty topics than the meaning of life and the inevitability of death. For a visitor who is looking for silence and solitude on vacation, who hopes to be steeped in the sort of breathtaking, muted beauty that inspires inner contemplation, a summer spent on the islands of Gotland and Fårö would be difficult to beat.

RIGHT

A barn with a traditional roof thatched with a local marsh sedge called ag (the style of roof is known locally as ag tak). The sedge is dried before being tossed up against the gables by the forkful and flattened by foot. The roofs can last sixty years if made correctly, so to celebrate the local custom, parties are thrown so that friends and neighbors can help flatten the sedge while enjoying food and drink.

OPPOSITE

Fårö Lighthouse, on the northernmost tip of the island, is still operational, although staffed remotely. In 2019, a sixteenth-century ship was found perfectly preserved in the sea between Sweden and Estonia. Historians speculated that it had been sunk during the 1521 to 1523 war in which Sweden won its independence from the Kalmar Union.

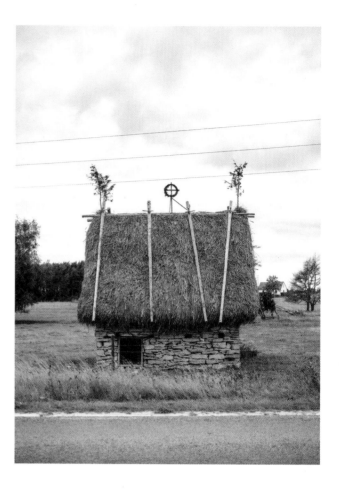

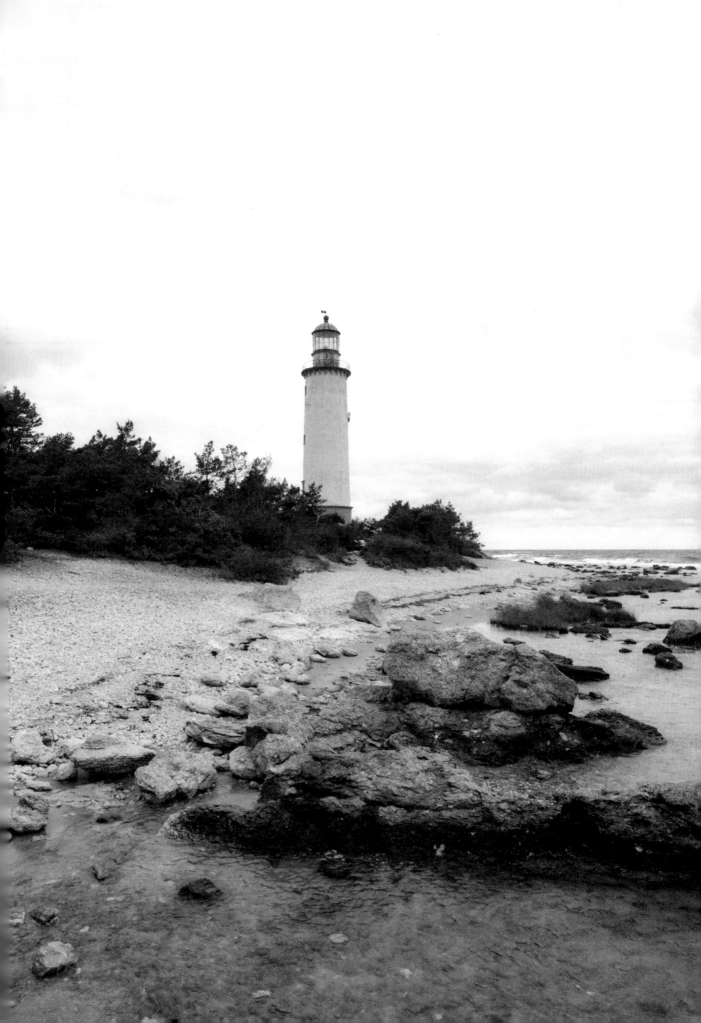

OPPOSITE

The small, scenic alley of Fiskargränd in Visby. The medieval town is home to Gotlands Museum, which houses the world's largest preserved horde of silver treasure, and several medieval churches. At the ruins of St. Karins Kyrka, there is an ice rink in winter, and concerts are sometimes held in summer.

FOLLOWING PAGES, RIGHT

The fence surrounding this house on Fårö is constructed in the *gärdesgård* style, known in English as roundpole fencing. Used to keep animals from straying, these fences are traditionally constructed from trees felled during forest thinning. On Fårö, you will also see many fences made of large rocks.

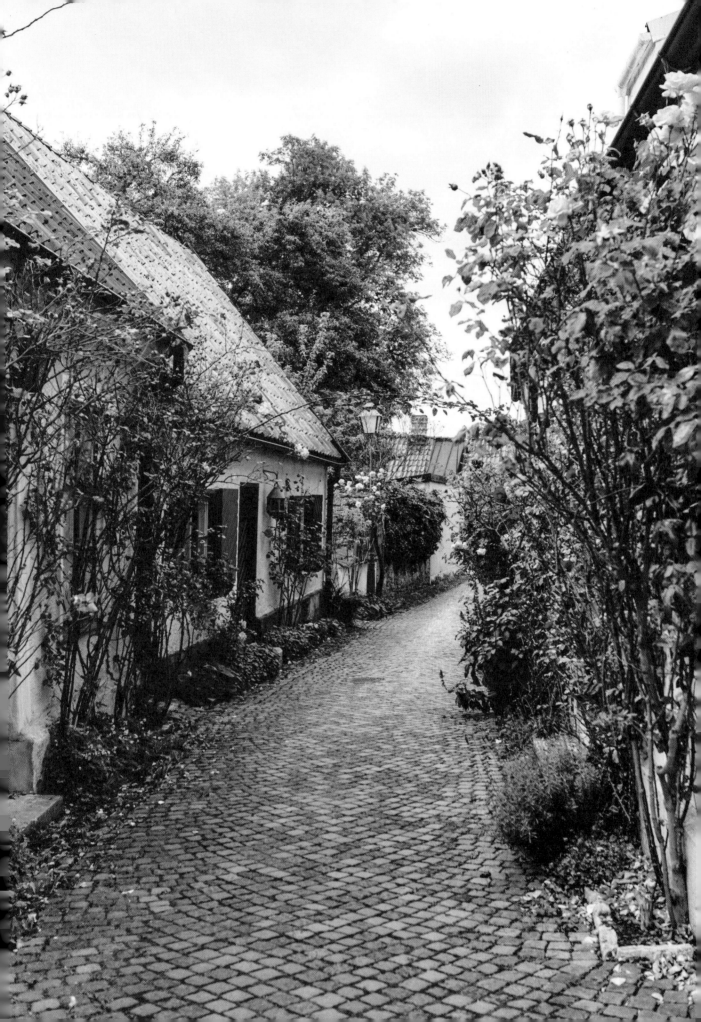

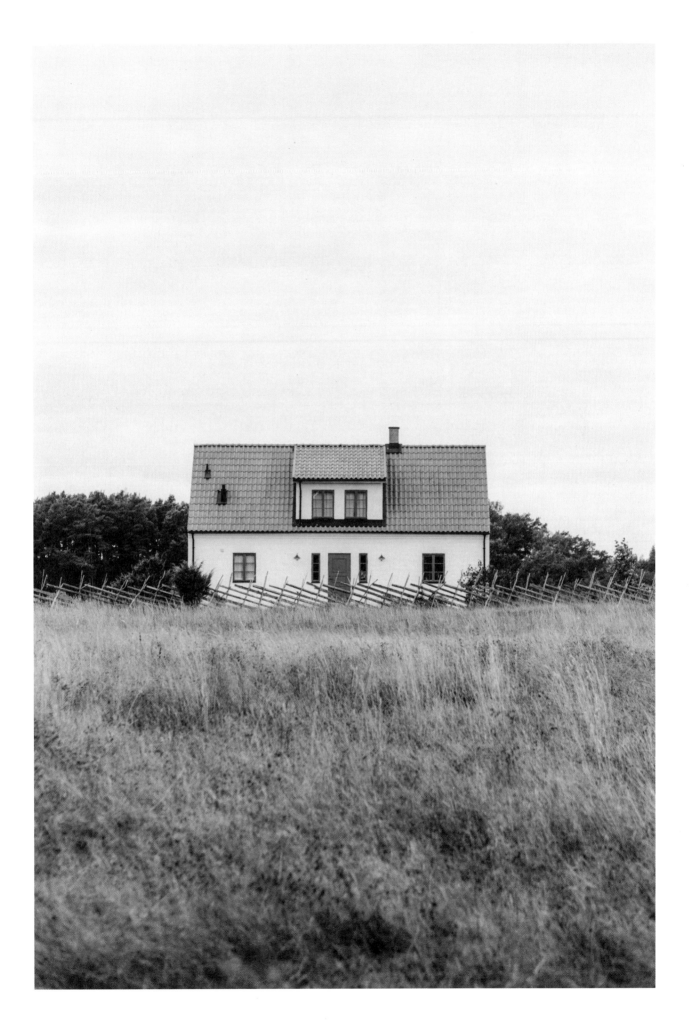

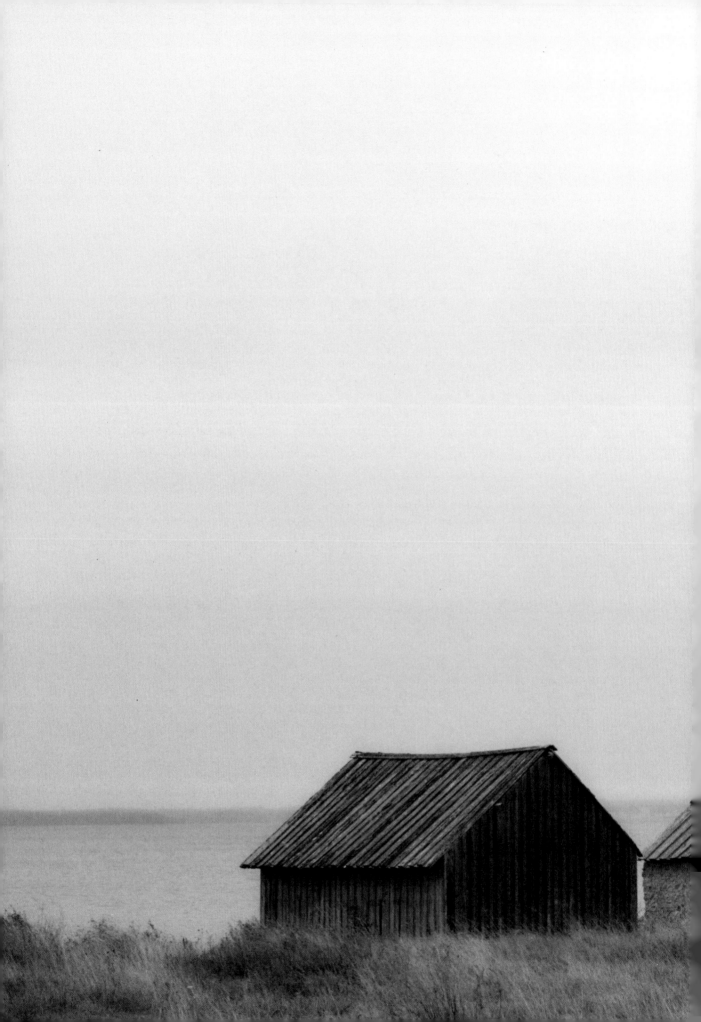

LEWIS & HARRIS

Sheltering in Scotland's secret, communal bothies

LOCATION	Outer Hebrides
COORDINATES	58.24° N, 6.66° W
AREA	683 sq. miles (1,770 sq. km)
POPULATION	18,500
MAIN TOWN	Stornoway

Through the westerly window of the Mangersta Bothy on the Isle of Lewis, a pale square of blue-gray Atlantic Ocean lies snug to the horizon line. The nearest coast in that direction is in Newfoundland, Canada, and there's nothing but water and whales, seabirds and ships for 2,000 miles (3,219 km) between it and this wind-lashed clifftop spot in the outer reaches of Scotland's Hebrides. This is life on the edge of the world.

The bothy, a stone shelter abutting the cliff, holds the barest of basic creature comforts: in this case, a fireplace, a sleeping platform and a table. Shafts of light fall onto the rough flagstone floor from triangular windows set in the wooden ceiling. For hikers, these Spartan shelters provide a safe haven on multiday treks, and they are a life raft for those who have been caught out by bad weather or injury—bothies are always left unlocked and are free to use. For those who love and revere bothy culture, they're also a refuge from the modern world and a place to recharge and reconnect with nature.

The word *bothy* comes from the Gaelic word *bothan*, meaning a small dwelling or hut, and has come to define a particular type of mountain hut especially found in Scotland. Here on

the Isle of Lewis, where Sabbath observance has persisted, the word has also meant a small hut used as an unlicensed drinking establishment, although Mangersta isn't one of those. This bothy is a place to cozy up beside a roaring fire after a long walk, a tot of whiskey in the mug in your hand. A logbook stashed in an old, rusted biscuit tin charts the decades of hikers who have slept on these planks before you.

Bothy culture came into being in the postwar period, when an increase in leisure time allowed people to explore nature like never before. As the boom in Munro bagging (climbing as many peaks as you can), mountaineering and hill walking continued, interest grew in finding places to stay overnight on the hills so adventures could be extended over a full weekend.

Unlike mountain huts in other parts of the world, bothies are not purpose-built and generally have few to no facilities. Originally abandoned farm buildings, some dating to the Highland Clearances of the 1700s, they are typically off the beaten path, with often little more than the roof over your head to keep you warm and dry. In better-appointed huts, you might find bunk beds and a basic toilet, but these are by no means

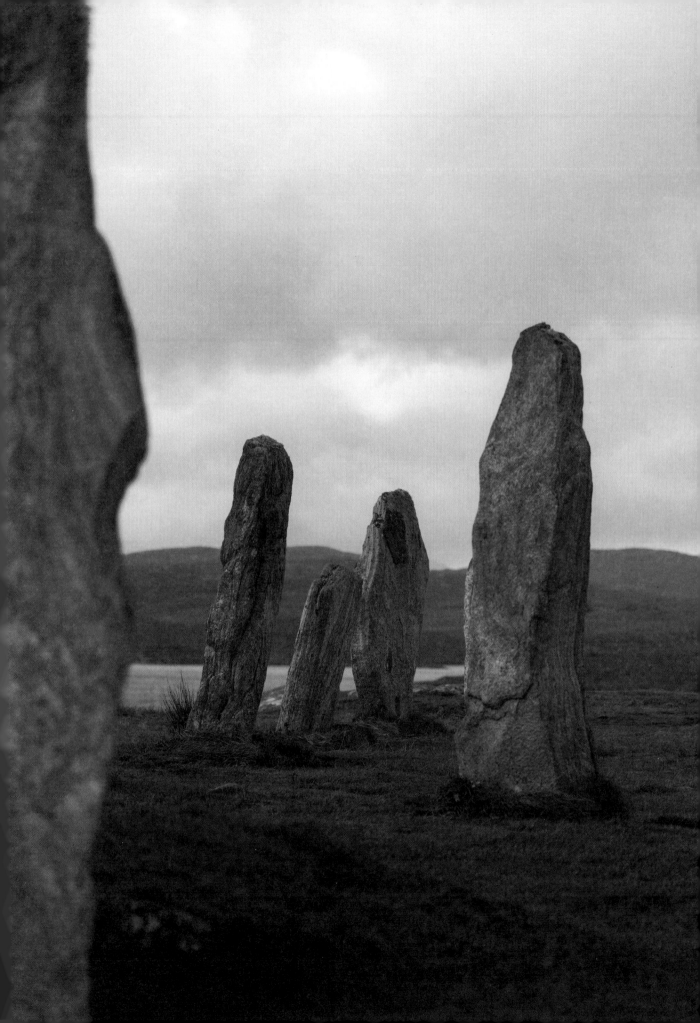

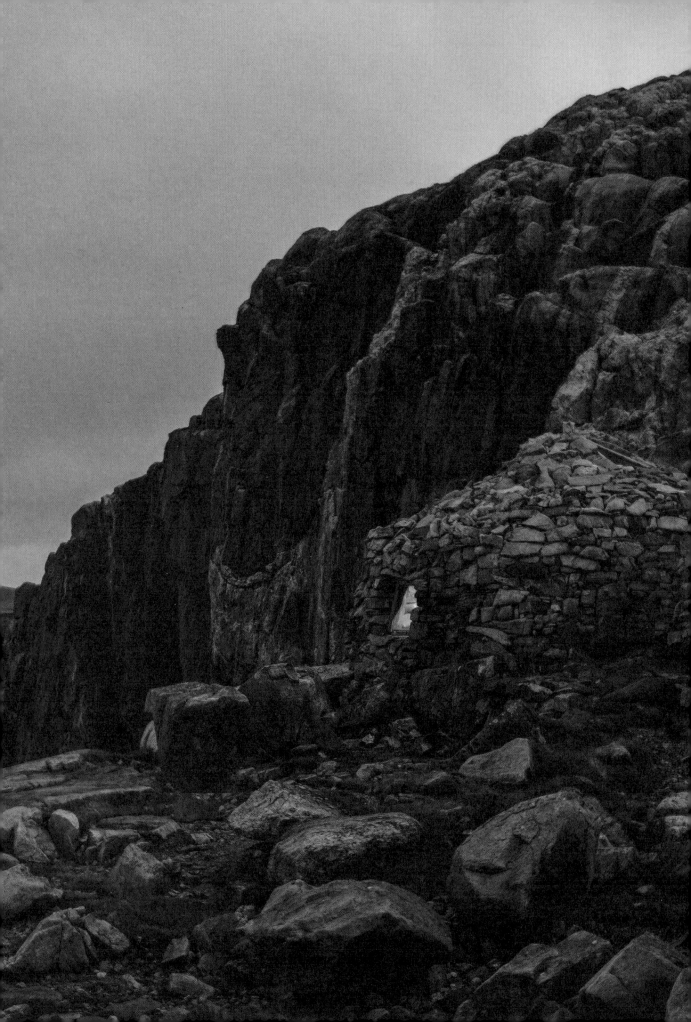

GETTING THERE

Take the CalMac ferry to Stornoway from Ullapool to begin your trip to Lewis. In Stornoway, the island's main town, you can rent a car. The bothy is an hour's drive along the B8011 road, then a twenty-minute walk from the village of Mangersta. The roads are generally quiet; many are single lanes, with plenty of places to pass. There is also a bus service that runs Monday through Saturday.

SEE & TOUR

Begin with the Calanais Standing Stones, a set of Neolithic standing stones older than Stonehenge. Then explore the island's white-sand beaches, like Traigh Bhostadh on Great Bernera. Harris Tweed is exclusively handmade on Lewis. Drop by the island's oldest mill, Carloway Mill, to buy handwoven fabric. Six Viking-age chess pieces that washed ashore on Lewis in 1831 can be seen at Museum nan Eilean.

STAY

There are plenty of options besides bothies, from hotels and bed-and-breakfasts to holiday cottages, campsites and Airbnbs. The most choice can be found in Stornoway but those seeking solitude may prefer the west coast. Stornoway's Lews Castle is the island's best hotel. The upper floors of this Gothic revival building are now home to a warren of palatial self-catering apartments and hotel suites.

WORTH KNOWING

A local seasonal delicacy is guga, a teenage gannet (a type of seabird) harvested from the island of Sula Sgeir in late August, which is said to taste like a challenging cross between soggy leather, fish and beef. Lewis is also home to several world-renowned smokehouses, which use traditional peat smoking to prepare delicacies including whiskey-cured, hot-smoked and cold-smoked salmon and Stornoway kippers.

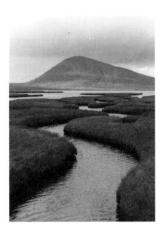

guaranteed. A trowel is often presented in lieu of a bathroom. "It's camping without a tent," explains Neil Stewart of the Mountain Bothies Association.

"It's important to know that you're not staying in a holiday cottage—there is likely no mobile phone reception—and you can usually access a bothy only on foot. You need to be able to read a map and compass just to reach them."

The Mountain Bothies Association was created in 1965 with a mission to maintain simple shelters in remote areas for the use and benefit of all who love wild and lonely places. Today they look after around one hundred shelters in the most remote reaches of Great Britain.

You typically can't book a bothy, which means that as well as hiking with fuel (coal or wood), food and a sleeping bag, it's a good idea to pack a tent in case the shelter is full. You should also abide by the bothy code, which asks you to respect other users, the surroundings and capacity restrictions.

To reach this magical spot in Lewis, you'll first have to get to Ullapool, a two-hour drive north of Inverness. From here, it's a two-and-a-half-hour ride on the Caledonian MacBrayne ferry to Stornoway, the biggest town in Lewis and the capital of the Western Isles, which include North Uist and South Uist. Lewis is the largest in this scattering of islands, and is one island in two

parts. Harris, known for its tweed, is the southern half of the island, while Lewis is the northern half, tapering off to a broken necklace of skerries, smaller islands and seal-strewn rocks at its tip.

Although hiking is the real highlight of a trip to Lewis, it's easiest to get around by car. With one, you can traverse the island's extraordinary scenery, from tropical-looking white-sand beaches to the Calanais stones, a group of standing stones older than Stonehenge. Note that access to Mangersta Bothy is on foot only.

If you have the time, the Hebridean Way opens up a world of slow travel possibilities. This 156-mile (251 km) trail leads you from Vatersay on the Isle of Barra to Lewis across ten islands via ferries and hiking routes, opening up to wide vistas of the Atlantic Ocean, hidden smugglers caves and secluded bays, crofting communities (a system of agricultural landholding unique to Scotland) and all-purpose village stores, and ospreys hunting over the sea lochs along the way.

Visit in summer and you'll have company along your walk including but not limited to the ubiquitous Scottish midge, but time your visit to late spring or early autumn and trails will be quieter and biting insects less prevalent. Whenever you visit, you can expect rain, a warm welcome and a slower pace of life.

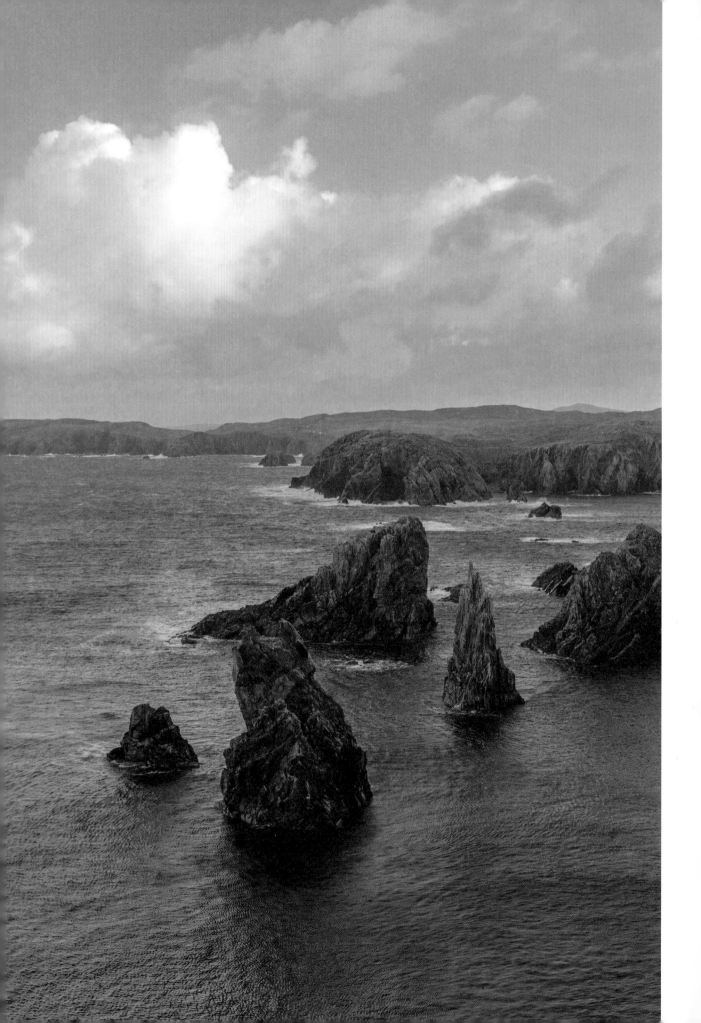

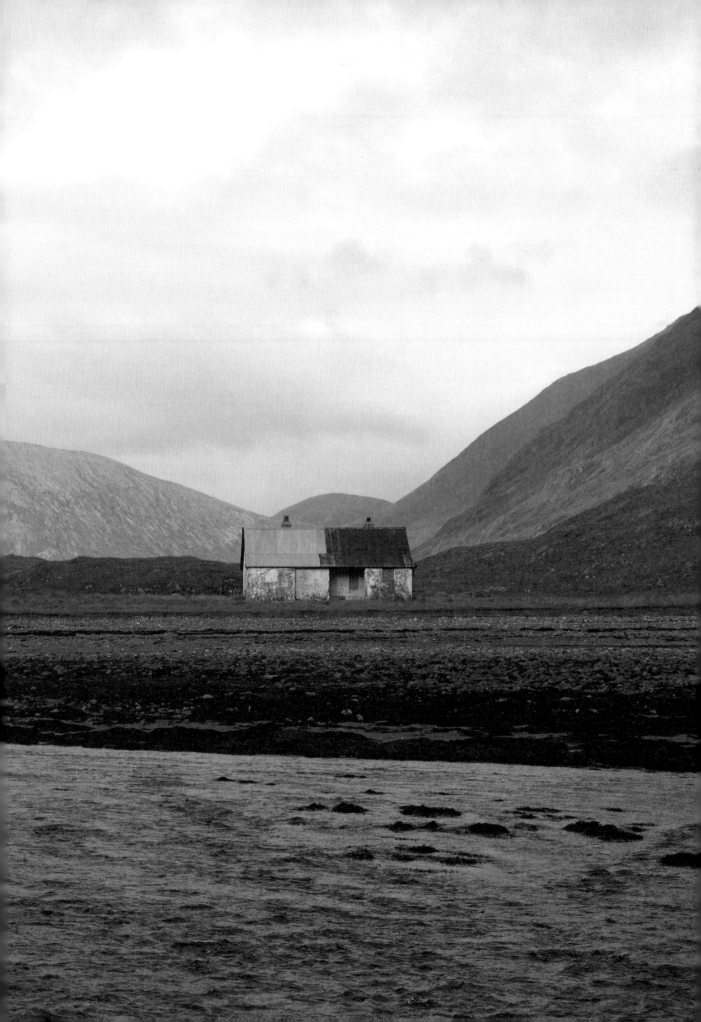

PREVIOUS PAGES, LEFT
The dramatic sea stacks of the Mangersta coastline have been created by coastal erosion, volcanic heat, ice and wind over tens of thousands of years. Join a sea kayaking expedition to explore the coastline up close. The sandy beach at Mangersta Sands is also popular with surfers. If you don't have your own board, you can rent one at Hebridean Surf in Lower Barvas.

BELOW RIGHT
Bunabhainneadar, the UK's most remote tennis court, is set into the lower slopes of Uisgnaval Mor on the Isle of Harris. Before the construction of the court in 1998, residents played tennis on the road with a fishing net strung across it, which had to be removed for cars to pass. Tennis-loving travelers sometimes head to the island specifically to play a match on this court.

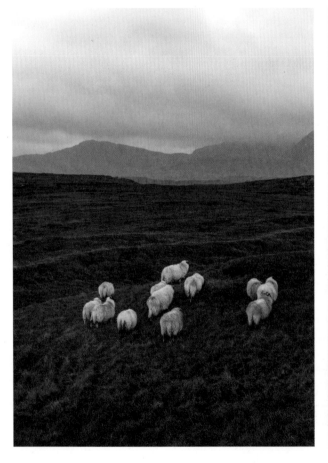

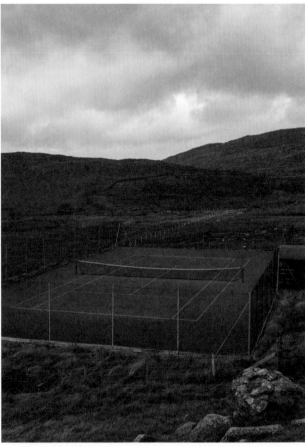

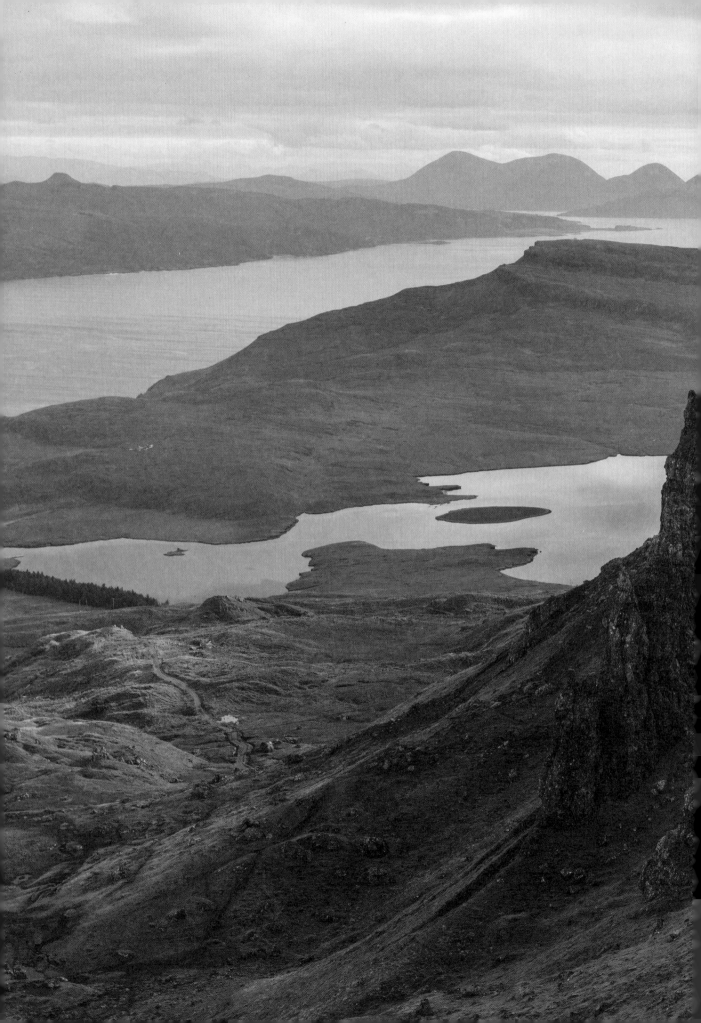

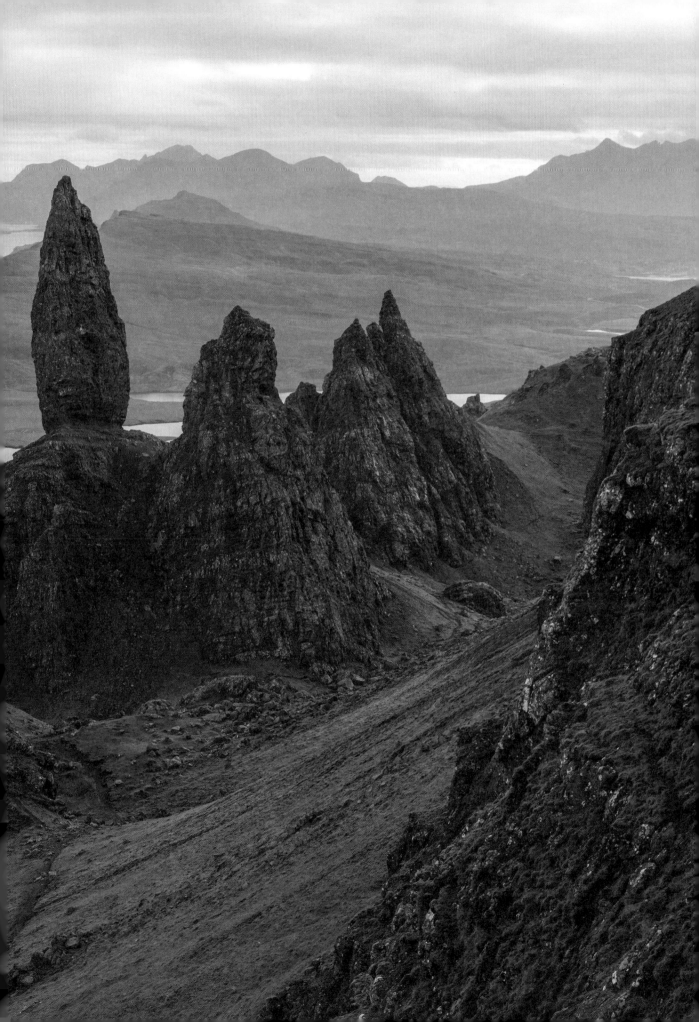

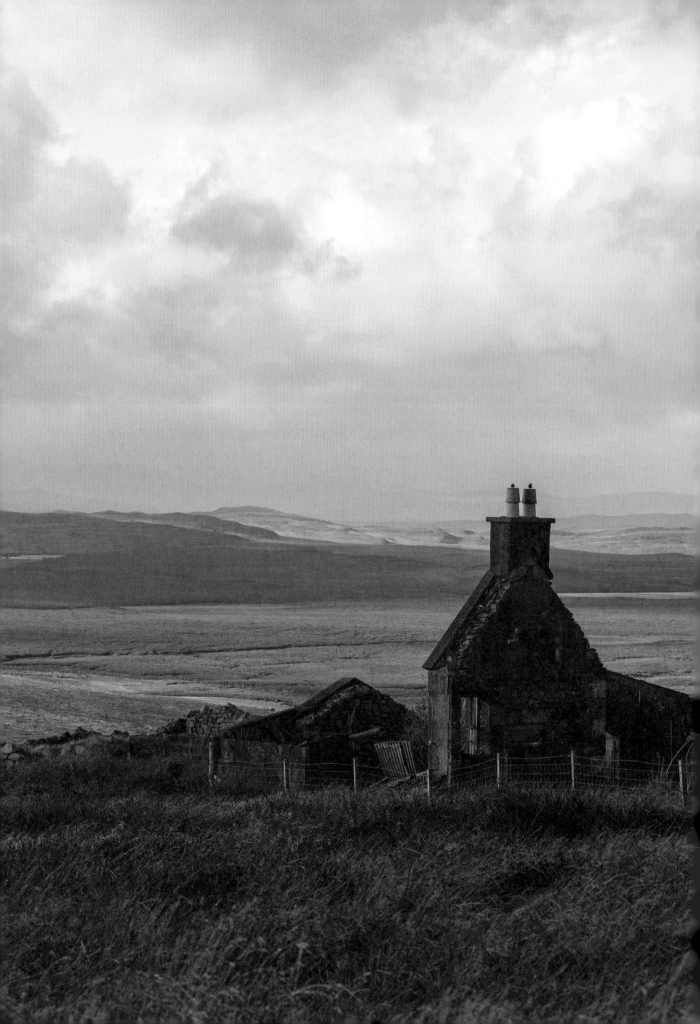

A ruined building at Garynahine on Lewis. In the 1960s, there were several nearby sightings of a ghost: a tall woman dressed in white who carried a staff and frightened motorists near the bridge. However, the Silver Lady of Garynahine was soon revealed to be local landowner Mrs. Perrins. "It's not ghosts I'm looking for, but poachers," she told the *Stornoway Gazette*.

Lookout Bothy, at the northernmost tip of the Isle of Skye at Rubha Hunish, was previously a Coast Guard station but is now run as a bothy and is popular with whale watchers. It sleeps a maximum of seven in wooden bunk beds and can be reached via an hour-long hike over boggy ground from the nearest road.

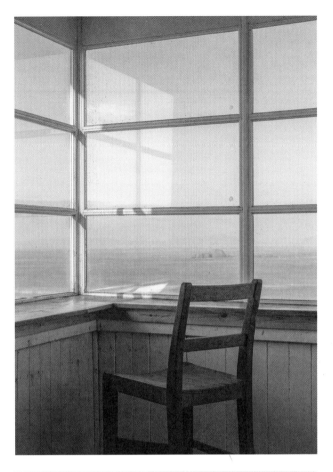

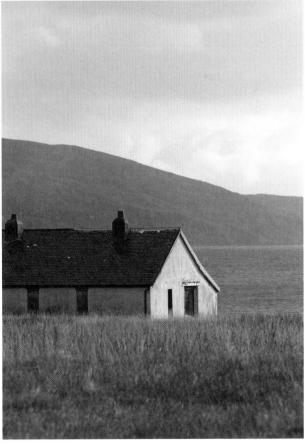

GALÁPAGOS ISLANDS
Set sail to the land of fabled fauna

LOCATION	Pacific Ocean
COORDINATES	0.95° S, 90.96° W
TOTAL AREA	3,040 sq. miles (7,880 sq. km)
POPULATION	25,000
MAIN TOWN	Puerto Ayora

"There's nowhere else in the world like the Galápagos," says Ramiro Jácome Baño, a guide to the Galápagos National Park, as he gestures along a wild beach on Isabela Island. "It's Noah's ark and the Garden of Eden rolled into one."

On the rocks nearby, marine iguanas are basking in the sunshine, piled up in a jumble of spines and scaly limbs. Sea lions laze along the tideline, barking hoarsely. Sally Lightfoot crabs, supposedly named after a particularly nimble Caribbean dancer, scuttle in the surf. Pelicans and frigate birds cruise through the sky; Nazca boobies squawk on the cliffs. A little way inland, a giant tortoise hauls its carapace through the scrub as it goes in search of breakfast.

"Incredible, no?" Baño says, tramping off along the beach in search of even more wildlife. "I have been exploring Galápagos for thirty years, and it still surprises me every day."

Roughly 600 miles (966 km) west of Ecuador in the Pacific Ocean, the twenty-one-island Galápagos archipelago sits at the junction of three tectonic landmasses—the Pacific, Cocos and Nazca plates. On Isabela, volcanic craters steam along the skyline and plains of petrified lava run down to the ocean's edge.

The island's largest volcano, Wolf, erupted spectacularly in 2015, and again in 2022. Despite being scorched and blasted by volcanic activity, the Galápagos support ecosystems of astonishing abundance and complexity. For centuries, the islands were known to sailors as Las Islas Encantadas—the Enchanted Islands—on account of the fabulous creatures who called them home.

One man who nurtured a lifelong fascination with the wildlife of the Galápagos was Charles Darwin, who arrived on Chatham Island (now San Cristóbal) in 1835, aged twenty-six, having signed on as ship's naturalist aboard HMS *Beagle*. His observations of the islands' animals—and the subtle adaptations they had made to survive in the unforgiving terrain—later inspired his most famous theorem: evolution by means of natural selection. "The archipelago is a little world within itself," Darwin wrote. "We seem to be brought somewhat near to that great fact—that mystery of mysteries—the first appearance of new beings on this earth."

Almost two centuries later, the Galápagos Islands exemplify the preciousness and the plight of the world's wild places. The islands have become a magnet for wildlife tourism, and although 97 percent of the islands' total landmass is officially protected

Flights to the Galápagos Islands travel from Ecuador's capital, Quito, via a layover in Guayaquil, with a flight time of around five hours. A boat is needed to tour between the islands; you'll find tour companies in the town of Puerto Ayora on Santa Cruz. Cruise passengers are limited by the space available on expedition ships; in 2019, there were some seventy ships with room for about 1,700 passengers.

Visit the Charles Darwin Research Station on Santa Cruz, where giant tortoises are bred in captivity before being released. Take a boat trip to North Seymour Island to see frigate birds and blue-footed boobies. Hike through the moonlike landscapes of Isabela and look out for pirates' graffiti at Tagus Cove. Head for the remote northern island of Genovesa to snorkel with hammerhead sharks.

Most tourist facilities are located on Santa Cruz, especially in and around the main town of Puerto Ayora, where you'll find a small strip of hotels, restaurants, tour companies, gift shops and nightclubs. There is also accommodation on other inhabited islands including San Cristóbal, Isabela and Floreana. Finch Bay on Santa Cruz is one of the islands' oldest hotels and offers eco-friendly services.

Roughly half of the land species and one-fifth of the marine species found in the Galápagos are seen nowhere else on earth. The marine iguana is endemic to the Galápagos, and each island hosts a species of unique size, shape and color. Despite making extensive observations on marine iguanas, Charles Darwin thought the creatures repulsive, and went so far as to describe them as the "most disgusting, clumsy lizards."

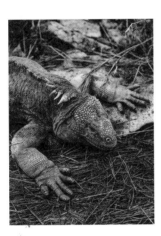

(the islands have been a national park since 1959 and a UNESCO World Heritage Site since 1976), their growing popularity as a destination, from just a few thousand visitors a year in the 1970s to more than 160,000 each year in the 2010s, has placed huge pressure on the fragile ecosystems. The Galápagos are also home to a permanent population of around 25,000 people, half of whom live in the main town of Puerto Ayora on Santa Cruz. It bustles with hotels, markets, schools and even the occasional traffic jam.

UNESCO now warns that the Galápagos Islands are one of the places most vulnerable to the impacts of climate change. As such, it is imperative to make any visit there as responsible as possible. Touring the islands by sea reduces the need for infrastructure, reducing each visitor's environmental footprint; it also enables park authorities to monitor access to the most fragile areas. Most trips begin on Santa Cruz, or on nearby Baltra or San Cristóbal, where the islands' two tiny airports are located. It's possible to arrange day trips by speedboat, but a quieter and cleaner

way to explore is by ship or sailboat. Strict regulations govern all visits. Vessels must be licensed by the Galápagos National Park Directorate and follow pre-agreed-upon itineraries to a small number of designated landing sites. Most important, visitors must be accompanied by certified naturalists, like Baño, at all times to ensure that interactions with wildlife are supervised and park rules are followed.

"Every problem Galápagos faces, bar none, is caused by humans," Baño explains. "We must all do our part to protect this precious place, of course, but that protection has to be paid for. Tourism can be a positive force if it's managed carefully. Fundamentally, I believe the best way to make people understand the importance of these islands is to come and see them for themselves."

He gazes out over the beach, watching a family of sea lions playing in the surf. "It is always a fine balance," he says. "And here in Galápagos, that balance is finer than anywhere else."

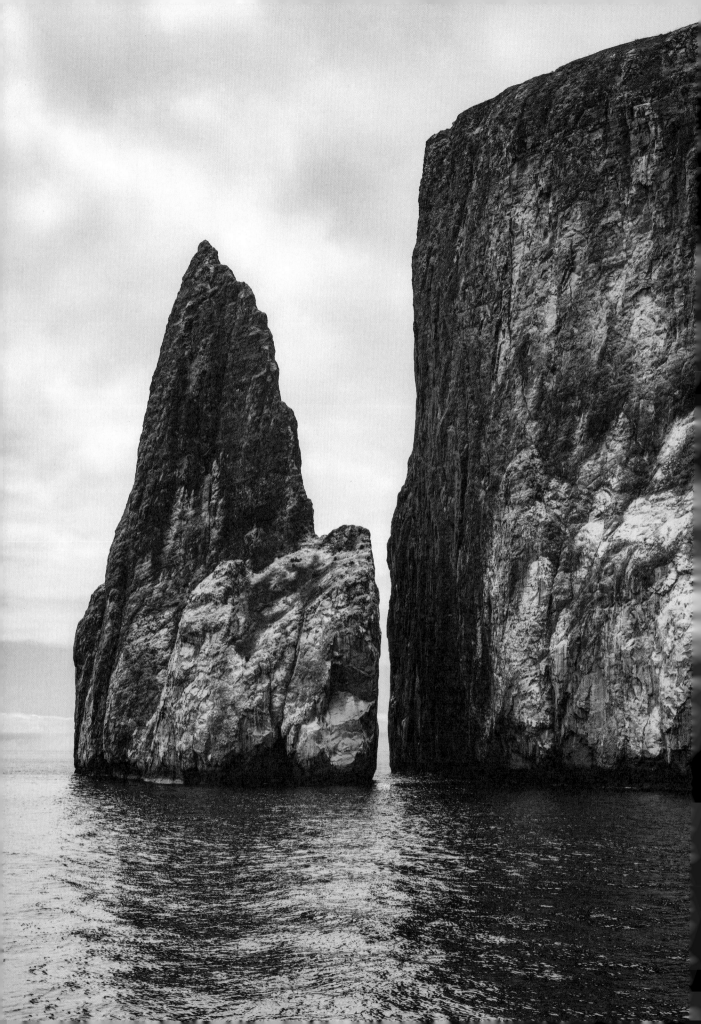

RIGHT

Galápagos sea lions generally prefer to form colonies on the beaches rather than rocks. They are small, sociable and happy cohabiting with humans: the biggest colony on the archipelago is in the administrative capital of Puerto Baquerizo Moreno. The alpha of a colony is called the beach master and shows his dominance by guarding the waterline and making loud belching sounds.

BELOW

Marine iguanas are unique to the islands. Scientists believe they arrived by floating on debris from South America and adapted to the habitat over the centuries, with features including flat tails to move through the water and glands that clean the blood of excess salt. Despite feeding in the ocean, marine iguanas can't actually breathe underwater. Instead, they hold their breath for up to an hour.

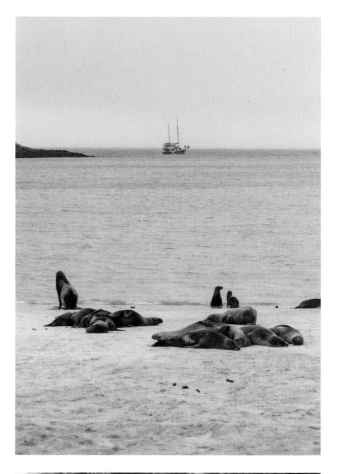

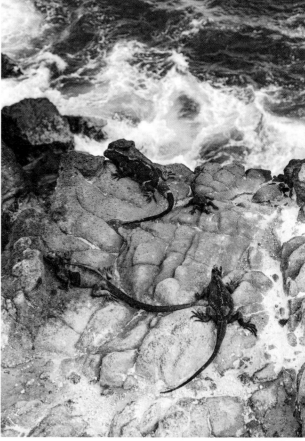

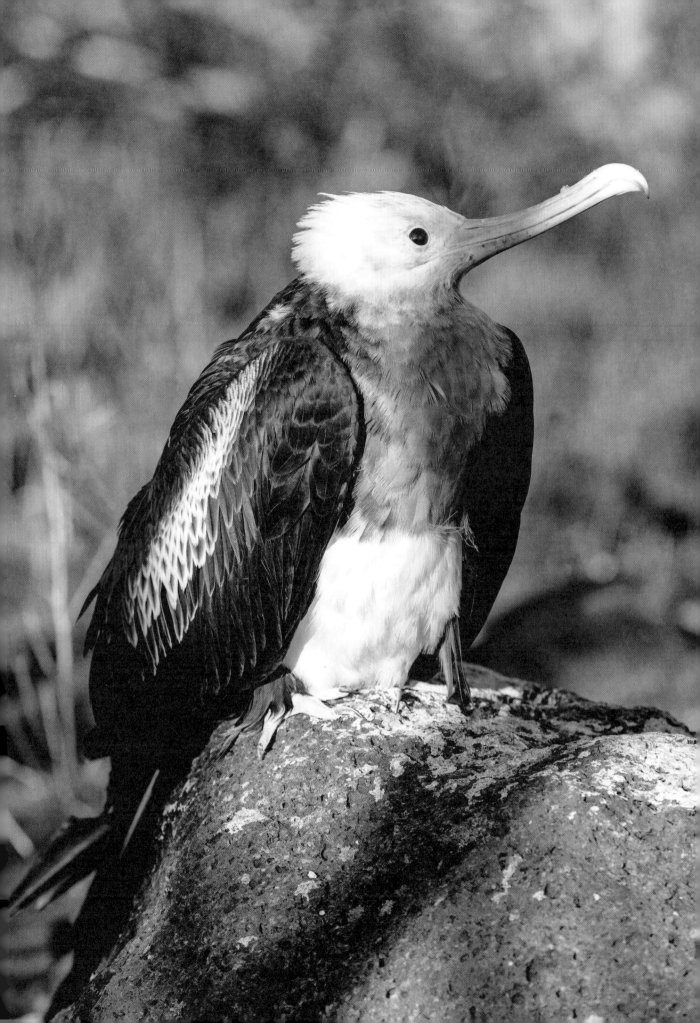

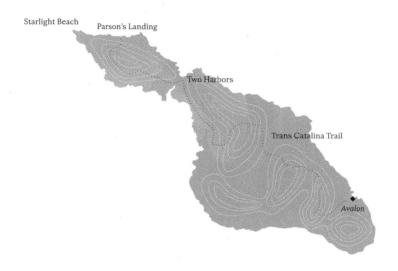

Starlight Beach
Parson's Landing
Two Harbors
Trans Catalina Trail
Avalon

SANTA CATALINA

Hikes, bikes and bison off the coast of Los Angeles

LOCATION	Pacific Ocean
COORDINATES	33.38° N, 118.41° W
AREA	75 sq. miles (194 sq. km)
POPULATION	4,096
MAIN TOWN	Avalon

Santa Catalina, the mountainous island of near-pristine chaparral that twinkles on the Los Angeles horizon, is accessible via a road that is the antithesis of natural beauty. Driving out on one of the ten-plus lanes of Interstate 405 through South Los Angeles, in the shadow of the gigantic container elevators that comprise the largest port in the Americas, it's easy to wonder what the area looked like before the city sprawled over it. An hour's ferry journey will take you far away from this urban sprawl.

Santa Catalina is one of eight islands that form the Channel Islands archipelago off the coast of southern California, and the only one with a significant permanent population. The scions of mid-century Hollywood once flocked to Santa Catalina, but today it's perhaps better known for its wildlife (the archipelago boasts 150 endemic species). On approach, pocket coves appear, their water a cerulean more Caribbean than Californian. Golden sunshine dances on the water and dolphins frolic in the waves. The sense of halcyon California intensifies while hiking, cycling or kayaking out of Avalon or Two Harbors, the island's two main settlements. For day-trippers intent on seeing Catalina's fauna, wildlife

bus tours regularly depart from Avalon—a resort town with tour operators, supermarkets, hotels and restaurants. But snapping photos of wild animals through the windows of an air-conditioned bus feels like cheating. On the other end of the spectrum is the 38.5-mile (62 km) Trans-Catalina Trail, whose steep paths make the views—whether wildlife sightings or the majestic vistas—feel well earned. Portions of the trail are more manageable than the whole thing, although one- or two-night trips are especially rewarding in the early-spring months. Winter rains turn the mountains and meadows green with grasses, new cactus shoots, and wildflowers including fiery red *Castilleja*. Summer and fall bring soaring temperatures, which can be especially uncomfortable for hikers on Catalina's exposed mountain trails.

While it's tempting to think that this is proto-California—a pristine vision of what the rolling, gold-and-green hills would have looked like before human interference—Catalina's flora and fauna are largely a result of the island's appeal to people as a place to live, work and play. With the exception of those dolphins and the brilliant orange Garibaldi fish, all the best-loved animals on the island were most likely introduced by people.

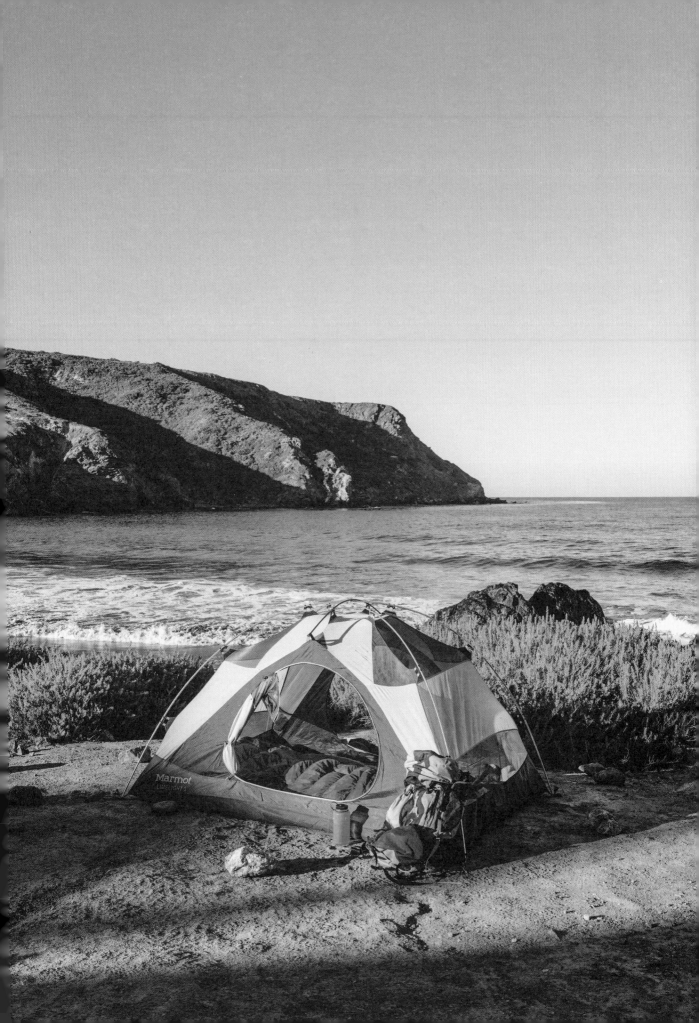

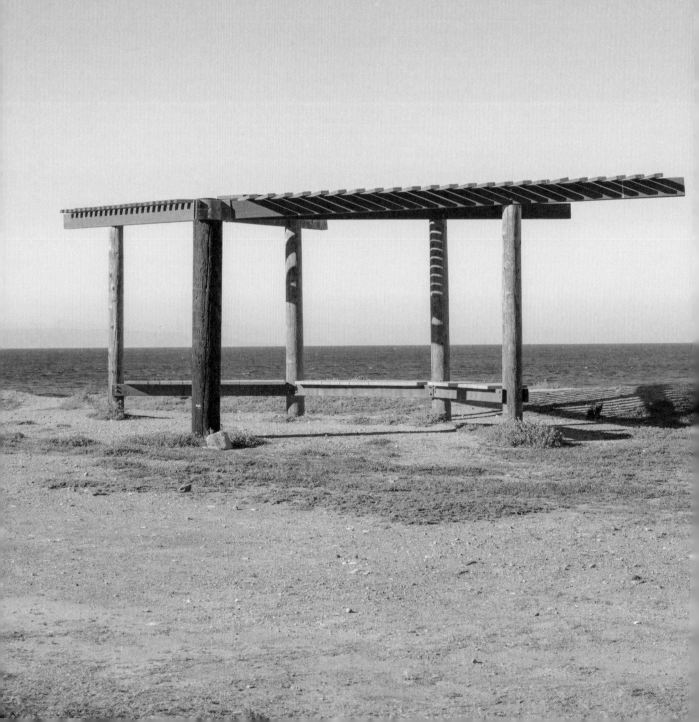

GETTING THERE

Passenger ferries Catalina Express and Catalina Flyer serve both Avalon and Two Harbors, departing the mainland from San Pedro, Long Beach and Dana Point. There are no passenger cars allowed on the island. Avalon and Two Harbors are small enough to be easily navigable on foot. Bicycles and golf carts are available for rent, but the easiest way to get between the two towns is by ferry.

SEE & TOUR

Try a Buffalo Milk cocktail at Harbor Reef Restaurant in Two Harbors, consisting of crème de banane, crème de cacao, Kahlúa, vodka and half-and-half. One should be plenty. Hike a mile (1.6 km) up to Airport in the Sky for what locals call the best burger on the island. The restaurant is halfway between Avalon and Two Harbors, three-and-a-half hours' hard hiking from either settlement.

STAY

Book any accommodation well in advance, especially for weekend visits, as there are limited guest rooms on the island. In Two Harbors, the Banning House Lodge is a twelve-room Craftsman bed-and-breakfast built in 1912. For peace, quiet and stunning views, it is a wonderful option. Book campsites ahead of time through the Catalina Island Conservancy's website.

WORTH KNOWING

The actress Natalie Wood fell off her yacht and died in the ocean off Two Harbors in November 1981, inspiring decades of conspiracy theories. In 2011, the case was reopened and her cause of death was changed from "drowning" to "drowning and other undetermined factors." The lead investigator and most witnesses on nearby yachts have since passed away.

The Tongva, an Indigenous people of California, were the first inhabitants of the Channel Islands, and it was probably them or their mainland cousins who brought the first foxes over to Catalina. As European (and later American) miners, smugglers and pirates began to colonize the island's protected coves and mountain hideouts, cats, rats, mice and other seafaring companions found homes on the island too. In 1924, a herd of American bison were brought over to take part in shooting for the silent western film *The Vanishing American*. The movie ran out of funding, so the bison were marooned in paradise. Today they are an accepted part of the ecosystem.

While fox and bison sightings aren't exactly rare, hikers and campers on Catalina are more likely to encounter an animal population that seems at least partially dependent on human presence. Ravens are everywhere on the island, and they grow to massive proportions. Famously clever, Catalina ravens pay particular attention to unattended snacks. Even zipped backpacks left on the beach or at a campsite are no trouble for the birds, who have learned how to unzip and unbuckle in pursuit of a free lunch. So-called "critter boxes" are provided to store food securely at many campsites on Catalina, but some ravens still manage to break into these. Even so, load up on groceries and camping supplies at Two Harbors General Store before heading out.

Traveling under your own power is the best way to see the island. Catalina's magnificent backcountry beach campsites are accessible only by foot, bicycle or kayak. A night on the beach at Little Harbor, facing the Pacific side of the island, means you can watch the sun set over the ocean. The eight campsites at Parson's Landing, on the remote west end of the island, each come with a singular view of mainland southern California. Bedding down in sand, with the waves crashing in the background, is possibly the best night's sleep one can get in a tent. The flickering lights of one of the world's most bustling metropolises are just over the channel. But from here, you might as well be looking at it from space.

The island's bison herd is kept to around 150 animals to protect the landscape from overgrazing. The bison (seen here on the ridge above Two Harbors) has become a local icon and appears on murals, menus and weather vanes. Visitors keen to get a closer look can take tours in open-top jeeps.

OPPOSITE

The 38.5-mile (62 km) Trans-Catalina trail meanders along scenic hillside paths, with five campgrounds dotted along the route. The full hike would take three to four days. Note that once you reach the end point of the trail at Starlight Beach, you will need to hike back to Two Harbors to catch a boat, which adds another 9 miles (14.5 km) to the trip.

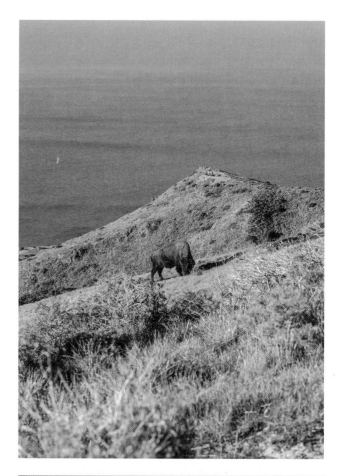

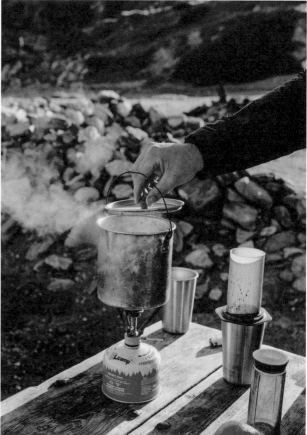

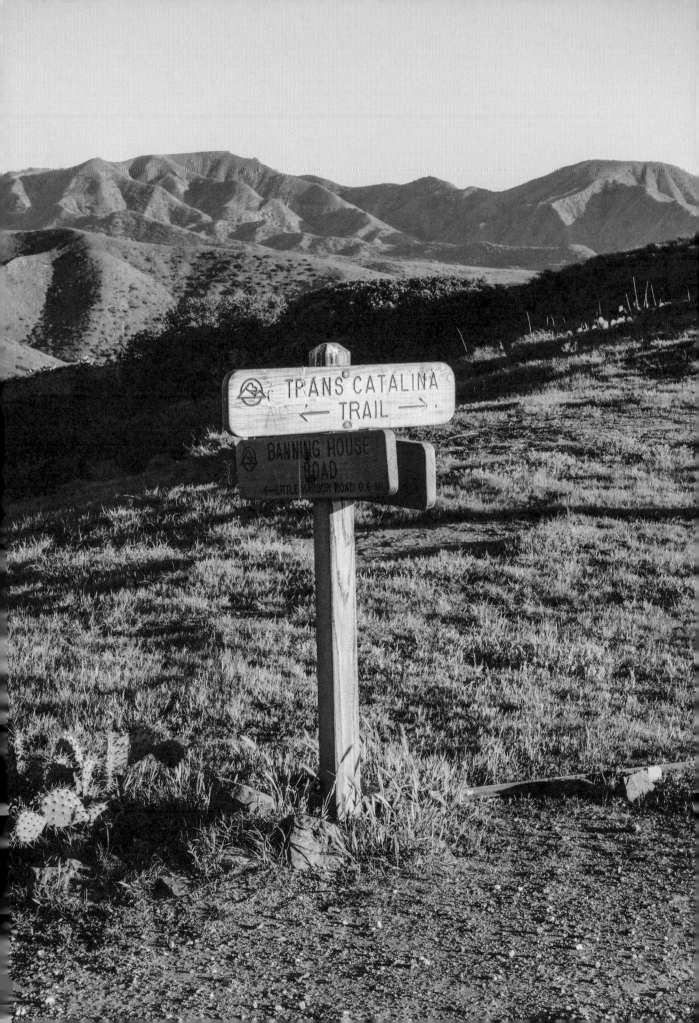

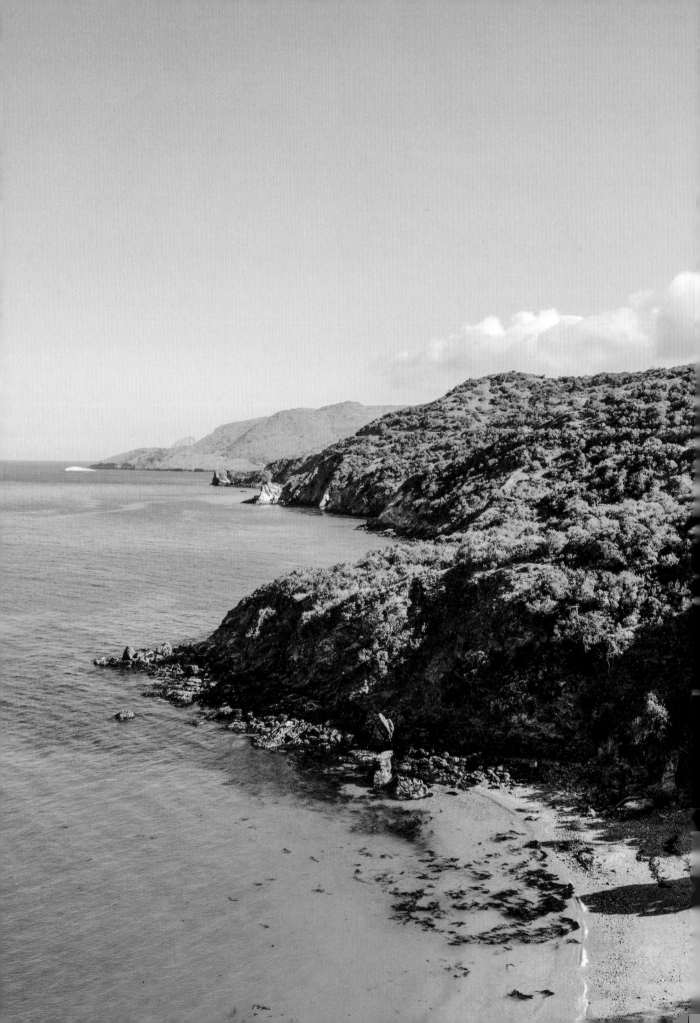

BELOW

You can travel to Catalina Island via high-speed ferry from mainland Los Angeles. For a slightly more unusual passage, take the catamaran from Newport Beach. Sadly, in 2017 Catalina Express ended its policy of offering free rides on your birthday.

FOLLOWING PAGES

Visitors should be aware that the coastal paths on the hike from Two Harbors to Parson's Landing are often strenuous, as they cut up and down through the many coves. It can also be very hot; hikers should carry a large volume of water—roughly 32 ounces (1 L) for every two hours on the trail. This same journey can be completed by kayaking along the northern coastline.

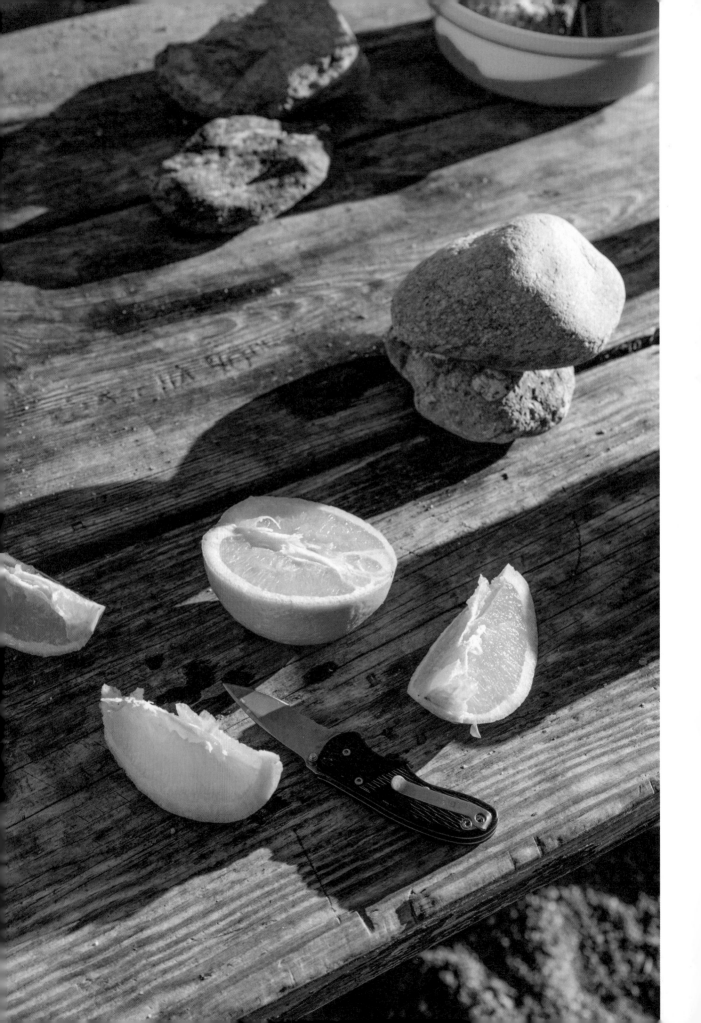

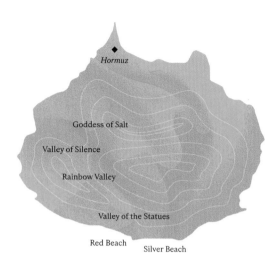

Hormuz

Goddess of Salt

Valley of Silence

Rainbow Valley

Valley of the Statues

Red Beach Silver Beach

HORMUZ

A psychedelic ride through a geological wonder

LOCATION	Strait of Hormuz
COORDINATES	27.06° N, 56.46° E
AREA	16 sq. miles (41 sq. km)
POPULATION	5,891
MAIN TOWN	Hormuz

The Strait of Hormuz gets a bad rap. Sandwiched between Iran, Oman and the United Arab Emirates in the Persian Gulf, this narrow channel sees a third of the global oil trade pass through its waters every day, making it a site of recurring geopolitical tension within the region.

But headlines tell only one side of the story. This busy meander of sea is also home to a happier accident of geography: a string of islands boasting turquoise-blue waters, jaw-dropping landscapes and rich cultural destinations. The jewel among them is Hormuz—a 16-square-mile (41 sq. km) island that can be reached by a thirty-minute ferry ride from Bandar Abbas, a port city on the southern coast of mainland Iran.

Don't let the diminutive size of Hormuz fool you: this teardrop-shaped speck is home to an explosion of geological oddities. Wandering beyond the edges of the island's only town, a kaleidoscope of color erupts in every direction. Glowing like embers under the intense sun, Hormuz's beaches, cliffs and mountains are streaked with dramatic shades of ruby red, crimson and ocher thanks to more than seventy minerals found in the landscape's volcanic, iron-rich earth.

The island has just one circular road by which to see its natural wonders. You can rent a bike in Hormuz town and explore on your own during the cooler winter months or find a rickshaw driver when the weather is warmer. (Hormuz is best visited between November and March, when daily highs remain below 86°F/30°C. In summer, the island is unbearably hot, humid and best avoided.) Traveling counterclockwise around the circuit, you'll pass through the Valley of Silence, where pinks, reds and creamy whites run in ribbons across salt-crusted rocks, before coming upon the Goddess of Salt, a shimmering salt mountain rising out of the earth in a complex of columns and caves. Take off your shoes and touch the salt crust with your bare feet; the mountain is believed to release positive energy.

Hormuz's psychedelic scenery and low-key lifestyle attract hippies from across Iran, who spend days (or weeks) exploring the interior and camping out on its beaches—one of the island's central attractions. Hormuz is home to numerous other valleys, each with starkly different geological features. A short distance southwest of the Goddess of Salt is Rainbow Valley, where the pigments in the soil are the most vibrant on the island and shocking streaks of red, purple, yellow, ocher and blue surge through the terrain. At the island's south, the Valley of the Statues features natural rock formations that have been weathered over thousands of years into arches, towers and otherworldly shapes.

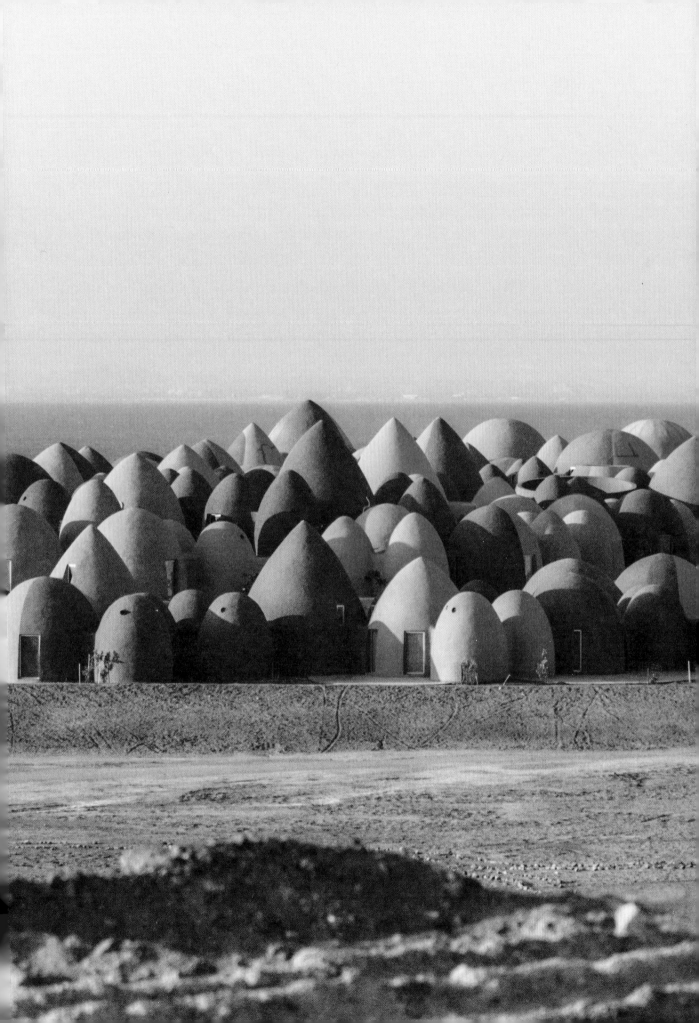

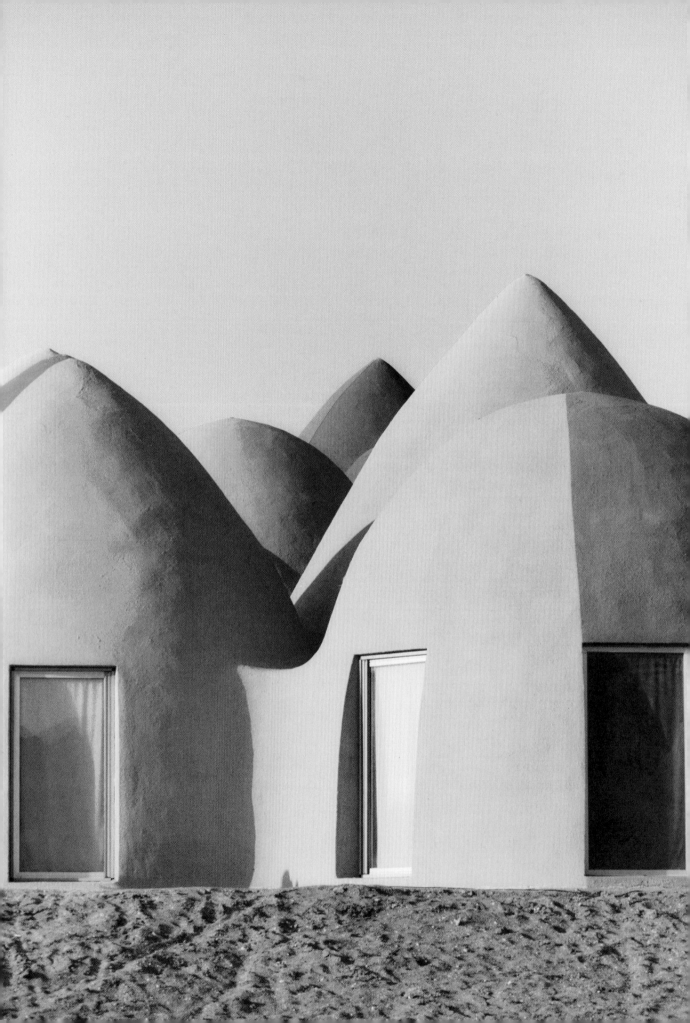

The ferry from Bandar Abbas is the easiest way to get to Hormuz. Renting a bike or wandering is a rewarding way to explore, but to make the most of a day trip—and stay protected from the sun—hire an autorickshaw driver to see the sites. If you would like to explore more islands in the Persian Gulf, take the ferry to Qeshm—the largest and most populated island, and a bastion of Bandari culture.

Hike through the island's stunning valleys, home to beautiful and bizarre geological formations. Visit the Portuguese fort and check out the cafés and galleries scattered nearby around Hormuz town. Swim at Red Beach and take in the sunset over its glimmering sand, which doubles as face paint (residents use it as a protective eyeliner). Sample local stews and curries spiced with the island's fragrant, powdery soil.

Hormuz town on the island's northern tip is the main community hub. The rest of the island has few, if any, amenities. Base yourself at a homestay so you can learn about local culture and eat delicious food in between sightseeing trips, or camp out on the island's southern beaches. Majara Residence offers all the comforts of a boutique hotel by the beach. Its lunar architecture is a draw in itself.

The famous Venetian traveler Marco Polo twice visited Hormuz, which was once one of the region's grandest port towns, facilitating trade between India, Africa and the Middle East. Scarcely any of the old and storied city remains, except for part of the Portuguese fort. If you take a close look at local flavors, clothes and music, however, you'll see these various influences still abound.

The best beaches can be found on the southern coast, where the red mountains and the soil's rainbow hues are fringed by azure water. At the island's southernmost tip, the tranquil waves at Silver Beach—named for its shimmering sands—are ideal for long swims.

Nature, while a prime attraction, certainly isn't the only thing to explore in Hormuz. While just across the strait Dubai defines itself with towering skyscrapers and glossy living, Iran's islands whisper another story of the Persian Gulf: one of ancient port towns and a hybrid culture that has drawn as much influence from East Africa and South Asia as it has Iran and the Arab world.

These traces can be seen at Hormuz's small port town. This humble collection of buildings was once at the heart of a vast maritime economy spanning Asia, Africa and Europe. In the fifteenth century, Hormuz was a cosmopolitan entrepôt, home to nearly forty thousand people, and imported vast quantities of wood, spices and fresh water to make life on the arid island livable and luxurious. The town was so famous that Portuguese colonizers conquered it in the sixteenth century and made it their regional base, building a red stone fortress that still dominates the horizon. Today, Hormuz is a sleepy but picturesque

fishing village home to a few thousand residents, and the perfect start and end point for exploring.

Hormuz lacks the amenities of a major tourist destination; a family homestay is your best bet to experience island culture firsthand while also contributing to the local economy. There are a handful of contemporary restaurants and creative spots, like Gelak Café and the Museum and Gallery of Dr. Ahmad Nadalian, and several restaurants in which to try local specialties, like ghelieh mahi (a spicy tamarind, turmeric and fenugreek fish stew) or poodini kooseh (shark cooked with dill, coriander and onion). Some dishes, like tomoshi, a tasty bread perfect with breakfast, or the curry-like stews that are a staple of Hormuz's cuisine, use the powdery red soil found across the island as an earthy-flavored spice.

Hormuz may not be the moon, but it definitely can feel otherworldly. You need only to take a swim to bring you back to earth; sharing the sea with oil tankers and warships will remind you that this is the world's most militarized sea channel. But look back toward the island and you'll be reminded of its vibrant beauty, diverse culture and laid-back atmosphere. Viewed from this angle, the military ships and oil tankers wash away with the peaceful rhythm of the waves.

PREVIOUS PAGES, LEFT

Hormuz is sometimes called "rainbow island" because of its red, mineral-rich soil. In designing Majara Residence, the Iranian firm ZAV Architects extended this color palette across some two hundred buildings. The goal of the development is to bring tourism to Hormuz in a sustainable, locally resourced way rather than plastering the island with prefab villas and high-rise holiday rentals.

OPPOSITE

The red soils of Hormuz used to be extracted via mines and exported in large quantities. The production has been stopped to protect the natural resources of the island, but the mines can still be visited by tourists. Surprisingly, the soil turns up on local menus: it is edible and often used as a seasoning, most often in a type of bread called tomshi, which is available on the island and all along the Persian Gulf's coastline.

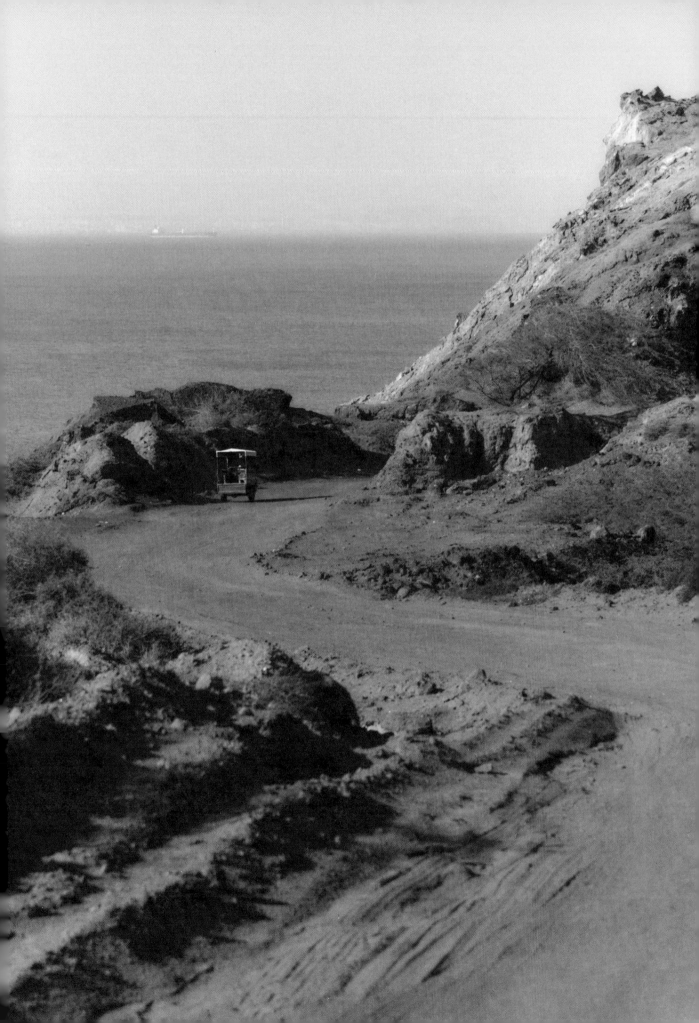

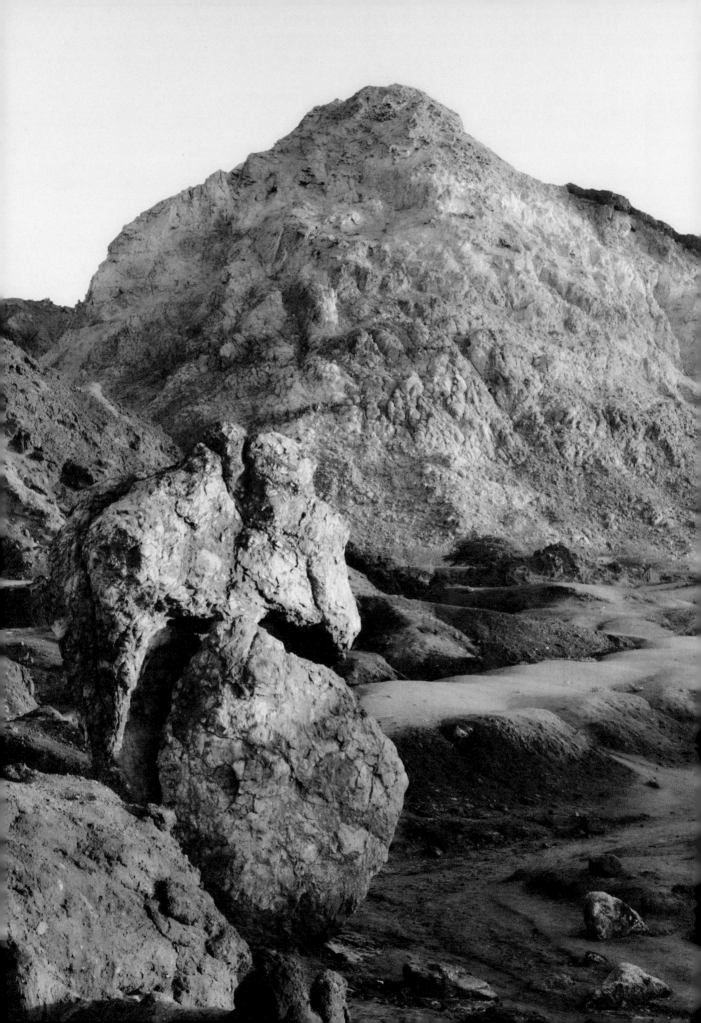

BELOW

The Museum and Gallery of
Dr. Ahmad Nadalian offers insight
into the island's creative life. Housed
in the old part of the city, it exhibits
art and sells souvenirs inspired by
Hormuz and made using materials
found on the island—both by
Nadalian, himself an artist, and by
local women whom he has tutored
over the years. The owner speaks
fluent French and English and is
often present to greet visitors.

OVERLEAF

The Jerry Pulak Historical House,
on the waterfront in the west of the
town of Hormuz, dates from the
Pahlavi period—the last Iranian royal
dynasty, which ruled between 1925
and 1979—and has been transformed
into a cultural center. Traditional arts
on the island include tent making,
henna application and Souzan douzi
(delicate embroidery featuring
elaborate patterns of stitching).

The Armchair Traveler

Words by Asher Ross

A surprising amount of the pleasure that we derive from travel consists of anticipation: the fantasies, expectations and reveries we spin as the day of departure approaches. There's always the hope that a certain providence awaits us on the other side—an insight we would never have had about ourselves at home, an adventure, maybe a beautiful person. The best trips rise to these expectations, often in unexpected ways. But other times we merely find ourselves transplanted to a destination where the sun shines with the same mute indifference it displays in the park at home. Dreams of travel are reliably enchanting, while travel itself is often not.

So why not stick to the frisson of anticipation? The phrase "armchair traveler" carries a mildly pejorative air, as if it were the cousin of the know-it-all armchair general or the unqualified armchair psychologist. But richly detailed daydreams of travel are a genuine and worthy pleasure, and they need not precede any actual travel at all.

Most human beings who have lived on this earth did so without knowing the physical bounds of the planet. The edges of the map were a place for monsters—*hoc sunt dracones*, they read: *here be dragons*. Indeed, for thousands of years, slow travel was a necessity, and a bored and curious public would have turned to travel literature, along with guidebooks, expedition journals and atlases, for ideas about the world. On these small, flat pages, all possibilities exist. They carry the imprint of faraway shores where life could go quite differently than it does at home.

Take Jean des Esseintes, the French aristocrat who dedicates his life to cloistered aesthetic fulfillment in J.-K. Huysmans's 1884 novel *Against Nature*. Deeply immersed in the work of Charles Dickens, des Esseintes is overwhelmed

with the desire to abandon his seclusion and visit rainy, dirty London. He purchases tickets, and even dines at an English restaurant as he awaits his train near the Gare du Nord. Just as he is about to depart, though, he turns back home. He dares not risk spoiling the delicate, perfect notion that he's cultivated in his reading. There, in the restaurant, among the chatter of traveling Brits, it has already reached its fullest possible reality. There's no more to see.

It is hard to guess what the sensitive duke would have made of the armchair travel opportunities in our own time. We can now see any place on earth, more or less, in an instant, in the flat, honest hues of satellite imagery. There is a pleasure in running one's fingers over a map, or, more likely, an image of a map on our phones. The contours of the topography, the names of the cities and their streets, the cheerful beige of beaches running alongside crayon-blue oceans: There, the liquor store in downtown Yangon. There, an impossibly well-painted, solitary house in the Australian outback. And there, best of all, the hardware store by the docks in Vanuatu, should we ever need a lightbulb in another life.

Impossible only a few decades ago, most of us have come to take cartography for granted. But during the recent pandemic, many homebound souls rediscovered its more fanciful possibilities, easing their wanderlust with midnight digital travel. These riches come at a price: we are free to see any place in the world on a whim, but we are no longer free to imagine whatever we want about the places we've never been to. The answers are always there, and our speculations can now be falsified by a few clicks.

Travel writing is a particular art, and many who have been graced with that talent have not been particularly bound to truth. The *Histories* of Herodotus plied ancient Athenians with tales of Egypt's winged serpents and phoenixes. It is suspected that François-René de Chateaubriand plagiarized or imagined many of the more exotic passages in his 1826 account of a trip to America, *Voyage en Amérique*, but it was enjoyed across Europe nonetheless. And some historians doubt that Marco Polo ever actually crossed into China.

Producing her own turn on this impulse (with considerably more transparency), the German author Judith Schalansky penned intentionally subjective accounts of fifty remote islands that she had never set foot on in her 2009 book *Atlas of Remote Islands*. Schalansky, who was born in East Germany under the USSR, did not travel far while growing up, but was spellbound by the way maps and atlases can set the mind to flight.

"Consulting maps can diminish the wanderlust that they awaken, as the act of looking at them can replace the act of travel," she writes in her introduction. "But looking at maps is much more than an act of aesthetic replacement. Anyone who opens an atlas wants everything at once, without limits—the whole world. This longing will always be great, far greater than any satisfaction to be had by attaining what is desired. Give me an atlas over a guidebook any day. There is no more poetic book in the world."

Schalansky is right to point out how profound our appetites are when we gaze at a map. In its longitudes and latitudes, its zones and shorelines and islands, we find two deeply human impulses at play. On one hand, the map embodies our need to understand and encompass the world, to arrest its endless permutations in a fixed, observable state. On the other, maps fulfill our desire *to make the world our own*, to give it the shape of our desires and fancies.

And so, while the old cartographers would render their home countries in laborious detail, leaving their nightmares on the outer edge of the sea, today it is the reader who abandons the nightmares at home to pore over the most mundane details of distant shores.

"On these small, flat pages, all possibilities exist. They carry the imprint of faraway shores where life could go quite differently than it does at home."

II

EXPLORE

Mile End ◆

Old Port

Downtown

Mount Royal

MONTRÉAL

Coffee and culture in Mile End

LOCATION	Saint Lawrence River
COORDINATES	45.51° N, 73.68° W
AREA	182 sq. miles (472.55 sq. km)
POPULATION	1,906,865

In Montréal, which has neither the sunny feel of a beach town nor the nautical pedigree of a maritime community, it's easy to forget you're on an island. Your gaze is drawn inward to Mount Royal, the mountain at the heart of the city, rather than out to the water.

At Mount Royal's eastern foot, where the buildings look like they're congregating to pay homage to the crucifix that tops the summit, is the neighborhood of Mile End. Despite what this implies, Mile End is not at the edge, or end, of anything. For that, you'd need to travel nearly 3 miles (5 km) east to the Old Port, where the cobblestone streets that define Montréal's Vieux France identity meet the Saint Lawrence River.

Mile End tells a different story. Italian, Portuguese and Greek migration surges in the mid-twentieth century have given the neighborhood a pan-European milieu. It has since experienced waves of gentrification, transforming from immigrant enclave to hipster hangout (having famously been home to musicians Arcade Fire and Grimes) to a hub of culture that's charming to explore.

On a weekday morning at Café Olimpico, the sound of clinking coffee cups is intercut with conversations buzzing in English and Quebecois French. One man waiting in line has double-parked his car on Rue Saint-Viateur to wait for his latte; another has left his BIXI (a rental bicycle booked through Montréal's bike-share system) leaning underneath the forest-green awning outside. This unpretentious, family-owned coffee shop, where espresso machines moan and whirr, soccer games are always on TV and psychedelic Khruangbin instrumentals play over the speakers, exemplifies the Mile End spirit. "It was a place to hang out with friends, make a little money and start a new life," says John Vannelli, the third-generation owner who now runs the café with the same ethos as his grandfather, Rocco Furfaro.

In 1970, Furfaro brewed Café Olimpico's first batch of coffee after immigrating from Rome to Quebec and settling in Mile End. Today the café is a local icon—an ascent that happened in tandem with the neighborhood itself. "It's the story of immigrants creating a new life in Montréal. They had no place, so they settled here," Vannelli says. By his count, there are now sixteen coffee shops on Rue Saint-Viateur alone, from no-frills ones like Olimpico (it only offers one-size cups) to specialty shops like Caffè in Gamba. Around the corner, on Boulevard Saint-Laurent,

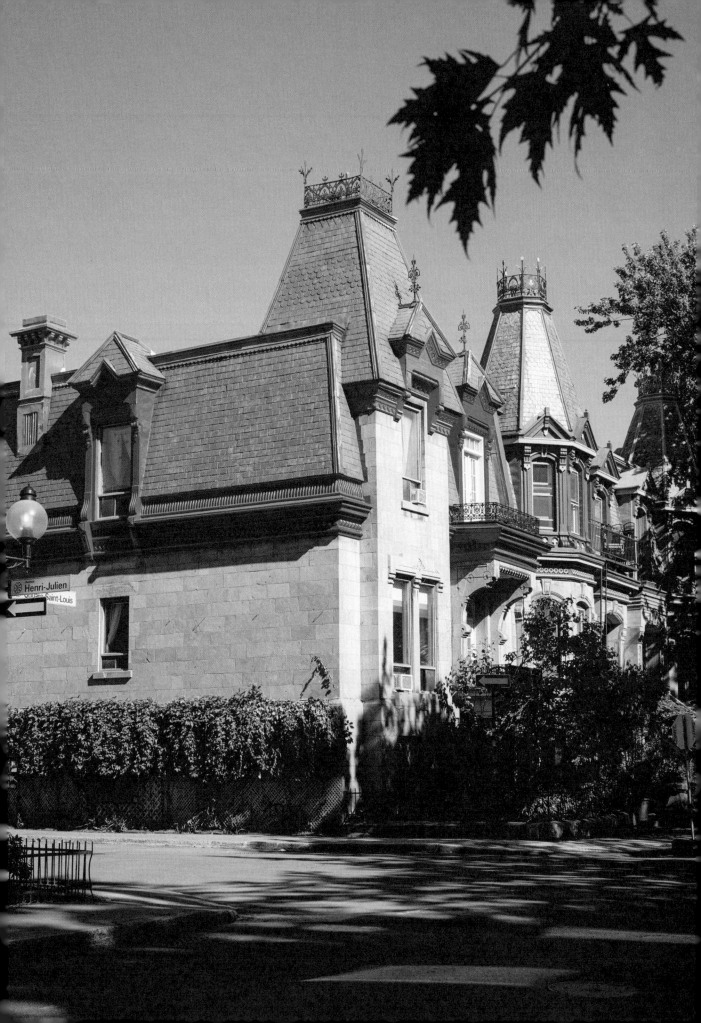

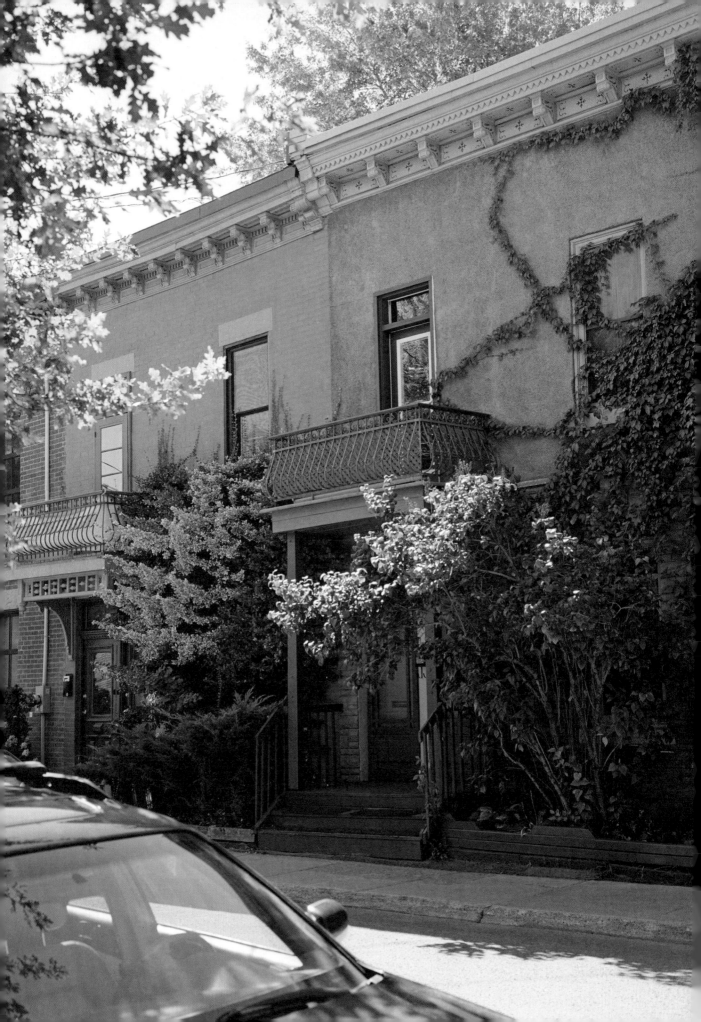

GETTING THERE

You can fly directly onto the island to Montréal–Pierre Elliott Trudeau International Airport, but if you're driving, the Île aux Tourtes Bridge at the western tip of the island is the most efficient route to get into town. Mile End is very walkable, but for lengthier trips, roomy bike lanes make bike hire ideal.

SEE & TOUR

Visit Never Apart, a gallery space and performance venue with an inclusive approach to programming. Dragon Flowers— the small, family-run flower shop located on Rue Bernard Ouest— is a neighborhood institution. Beautys is still one of the local go-tos for breakfast (signature dish: the Mish Mash).

STAY

There are no hotels in the neighborhood, but it's easiest to immerse yourself in the Mile End experience when you're renting an apartment. Just outside of Mile End, Casa Bianca is a rustic, romantic bed-and-breakfast that's within walking distance from all of the neighborhood's most memorable sites.

WORTH KNOWING

Outside of Mile End, closer to the center of the city, you'll find the Fairmont The Queen Elizabeth Hotel, the site of John Lennon and Yoko Ono's 1969 Bed-In protest, where they recorded "Give Peace a Chance". Housekeeping had to vacuum the corridors frequently as Lennon was prone to scattering flower petals.

the all-pink, Wes Anderson–esque Pastel Rita café offers momentary pleasures like vegan pastries—and more enduring ones, like tattoos, from the adjoining studio. Right off Saint-Laurent, on Maguire Street, Café Éclair's in-house microlibrary gives it the air of an off-screen oasis. And French lore abounds at Larrys, a local haunt beloved for its brunches and traditional cuisine, from terrines to tartare.

Back on Rue Saint-Viateur, the scent of freshly baked bagels—a global culinary emblem of the city—wafts from the doors of St-Viateur Bagel, where every bagel is hand-rolled and boiled in honey water. Mere blocks away, there's another bagel shop where the door doesn't lock and the lights never go out: Fairmount Bagel, which is over a hundred years old and operates twenty-four hours a day. Vannelli, the owner of Café Olimpico, refuses to name which is his favorite, given how divisive the dueling bagel shops can be (choosing between the two is akin to a New Yorker choosing between the Yankees and the Mets). A morning stroll on this island is not complete without sesame seeds spilling onto your coat and latte foam sticking to your top lip.

Generations ago, the affordable rents available in Mile End attracted an influx of artists and creative types, whose mere presence has left a long-lasting imprint of cool. But their arrival didn't mar what had already been built by the city's Jewish population: today the neighborhood remains home to a large Hasidic community. There are, of course, many places in both the province and country where communities of many different stripes live side by side, but in Mile End, there's a coalescence of orthodoxy and bohemia that's singularly seamless.

The storefronts on Mile End's main streets offer a range of independent shopping options, like the bookstore Librairie Drawn & Quarterly, or Montreal's secondhand crown jewel Citizen Vintage. The tree-lined side streets, too, are something to behold. Where other Canadian cities are inundated with highrises, the streets of Mile End are populated with "plexes"—signature split-level walk-ups with whimsical, winding outdoor staircases. It seems like *everyone* has a balcony.

Canadians like to imagine their country is a mosaic, rather than an American melting pot. This means that you arrive and assert your identity instead of assimilating into a universal one. The individual cultures and the sense of community are what give Mile End its flair; it's the residents that have earned the neighborhood its reputation as an enclave for creatives. "The small, tight-knit community makes it seem like we're all living in a tribe," Vannelli says. "It definitely feels like a little island."

RIGHT

The original location of Café Olimpico, a stalwart coffee shop in the heart of Mile End, has become something of a neighborhood landmark. More than fifty years after it first opened in 1970, the beloved city institution has spawned two further branches in Montréal's Old Port and Downtown. It remains a family business.

OPPOSITE

Montréal's iconic modular housing complex Habitat 67. The building, designed for Expo 67 by Israeli Canadian architect Moshe Safdie, stands on a narrow, man-made peninsula just south of the Old Port, around 5 miles (8 km) from Mile End. Safdie designed the complex in an attempt to reinvent city living. The complex is one of the most recognizable buildings in Montréal and remains a functioning icon of 1960s utopianism.

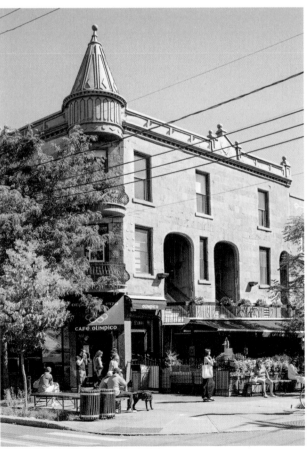

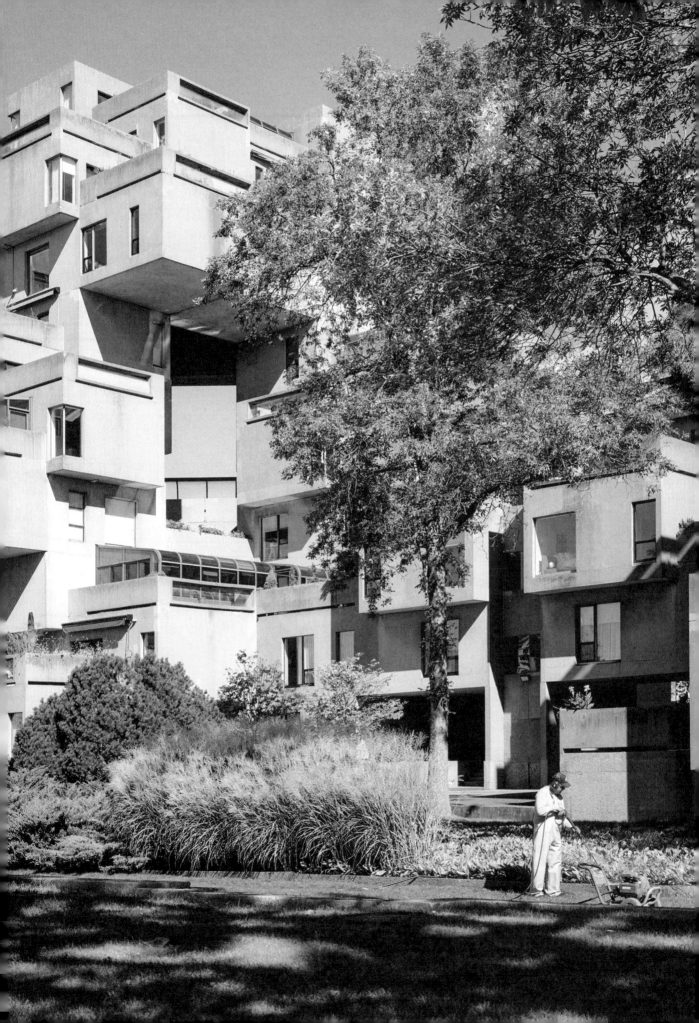

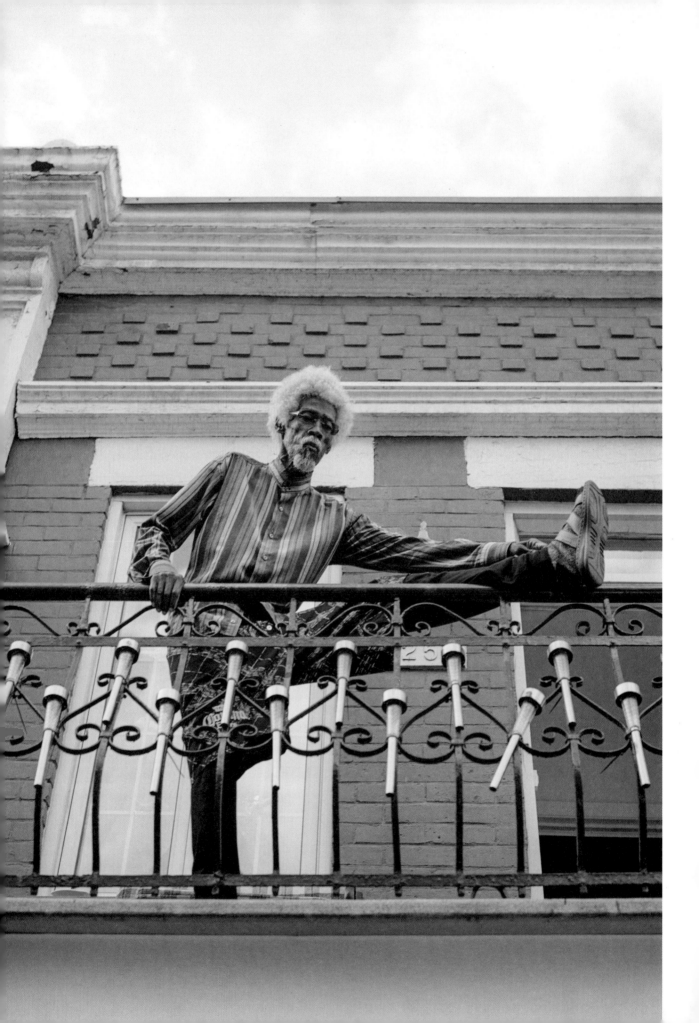

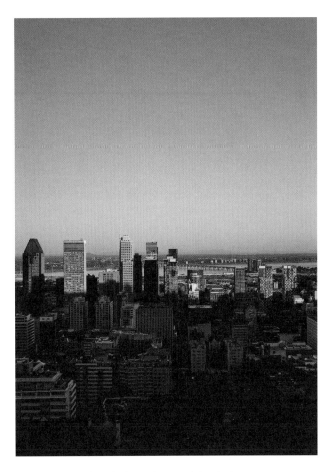

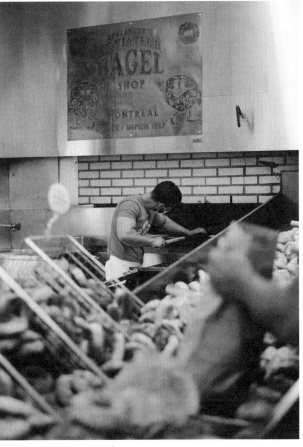

ABOVE

Montréal's skyline, seen from Mount Royal. Montréalers are proud of the "mountain" that dominates the center of their city. The charming, leafy park surrounding it is popular for jogging, walking, cycling and picnics in summer and for skating and cross-country skiing in winter. The park can be accessed from Mile End at the intersection of Park Avenue and Mont-Royal Avenue.

RIGHT

Along with poutine (a dish of french fries, cheese curds and gravy), the bagel is a culinary symbol of Montréal, rendered distinctive by being boiled in honey-infused water before being baked in a wood-burning oven. The legendary St-Viateur Bagel on Rue St-Viateur claims to be the longest continuously running bagel shop in the city.

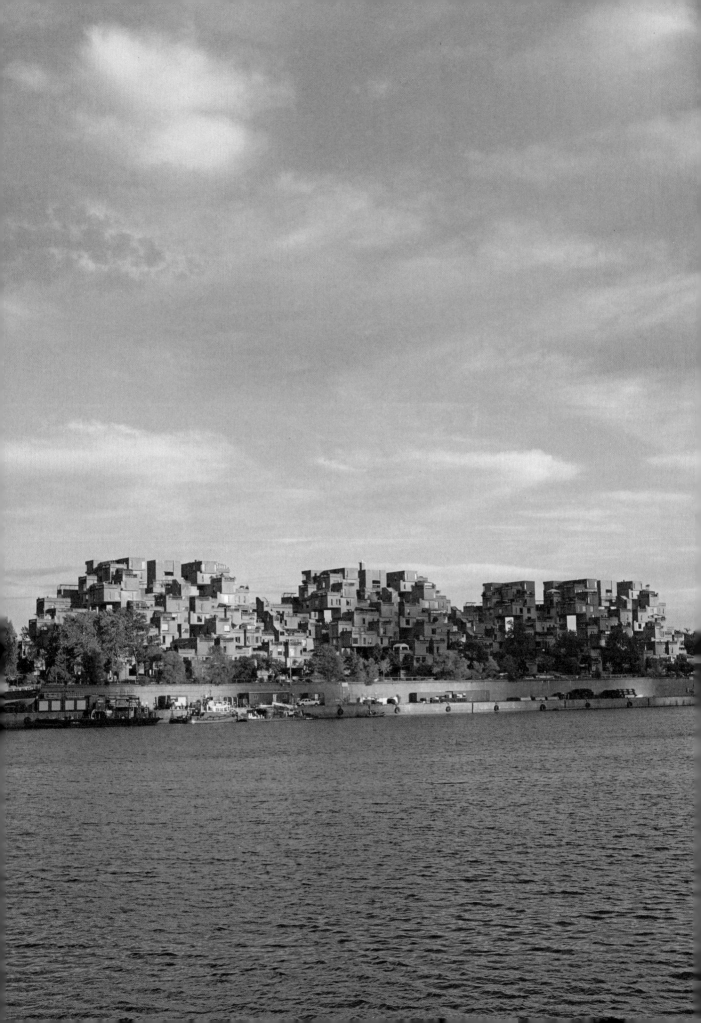

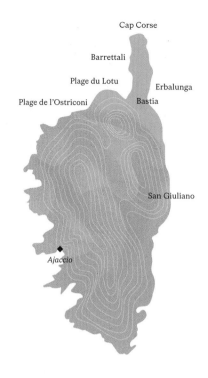

Cap Corse

Barrettali

Plage du Lotu

Erbalunga

Plage de l'Ostriconi

Bastia

San Giuliano

Ajaccio

CORSICA

A slice of tranquility amid ancient citrus groves

LOCATION	Mediterranean Sea
COORDINATES	42.03° N, 9.01° E
AREA	3,368 sq. miles (8,722 sq. km)
POPULATION	349,465
MAIN TOWN	Ajaccio

Corsica is a fragrant marvel. Beyond the island's principal cities and the seaside resort towns that feature on its postcards, there are jagged mountains ringed with lush vegetation reaching all the way down to white sandy beaches and the Mediterranean beyond. The perfume of rosemary, lavender, thyme, sage and mint common across the Mediterranean carries a top note of lemon here: the citrus groves tucked within the island's vertiginous interior are a Corsican dietary staple.

An hour's drive south of Bastia on the east coast, the Citrus Biological Resource Center in San Giuliano is a sprawling menagerie of nearly a thousand varieties of citrus fruit. The groves here nurture kumquats and Buddha's hands, yuzu and the unique Corsican clementine, plus grapefruit, oranges, tangerines and—of course—lemons. The garden promotes citriculture in Corsica and throughout France (the island is a French territory with a measure of self-governance; some Corsicans wish it was independent) and is one of the most important collections of citruses in the world. It's a favorite destination of perfumers and chefs, including Anne-Sophie Pic, a French chef with six Michelin stars to her name, who was so inspired by the groves of San Giuliano that she published the cookbook *Agrumes*, which means "citrus" in French.

A predecessor of the lemon, citron—*cédrat* to French-speaking locals—is a pale-green fruit with a gnarled rind, a football shape, a juicy but bitter flesh and an invigorating aroma. Corsican citron was the foundation of the island's export economy in the nineteenth century, and today this local variety is resurging as chefs seize on its distinctive notes to energize their recipes.

Cap Corse, a small finger of land to the north of the island, is home to some of Corsica's most jungly stretches, and citrus groves flourish amid its wild landscape. Barrettali, an hour-and-a-half drive north of Bastia, was long Corsica's prime citron-growing territory, and it is here that Xavier Calizi is reviving the tradition at Les Cédrats du Cap Corse. He welcomes visitors to his 4 acres (1.6 ha) of citron groves, where he produces artisanal citron-laced jams, liqueurs, beers and beauty products.

On the other side of the Cap, forty minutes from Barrettali, the cliff-top Hôtel Misincu is ensconced in a park of olive groves and citrus trees (the latter of which inspired the Corsican tea brand Callysthé to create its own Secret de Misincu blend, with lemons sourced from the hotel's domain). The eco-resort, with a whitewashed exterior of arches and views over the viridian

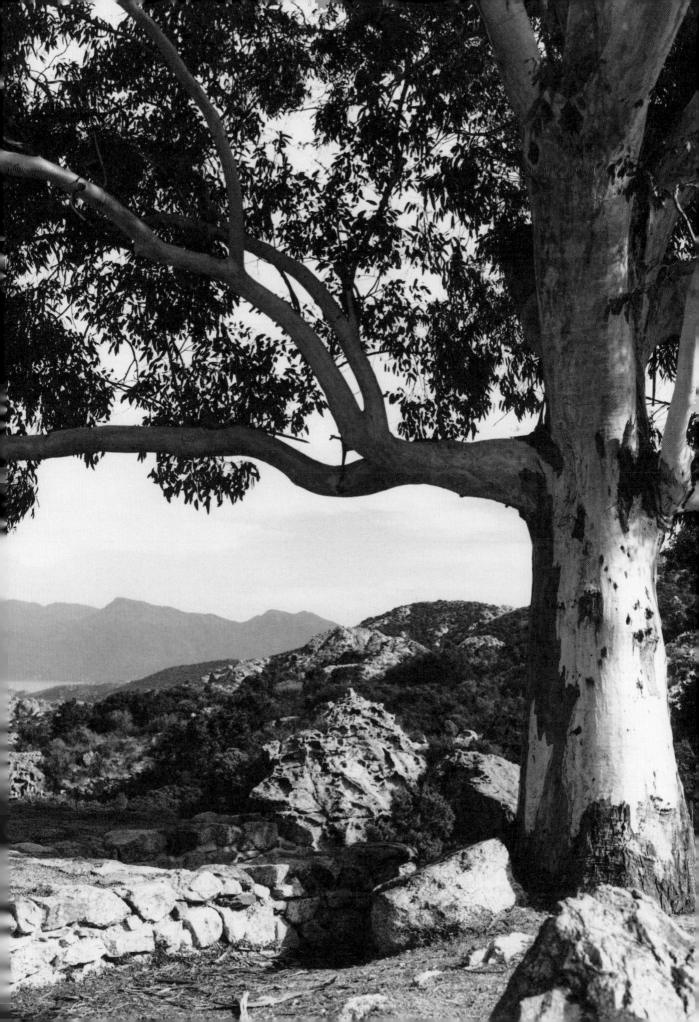

GETTING THERE

The best way to explore the mountainous interior of Corsica is to hire a rental car. Bastia is a two-and-a-half-hour drive from Ajaccio, right through the heart of the island on the T20. Alternatively, Chemins de Fer de la Corse operates a train between the two cities four times a day. Bastia is also reachable by ferry from mainland France at Marseille, Nice and Toulon, and from the Italian town of Livorno.

SEE & TOUR

It is possible, over the course of an afternoon in Corsica, to travel from forested mountains to one of the island's soft-sand beaches. In the north, Plage de l'Ostriconi and Plage du Lotu are renowned for their wild and rugged beauty. Cap Corse is often referred to locally as an "island within an island," and there is plenty to explore. The small, ancient fishing village of Erbalunga is one of the most picturesque in the region.

STAY

There are ample options for every budget in Cap Corse, and even the smallest guesthouses take reservations by email. The Couvent de Pozzo, around a twenty-minute drive north from the center of Bastia, is a former fifteenth-century monastery that has been brought back to life as a peaceful guesthouse by owner Emmanuelle Picon. There are stunning sea views from the hotel.

WORTH KNOWING

Although Corsica has been part of France for more than two centuries, its native language, Corsican, is officially a dialect of Italian. While most Corsicans speak French, the French spoken on the island is Italian accented. The Corsican language is taught as part of every school's curriculum, and it's helpful to know a few basics: *bonghjornu* is "hello"; *per piacè* is "please"; and *à ringraziavvi* is "thank you."

of the sea, offers accommodations by London-based designer Olympia Zographos that bring the drama of the island's nature inside, with driftwood details and raw-wood beam ceilings, plus volcanic rock pools for each of the private villas; the famed terroir-to-table restaurant Tra di Noi serves up the taste of citrus and the rest of Misincu's garden.

The Couvent de Pozzo, a half-hour drive south, is a fifteenth-century monastery for Capuchin monks that has housed the family of Emmanuelle Picon since the French Revolution. A decade ago, Picon decided to open the doors of this private cloister to visitors. Today, as an inn, it maintains centuries of the family's original furnishings inside the stone palazzo. Like Hôtel Misincu, Couvent de Pozzo is surrounded by groves of lemons, mandarins, and clementines, plus permaculture gardens of vegetables, fruits and olive trees. Picon's great-great-grandfather cultivated citron in the mid-1800s, and today she serves the fruit as marmalade and confit to guests. Citrus suffuses other dishes on the menu, from the fresh-squeezed orange juice at breakfast to the sharp-flavored lemon rind used in fiadone, the traditional cheesecake of Corsica. A basket of just-picked lemons is a fixture in the

kitchen. "Corsican food is really farmer food," says Picon. "People use what they have around them, and here everyone has citrus trees in the garden."

Corsican chefs approach this local abundance with ingenuity. The beloved Libertalia Bistro Tropical, a thirty-minute drive east of Bastia, is a barbecue and brewery set among sylvan greenery. At this verdant restaurant, run by Pierre-François Maestracci, the homemade lemonade is as much of a signature as the proprietary beers on tap. Nearby, in Saint-Florent, the pier-front terrace of Mathys turns out perfect fish with added zing from hunks of locally sourced lemon.

At L.N. Mattei, a Corsican distillery that dates back to 1872, the original recipe for cédratine—a liqueur combining citron with a delicate concoction of herbs—is still in production. The aperitif can be tasted at Mattei's own boutique in Bastia, at bars across the island and at the countless delis stocking Corsican specialties, like the renowned Épicerie Scotto in Saint-Florent. "Everything we eat is connected to what we grow," says Picon, the hotelier at Couvent de Pozzo. "Life on an island is always about using what the island gives you."

RIGHT

The Citrus Biological Resource Center in San Giuliano is the leading rare citrus authority in France; nearly a thousand different species of citrus are grown in a 32-acre (13 ha) orchard, including three-hundred-plus varieties of mandarin oranges alone. The center studies diseases specific to citrus fruits and the effects of climate change.

BELOW

An unripe Corsican citron at the Citrus Biological Resource Center. The fruit is lemon yellow when ripe, and the pulp has a sweet flavor. The cédrat, as it is known locally, was once a considerable source of wealth for Corsica, to the extent that the island exported nearly 50,000 tons (45,000 MT) a year. Its production has shaped the island's landscape.

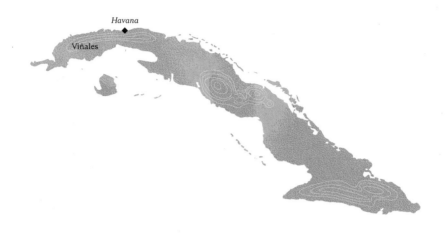

Havana

Viñales

CUBA

A horseback ride through the verdant Viñales Valley

LOCATION	Caribbean Sea
COORDINATES	21.52° N, 77.78° W
AREA	42,426 sq. miles (109,884 sq. km)
POPULATION	11,181,595
MAIN TOWN	Havana

There's the feeling that if you drop a seed in Viñales, any seed, it will grow. The soils of western Cuba are rich in potassium, magnesium and sodium, supporting an abundance of trees and plants that yield vegetables and fruits. The most iconic of its crops is tobacco. Carpeting the Viñales Valley, the plants line up like toy soldiers in tidy rows, each sown by hand and carefully spaced 10 inches (25 cm) apart.

At La Finca La Selva, tobacco grower Mario massages a plant and dissects its leafy layers, demonstrating what will become filler, wrapper and binder during cigar production in the coming months. This is his thirty-fifth year farming, or perhaps it's his fortieth—he can't remember. His father acquired the farm shortly after the Cuban Revolution in 1959, and like most in the valley, it's a multigenerational operation. The wind cuts his speech, whistling down the mountains and through the bush of pine and oak trees. "Guayabita?" he inquires, laughing, aware that it is not yet afternoon. "To keep warm." He's referring to a rum made with tiny guava berries—the signature drink of Pinar del Río, the region where Viñales is situated. He reminds us that there's no reason to rush, which is true. The sky is wide and blue

today. He prepares a shot glass, pointing to his guayabita trees, and explains that their fruits will be taken to a nearby factory and turned into rum.

La Finca La Selva is the first stop on a six-hour horse ride through the valley led by a guide called Javier. Three hours east of here, tourists lie on sun beds at beaches on the outskirts of Havana. The capital city is the most likely starting point for a trip to Viñales; your hotel or host should be able to help you secure a bus ticket or a seat in a shared taxi, both of which require advance booking, and assist in exchanging currencies. In Havana, you'll often hear "Change money?" whispered at you; the black-market money exchange determines the most common conversion rates in Cuba's inflating economy, which now uses euros, dollars and Cuban pesos.

The road to Viñales is bordered by grazing cows, banana farms and skinny royal palm trees that sway with the breeze. The rattling mechanics of Havana's classic cars gradually fade into the rhythmic patter of hooves, with some farmers riding horse-back, others guiding their steed from wooden carriages. The air softens and mountain silhouettes emerge. Trails of red-orange

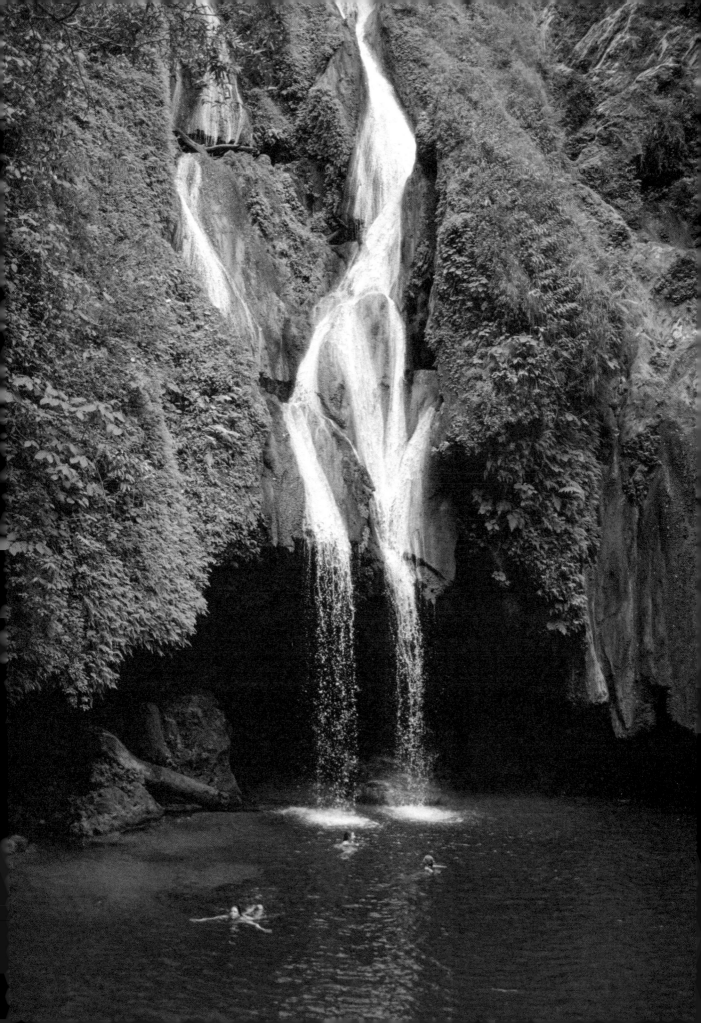

GETTING THERE

A trip to Viñales is one of the most popular excursions from Havana, and there are several ways to get there. A private taxi—the most expensive option—will take around two and a half hours, whereas catching a bus or a shared taxi from the National Bus Terminal will take between three and four hours, which makes a day trip more difficult.

SEE & TOUR

West of the town of Viñales, you'll find the Mural de la Prehistoria painted on the side of a cliff, Mogote Pita. The colorful mural, featuring a huge snail, dinosaurs and sea creatures, was designed in 1961 by Leovigildo González Morillo, a follower of Mexican artist Diego Rivera's. It took eighteen people four years to complete.

STAY

There is one hotel in the town of Viñales—the Hotel Central Viñales—and three sister hotels in the surrounding countryside: Los Jasmines, La Ermita and Rancho San Vicente. There are, however, hundreds of casas particulares, or guesthouses, available in the region. Many of these also include a paladar—a restaurant with fewer than twelve tables.

WORTH KNOWING

Despite there being no wine production in Cuba, Viñales is named after grapevines. During the nineteenth century, Spanish colonizers tried to grow vineyards and produce wine in the valley. They switched to tobacco after realizing wine production was a bad idea in a tropical climate, but the name stuck.

earth splinter through the plantations at either side of the road. Historically, the area was known for its sugar plantations, and while literature around the history of slavery in Cuba typically focuses on sugarcane production, it's important to acknowledge that the nation's global reputation for fine tobaccos is also indebted to several centuries of enslaved labor.

Ahead of lunch, Javier leads the group to the Cueva del Palmarito, a cave that's large enough to sail a boat inside. A few locals linger here, where they charge 300 pesos to light the pitch-black cave and provide narration. In the cave's humid belly, the rocky terrain looks to have been shaped by a small meteor shower. Chandelier-like stalactites of calcium and carbon glitter and sweat. Over the years, condensation has produced water ponds inside the cave, with one pool that's large enough to swim in (providing you're not afraid of cold water).

Hunger, and a little bodily soreness from sitting astride for six hours, make lunch at El Corazón del Valle a welcome final stop on Javier's tour. As its name suggests, this farm-to-table restaurant is situated "in the heart of the valley." A cocktail of fresh coconut water, rum and honey is served on arrival. For 1,000 Cuban pesos, today's set menu includes chicken and

fried yucca with a homemade salsa of garlic, tomato, onion and pepper, served with moros and cristianos (black beans and rice). The sides include tomato and cabbage salad, alongside thinly sliced banana chips.

Moving through the farmlands toward Viñales town center, Javier identifies other plants growing in this fertile plain: yucca, papaya, tomato, sweet potato, coffee, maracuya, malanga, guava, bananas, plantains, pineapple, garlic, lettuce, coconut, corn, beans, and even rice. Farming practices are still slow and organic here, far removed from industrial equipment and additives of North America. Free-range is not a sticker label, it's the norm.

Back in Viñales's humble city center, baby pink and sea-foam green homes invite visitors inside. *Casa particulares* (homestays) are concentrated here but also scatter the valley, where families offer organic farm-to-table cooking and mojitos served with garden-fresh lemon, spearmint and honey. Keep an eye out for homes marked with small blue-and-white signs, signaling that the owner has registered as a homestay. A knock on the door will let you know about vacancies, and welcome you with one of the cornerstones of Cuban hospitality: a coffee or a cocktail.

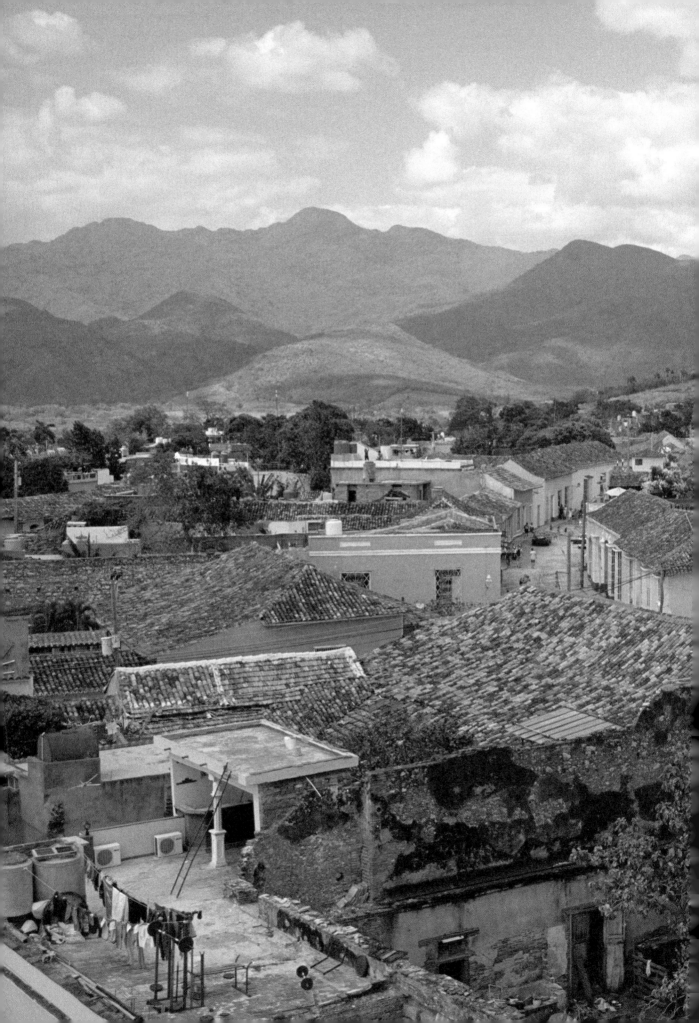

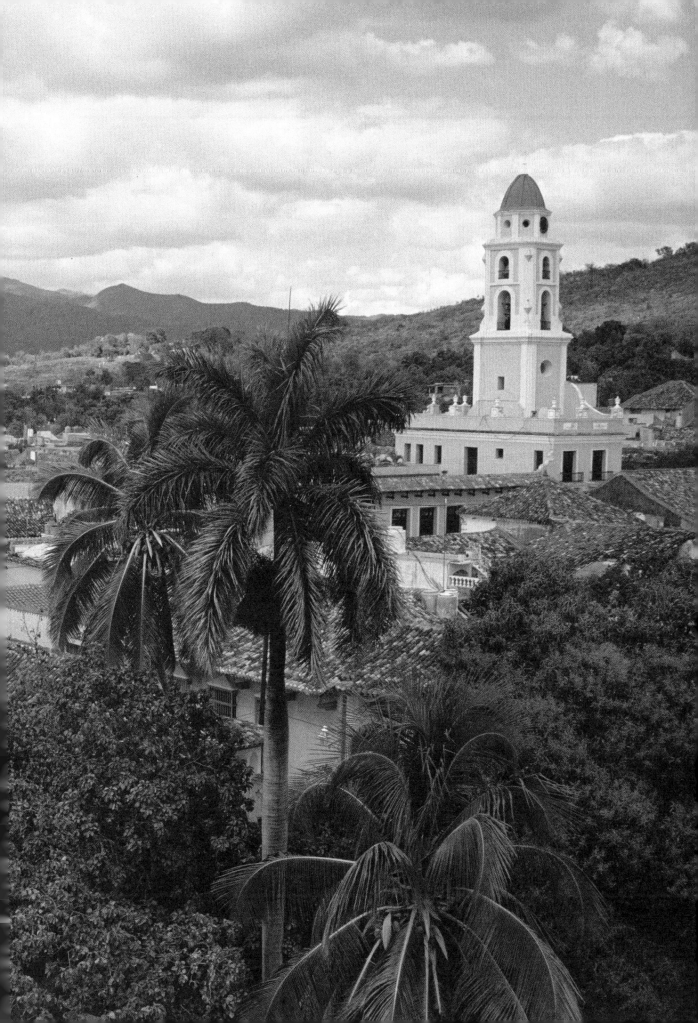

Horseback riding is a popular way of touring the Viñales Valley. It's also practical—the earth is quite often too muddy for hikes. Most tours take around four hours and will generally include a visit to a tobacco plantation, a break at a natural lake and lunch at the home of a local farmer. It is recommended that you bring long pants, closed shoes, insect repellent and sunscreen.

OPPOSITE

The karst landscape of the Viñales Valley is notable for its striking mogotes—the spectacular dome-like limestone outcrops that can rise as high as 1,000 feet (300 m). These unusual rock formations have earned the valley the status of the mecca of rock climbing in Cuba; there are over 250 bolted routes in the area.

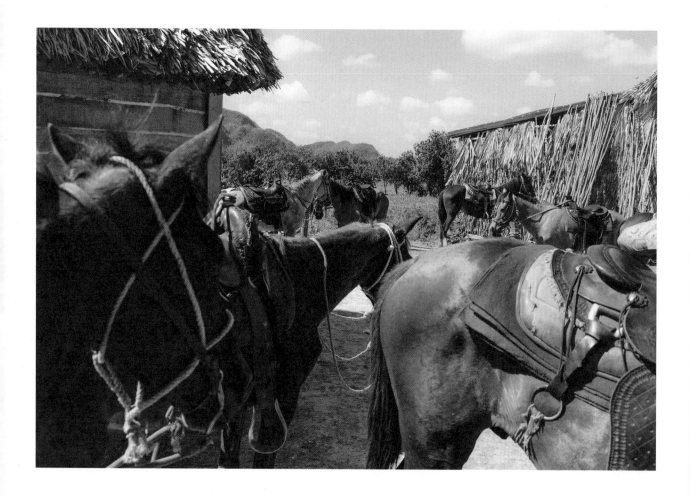

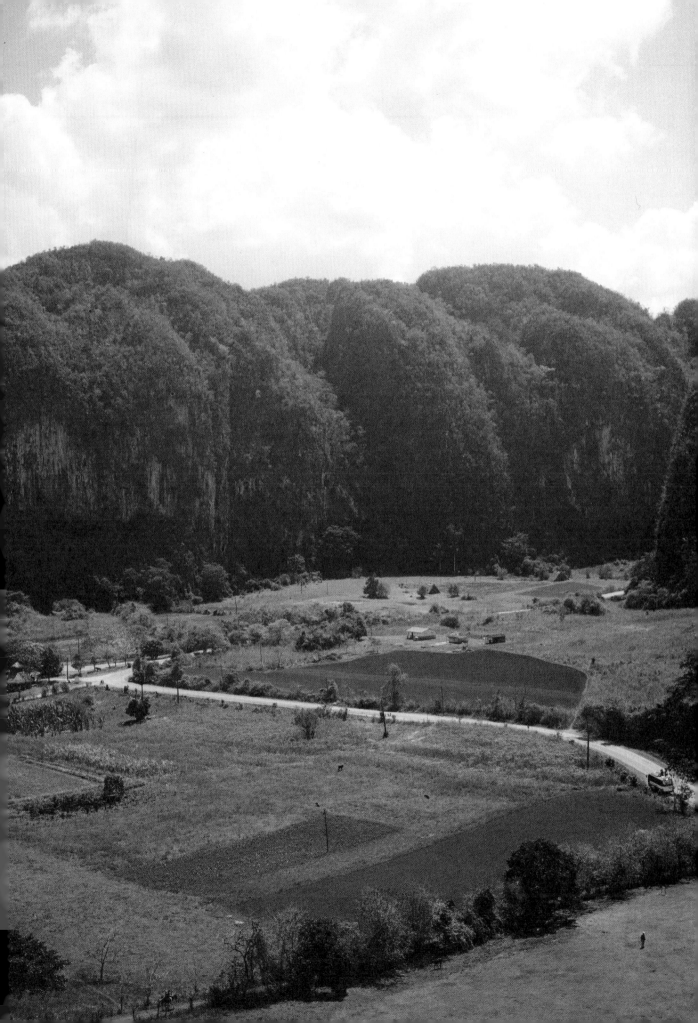

ABOVE

A shared taxi swaps passengers on Avenue 23 in Havana. Known locally as *almendrones* or *colectivos*, shared taxis travel along a fixed route through the city; people hop in and out as needed. In Havana, the cars are often colorful ones from the 1950s with a taxi sign in the window. Confirm the price before getting in.

FOLLOWING PAGES

A couple walks through Colón Cemetery in Havana. The site is a national monument and one of the largest cemeteries in the Americas. There are over five hundred mausoleums, with funerary architecture styles ranging from renaissance to neoclassical to art deco. A map showing the graves of Cuban artists, politicians, writers, scientists and revolutionaries can be found for sale at the entrance.

P 171672

Kandalama

Colombo
◆

Beruwala

Bentota

Galle

SRI LANKA
A guide to Geoffrey Bawa's Colombo

LOCATION	Indian Ocean
COORDINATES	6.92° N, 79.86° E
AREA	25,332 sq. miles (65,610 sq. km)
POPULATION	21,920,000
MAIN TOWN	Colombo

The Colombo residence of the late Sri Lankan architect Geoffrey Bawa is accessed through the garage. A translucent paneled door etched with a gigantic heraldic sun by artist Laki Senanayake, a friend of Bawa's, opens onto the room where Bawa's 1934 Rolls-Royce and vintage Mercedes are permanently parked.

Immediately, the architect's home at Number 11 Thirty-Third Lane feels like a refuge against the city outside, with its incessant honking of motor vehicles and chattering of crowds at nearby cafés. A long, white sunlit corridor connects the garage to Bawa's private spaces, opening first onto a courtyard where a tranquil pool of water is fringed by salvaged carved Chettinad columns from South India.

Bawa was a pioneer of what has become known as tropical modernism, although the architect himself never used the term. He was one of South Asia's most prolific architects, celebrated for his blending of indoor and outdoor spaces. "His buildings are layered in history, in a very multifaceted way; there's a connection to the landscape where outdoors and indoors are always intertwined; there's often a celebration of art," says Shayari de Silva, curator at the Geoffrey Bawa Trust, a nonprofit Bawa set

up in 1982 to advance the fields of architecture, fine arts and ecology. De Silva explains that Bawa integrated visual art into his designs and referenced local materials and vernacular techniques. "It's something you constantly see in his work."

Bawa's own home is dotted with art and antiques gifted by friends; in addition to the door by Senanayake, the home features table linens by batik artist Ena de Silva. "The objects in this place are testament to the country's history—a culture that's informed by multiple places, communities and different periods," de Silva says.

Typically, the forty-five-minute public tour at Number 11 begins with a small documentary about the house, which is then toured with a guide. The villa is actually a row of four bungalows that were bought and combined by the architect over the years. Bawa demolished the first one, building a four-story tower in its place, with each floor connected by a curved, white staircase. There are two small but comfortable guest rooms with a common bathroom on the first floor, which art and architecture enthusiasts may book as accommodation. After passing through a loggia—a covered exterior corridor—on the third floor, visitors

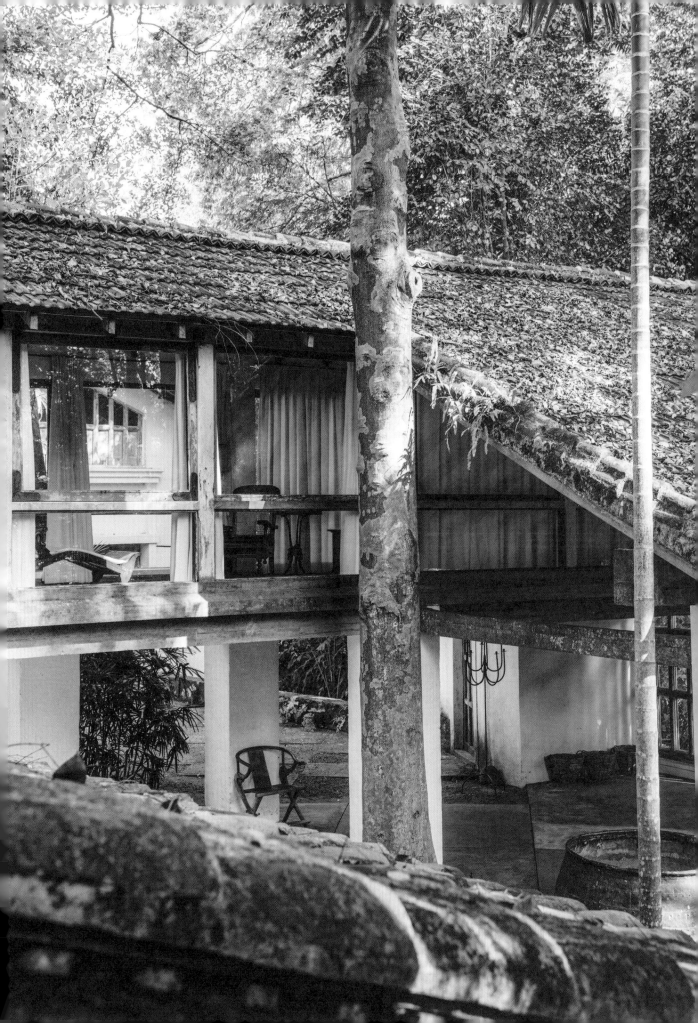

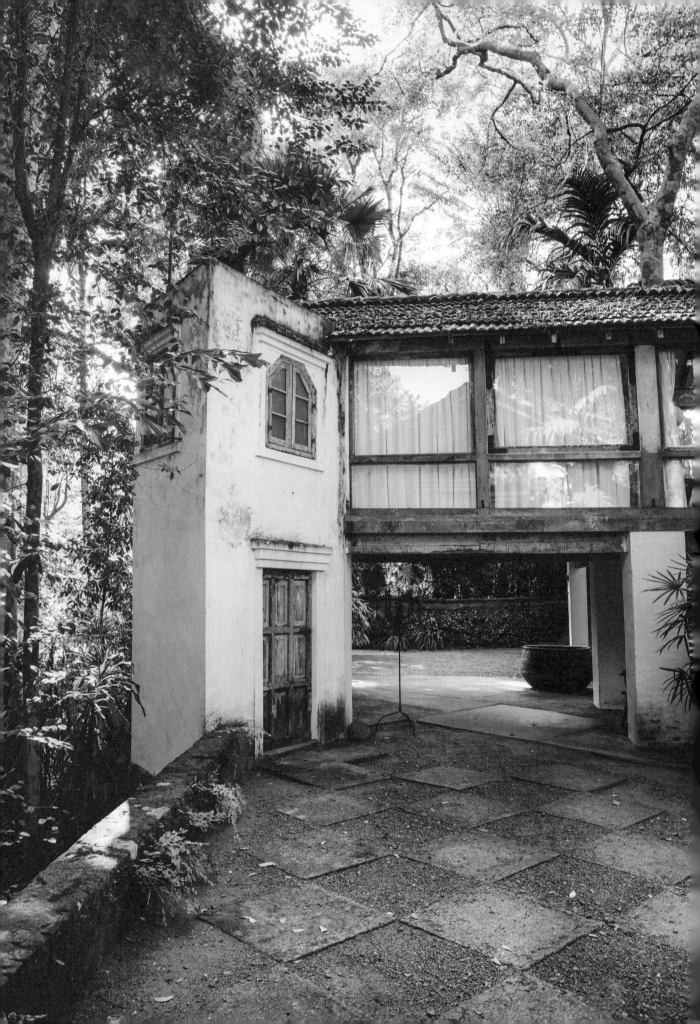

GETTING THERE

Both Number 11 and De Saram House are in the heart of Colombo and can be reached on foot or via a three-wheeled tuk-tuk. You can rent a car or moped to explore Bawa's architectural marvels outside of the Sri Lankan capital. Bentota is roughly an hour and a half's drive along the Southern Expressway.

SEE & TOUR

In Colombo, begin with a tour of Number 11, then explore De Saram House and Paradise Road. The Gallery Café (Bawa's former office that has been turned into a Sri Lankan fusion restaurant) is an excellent spot for a lunch of black pork curry. Drop into the Bawa-designed Bentota Railway Station.

STAY

Bookings for Number 11 can be made via the Geoffrey Bawa Trust. Overnight stays at Lunuganga can be booked via the Lunuganga Trust. The five-star Cinnamon Bentota Beach hotel is also a great option if you'd like to see the architect's work up close. Otherwise, Colombo offers plenty of accommodation options.

WORTH KNOWING

Bawa's older brother, Bevis Bawa, was a landscape artist. In 1929, Bevis began designing his own country home, Brief Garden, in Beruwala. The 20-acre (8 ha) garden is a 10-mile (17 km) drive from Lunuganga and boasts beautiful plantings with vine-covered walls, carved statues and verdant archways.

arrive at an open, cemented terrace that looks out over the city and its skyscrapers.

Visitors can't take photos of Bawa's private rooms, but you do get to see the lounge courtyard, where finger palms rustle and rainwater drips, and the master suite, which overlooks a large frangipani tree. De Silva says that Bawa's designs exemplify the ways of the island, which is to say living seamlessly with the outdoors.

Before his death in 2003, Bawa designed a series of individual houses, hotels and public spaces in Sri Lanka, including the nation's parliament building. A 2-mile (3 km) ride from Bawa's compound takes you to the De Saram House on Ward Place, which was renovated by Bawa in 1986 for the acclaimed pianist Druvi de Saram and his family, and later restored by the Geoffrey Bawa Trust.

The small southern town of Bentota, 63 miles (102 km) from Colombo, is also a good place to see Bawa's work, including the fully restored Cinnamon Bentota Beach hotel, a late '60s building situated between the beach and the Bentara River. Like most other properties designed by Bawa, the hotel brings greenery, natural light and open-plan facilities into one harmonious space. A vibrant batik ceiling by artist Ena de Silva is not to be missed.

Another of Bawa's inventive, and perhaps most iconic, buildings in Bentota is Lunuganga, his country retreat. Surrounded by greenery on the banks of Dedduwa Lake, the 12-acre (5 ha) property was bought by Bawa in 1948 and slowly transformed into a country residence over fifty years; the entire estate has been preserved as it was found upon his death. Visitors can book one of five private suites onsite.

Climbing up the steep track from the property's entrance gate to its main bungalow, the property's romantic, magical garden comes into view. The bungalow's veranda overlooks a lawn that sweeps down toward Cinnamon Hill, where a large Chinese urn is nestled under a Spanish cherry tree, and beyond, to the lake. Bawa had no formal plan for the garden; it unfurls and sprawls over the landscape, barely taming the jungle.

It is here in Lunuganga's garden, among water lily–filled ponds and ornamental rice fields guarded by tropical frangipani trees, where sunlight dapples the ground and birds sing and leaves rustle, that Bawa's soul is revealed.

ABOVE LEFT

A classical Greco-Roman statue
sits in the dense, barely tamed
tropical gardens of Lunuganga.
Bawa cultivated the gardens
without any formal plan, but
he borrowed stylistic elements
from English landscaping, Italian
Renaissance gardens and ancient
Sri Lankan water gardens. Guided
tours are available three times a
day with an entrance fee; lunch or
afternoon tea can be arranged in
advance for an additional charge.

OPPOSITE

Lunuganga, the former country
home of Sri Lankan architect
Geoffrey Bawa, is now run as
a boutique guesthouse; five
private suites across the estate
are available for reservation. The
Garden Room, a double-height
structure built almost entirely with
salvaged materials, opens onto
the property's enchanting
tropical garden.

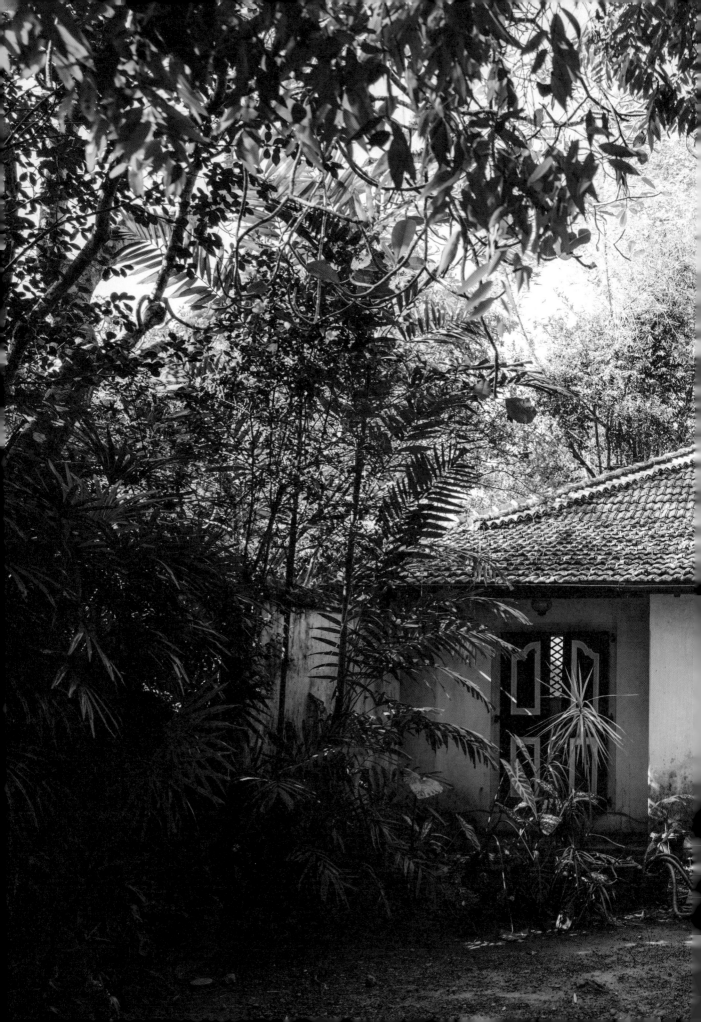

OPPOSITE
Vithana Arachchige Rohana, a staff member at Lunuganga. As Sri Lanka emerged as a tourist destination during the 1960s, Bawa designed a series of luxurious hotels that set a new standard for resorts in southeast Asia; the Triton Hotel in Ahungalla, on the island's west coast; the Lighthouse, a seaside hotel at Galle; and the Kandalama Hotel, which clings to the hillside near Dambulla in central Sri Lanka.

FOLLOWING PAGES, RIGHT
Bawa's personal residence was a three-story villa known as Number 11. The dining table is an epoxy-painted slab of concrete surrounded by Eero Saarinen–designed Tulip chairs; the walls are adorned with part of a poster portraying Lenin's legs.

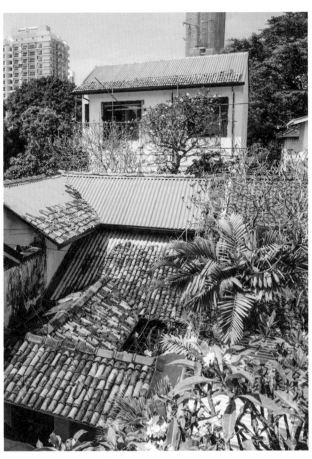

OPPOSITE

A small roof aperture draws natural light down through Number 11 toward a plot of vegetation. The architect was a pioneer of tropical modernism, an architectural style that integrates the lush Sri Lankan environment into living spaces. Throughout the home, pockets of greenery are visible from interior rooms; from Bawa's bed, for example, an enfilade of doors opens onto a view of a frangipani tree.

BELOW

Bawa's home on Thirty-Third Lane was built from four smaller bungalows that the architect bought and combined over several years. He filled the labyrinthine spaces with beloved objects and works of art. Most striking are batiks by artist Ena de Silva, textiles by Riten Mazumdar.

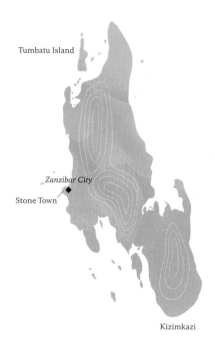

Tumbatu Island

Zanzibar City

Stone Town

Kizimkazi

ZANZIBAR

Step through the storied doors of Stone Town

LOCATION	Indian Ocean
COORDINATES	6.13° S, 39.36° E
AREA	951 sq. miles (2,462 sq. km)
POPULATION	1,503,569
MAIN TOWN	Zanzibar City

Nothing about the archipelago of Zanzibar is straightforward, but that's part of its appeal. The tangle of Hindu temples, Persian bathhouses, colonial buildings, coral stone mansions and crumbling palaces that make up the historic quarter of Stone Town may seem eclectic—but they tell the stories of those who traveled here before you.

Because Zanzibar Island (known locally as Unguja) boasts year-round sunshine, absurdly turquoise waters and powdery white beaches, it is best known as a destination for honeymooners looking to unwind post-safari rather than a cultural haven. "Many tourists don't see the value of understanding what makes it so special," says local tour guide Ally Jape. "Stone Town is a UNESCO World Heritage Site because of over two thousand years of cultural fusion and harmony, coupled with its architecture and urban structure."

The first inhabitants of Zanzibar migrated here from the African mainland several millennia ago. They were joined by Shirazi immigrants in the tenth century, Portuguese colonizers in the fifteenth century and Omanis in the late seventeenth century. Zanzibar became a trading hub, and enslaved people were

regularly brought here from other parts of Africa to be sold in Stone Town. Indian and European merchants followed suit, most of whom stayed until Zanzibar was declared a British protectorate from 1890 until 1963. A revolution in 1964 resulted in unity with the historical state of Tanganyika to form Tanzania.

Today these various cultural imprints are awash in Stone Town: the call to prayer that wafts over church spires, the lateen sails of passing Arabian dhows, the ubiquitous Omani kuma cap, hearty Swahili urojo stew and the games of East African bao that sprawl over the streets. Nowhere is the rich tapestry more tangible than in its architecture. A signature flourish are the rosewood balconies that perch overhead. Usually enclosed and intricately carved, this Indian import allowed for the women in nineteenth-century households to get some fresh air away from prying eyes. A masterpiece of the genre awaits at the peppermint-hued Old Dispensary on Mizingani Road. Such monuments make Stone Town an open-air museum, but they're deteriorating due to a combination of time, weather and neglect—decay that is romanticized by tourists, dreaded by locals.

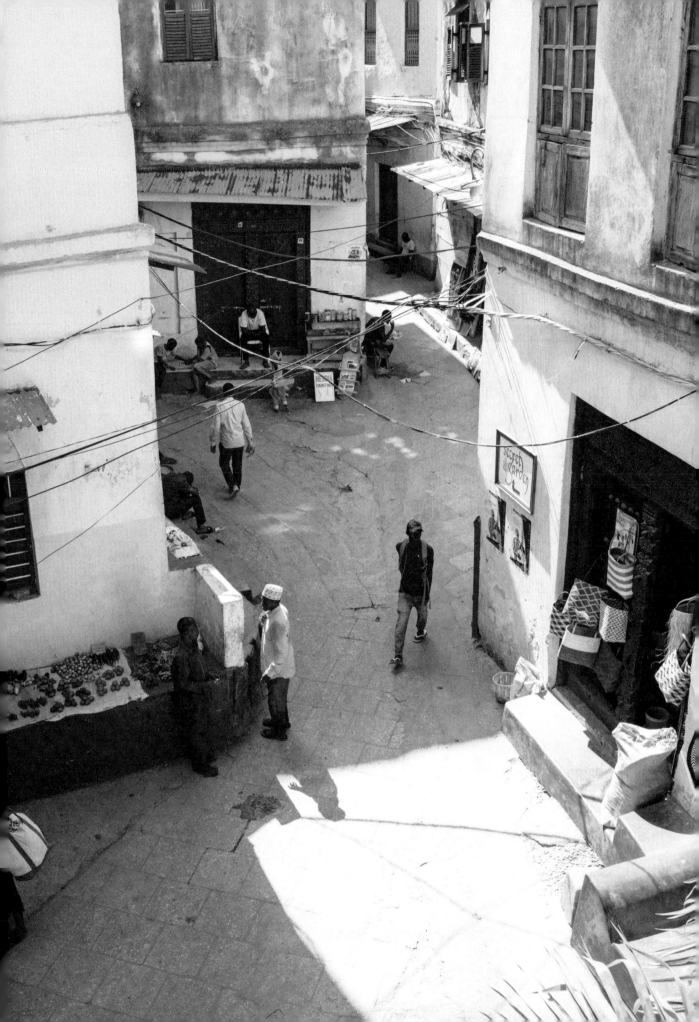

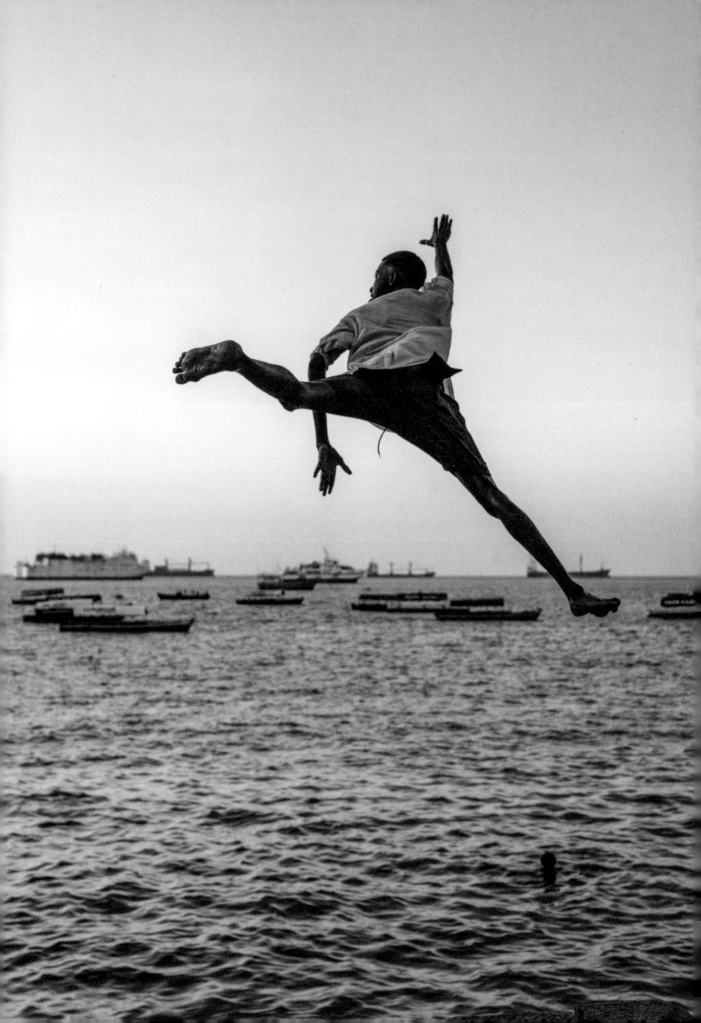

GETTING THERE

Catch a flight to Abeid Amani Karume International Airport or take the Azam Marine and Kilimanjaro fast ferry from Zanzibar Ferry Terminal in Dar es Salaam to Unguja (book ahead of time). Boats run four times a day each way, and the trip takes about two hours. From here, you'll take a taxi to Stone Town, which is best explored on foot.

SEE & TOUR

A symbol of Zanzibar's beleaguered past, Christ Church is built on the site of the world's last open slave market. A half-day trip to the former quarantine station of Prison Island promises time to snorkel and sunbathe. Relax at Mrembo Spa, where massage therapists with impaired vision/hearing deftly tend to strain and knots.

STAY

Everything from budget bunks to beach resorts is on offer, but nothing beats Stone Town's atmospheric boutique hotels. Emerson Spice, a stylishly restored merchant's house, wins rave reviews. Elsewhere, the Kizikula guesthouses designed by Mumbai's Case Design offer simple coral stone structures along the seashore.

WORTH KNOWING

Zanzibar's rainy season lasts roughly from March until May. Booking a trip during this period if you're set on a beach holiday is not a good idea. Another shorter rainy season happens between November and December but is not nearly as intense as the spring. In winter, torrential rain will soon turn to blue sky.

Proximity to the sea has also shaped island architecture. "Every single detail has a meaning behind it," explains Jape. "Coral stone was used in construction because of its ability to absorb dampness. Houses were built close together so that sea breezes circulate around town. Tall buildings helped create shade on the streets."

No single architectural element is as memorable as the massive, ornately carved Zanzibar doors. Only a few hundred of these relics from the eighteenth and nineteenth centuries have survived, with most of them anchored in Stone Town. Several have been sold to international collectors, some are graffitied and weathered, but what remains is easy to find. Just walk aimlessly in any direction until you spot one. And once you do, you'll want to pause and peer closely. These functional works of art are silent storytellers, revealing the origin, occupation, religious beliefs and social status of their original owners.

One-upmanship was an important consideration, with powerful men commissioning elaborate entryways as a visual manifestation of their affluence. Generally speaking, there are two types of doors, according to Mwalim Ali Mwalim, former director general of Stone Town Conservation and Development Authority (STCDA). Indian (or Gujarati) doors feature coffered panels and foldable shutters, and are often seen in bustling bazaars. Arab doors, meanwhile, tend to feature a delicately decorated frame and Quranic inscriptions on the top frieze. As for the embedding of sharp brass spikes? An influence from India, where they helped defend against the battering of war elephants. Zanzibar doors are also rooted in symbolism, and recurring motifs like the rosette, lotus and fish bring with them varying interpretations. For example, some believe that a chain depicted on a door frame indicates the house of a slave trader, but—according to Jape—it was carved to ward off evil spirits.

Although the doors that are part of Stone Town houses are protected by STCDA, Mwalim says that there is a strong and welcome trade in the construction of new doors. "Rumors about restrictions on exporting [the doors] are based on past vandalism, when Zanzibar doors were plucked from their houses to be sold as antiques," he says. Carpenters have now set up a community in the village of Kidimni, training the next generation of craftsmen and making reproduction doors for sale.

If bringing home an example of this weighty art form isn't an option, ethical souvenirs await at Sasik, Moto and Captain Souvenirs. Jape warns that the Tingatinga paintings touted to tourists are incorrectly associated with Zanzibar and vary considerably in quality. Instead, he suggests making a pit stop at Cultural Arts Gallery, housed in Old Fort, to watch local artists in action and purchase their work. Incidentally, the fort faces Forodhani Gardens, home to a nightly food market where the dishes come cheap and the vibe is cheerful. Round off your trip to Stone Town by following your nose to Darajani Market, where nondescript stalls sell wonderful spices like nutmeg, cloves and cinnamon. Make sure you take any opportunity to get lost along the way.

PREVIOUS PAGES, LEFT

Jumping into the water at sunset in Stone Town is a nightly ritual. Pick up a snack at the evening food market at Forodhani Gardens, a popular meeting place on the waterfront where stalls serve local street food staples like fish skewers and chile salt–dusted mango slices, and enjoy the show.

OPPOSITE

The Old Fort of Stone Town, also known as Ngome Kongwe, was built by Omani colonizers in 1699 and is one of the oldest buildings on the island. Today, there is a tourist market among the ruins selling handicrafts, and the site's amphitheater is used for cultural events, like the Zanzibar International Film Festival.

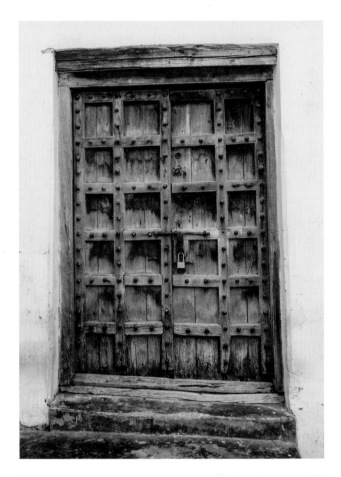

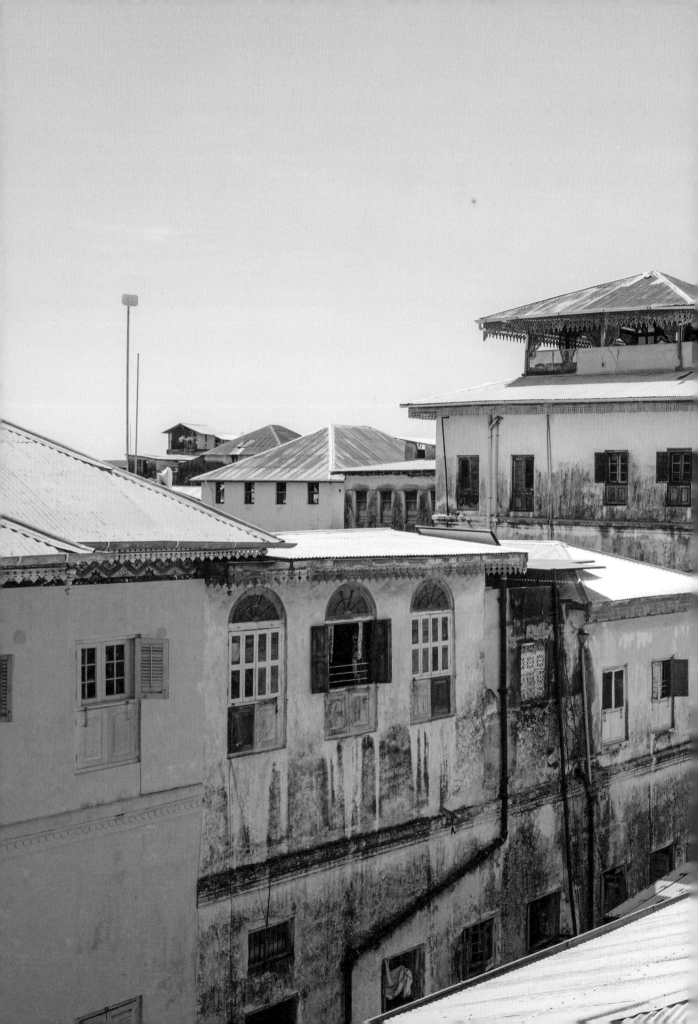

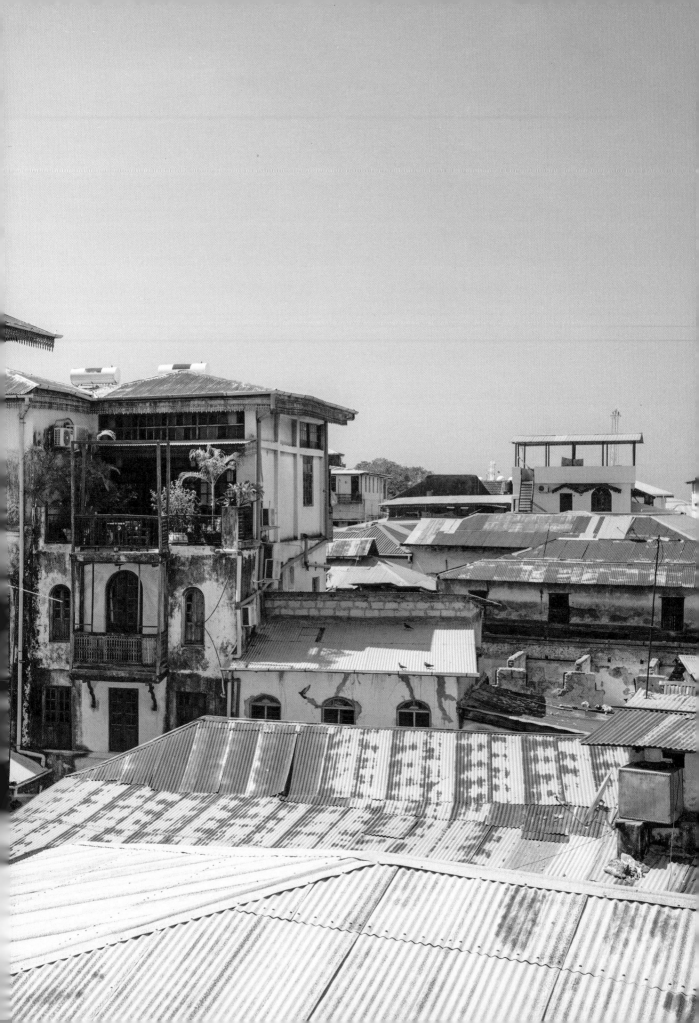

JAMAICA
The country charm of Port Antonio

LOCATION	Caribbean Sea
COORDINATES	18.11° N, 77.29° W
AREA	4,244 sq. miles (10,991 sq. km)
POPULATION	2,726,667
MAIN TOWN	Kingston

The chaotic buzz of urban living mellows to a quiet hum in the Jamaican city of Port Antonio. The sound of waves crashing onto the shore acts as a metronome for daily life, drowned out only during the bursts of activity that bookend the working day. The capital of Portland—a parish nestled on the northeasterly coast of the island—Port Antonio is emblematic of what its residents might call "country," which is not to say that it is a particularly small or entirely rural community, just that it proceeds at the pace of one.

The city is dotted with clues to the many lives that have called its shoreline home. The remains of Fort George, which sits on an inclined cliff jutting out into the sea, was constructed by the British in 1729 to prevent attacks from a possible Spanish invasion as well as from the Maroons, who were then enslaved people fighting for autonomy from the British.

Today the Maroons still celebrate their ancestors' culture; Queen Nanny, a feared Maroon leader, graces Jamaica's $500 bill. Moore Town, one of the many Maroon settlements on the island, may now be accessible by car from Port Antonio, but its location up in the highlands of the Blue Mountains is telling: the Maroons have always clung to their autonomy and self-determination.

"A lot of people talk about the Maroons. They never get stale," says B. Dunkley, a resident of Port Antonio who works in hospitality. Jokingly, he shares, "Even in a simple conversation, the Maroons will come up 'cause we always say the Maroon duppy ["spirit" in Jamaican patois] is strong. If you walk, buck yuh toe and nearly drop—or almost drop—we will say, 'Yeah, the Maroon duppy deh wid yuh.'" Dunkley's anecdote speaks to the Caribbean folklore around the supernatural: when people stub a toe and fall, lore has it that it's caused by a nearby Maroon spirit.

Outside of day-to-day conversation, the Maroons continue to have a presence in Port Antonio, and their traditions have contributed to one of Jamaica's biggest exports: jerk. The community's decision, driven by survival, to inhabit the mountains led to a unique cooking technique—a pit in the ground, used to conceal smoke from the British. The technique, which is thought to either have been historically carried from Africa by enslaved people or adapted from Jamaica's Indigenous Arawak and Taíno people, gradually traveled down from the mountains

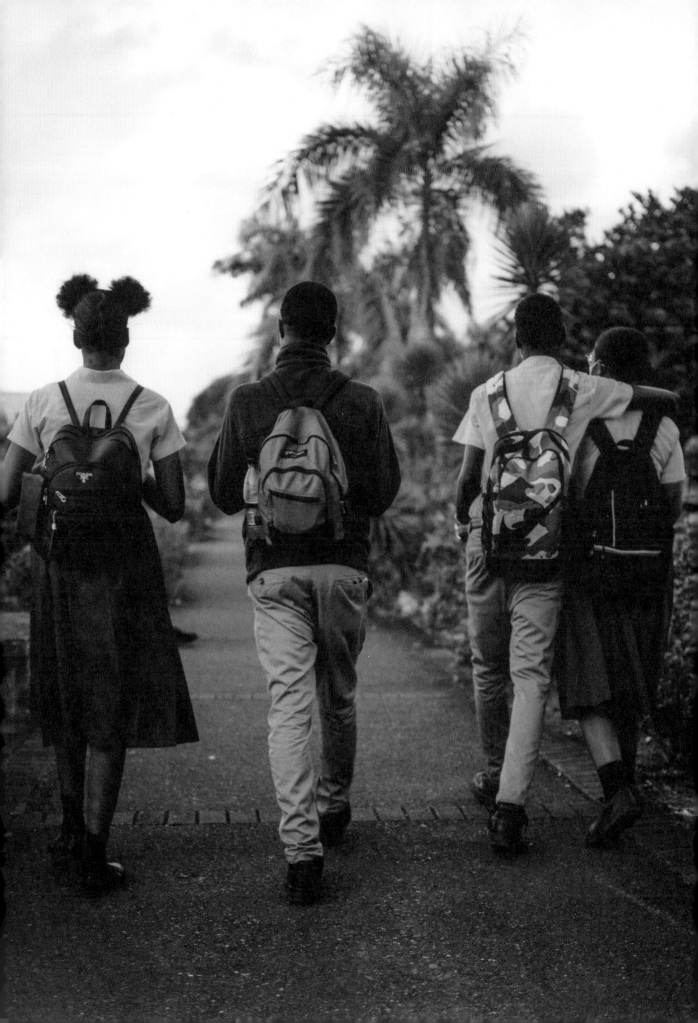

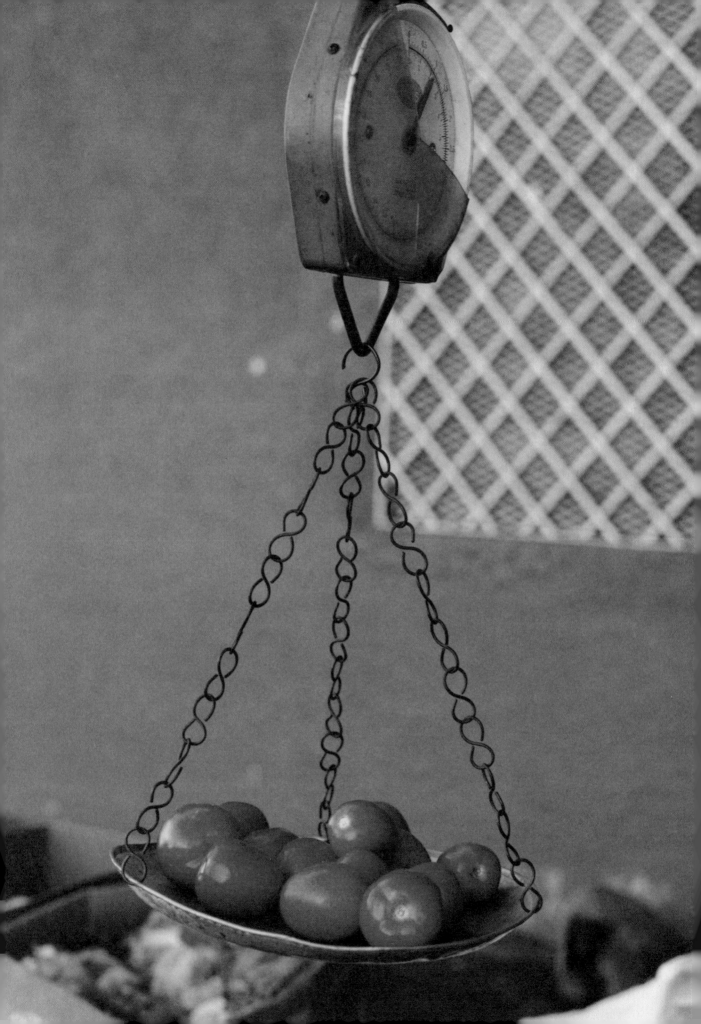

GETTING THERE

The easiest way to get to Port
Antonio is to fly into Kingston,
then drive north and east across
the island or take the Knutsford
Express buses. In downtown Port
Antonio, there are no traffic lights,
and parking is scarce. It is much
easier, and more scenic, to walk to
your intended destination: hire a taxi
when traveling at night.

SEE & TOUR

Jamaica's largest river, the Rio
Grande, runs through Port Antonio.
Bamboo rafting down its bank is a
favorite leisure activity. Alternatively,
the Blue Lagoon, which is known
for its stunning waters, offers boat
tours. At the large craft market in the
center of town, you can get hand-
carved statues and jewelry, and a
cold drink at the bar.

STAY

There are ample boutique and
luxury hotels in Port Antonio, such as
Jamaica Palace Hotel, Kanopi House
and Geejam Hotel. The latter boasts
a private recording studio, which has
hosted many famous musicians (such
as Björk). Guesthouses offer a more
authentic experience. Inn the Town is
a newly renovated option right at the
heart of things.

WORTH KNOWING

Jamaica is actually an archipelago,
and Monkey Island (also known as
Pellew Island) is one of twenty-seven
smaller islands that make up the
country. It is said that at low tide, the
water is so shallow that you can walk
to Monkey Island from the coast
of Port Antonio. There can be sea
urchins on the seabed, so watch your
step if you're barefoot.

to the shore of present-day Boston Beach, which is considered the polestar of jerk.

Today jerking is done aboveground in repurposed oil drums. Time has passed, but the art of slow cooking remains. "Boston has a lot of tings," Dunkley says. "You can get jerk chicken or jerk pork, you place your order and you have to wait because it's not fast food." If you're in the mood for freshly caught fish, they are abundant at Gold Teeth Jerk Center in Fairy Hill, a neighborhood in the Boston Beach area.

Elsewhere in town, savory chicken foot soup can be found at Piggy's Jerk Center. Piglet (who is the son of Piggy's owner) makes cold-pressed juices and tasty festivals—a sort of sweet fried dumpling—while the Honest John's Jerk Pork kiosk offers the best traditionally prepared jerk using wild boar. Vegan food is available at Miss Dixon on Bridge Street. Wherever you eat, you'll find none of the bustle of other tourist hubs such as Kingston and Montego Bay; in Port Antonio, food takes as long as it takes.

Head to the Errol Flynn Marina to experience a slice of local life. Here reggae and dancehall from several bars intermingle in the warm air, students crowd the wharf's shoreline and street vendors line up to sell them gizzada pastries, roasted peanuts and coconut drops. To walk off a hangover, stroll to Titchfield Peninsula, the town's highest peak, from where you can see the now-barren Monkey Island, part of Jamaica's twenty-seven-island archipelago.

During the early 1900s, the island was home to a colony of monkeys imported by an archaeologist—the son-in-law of Annie Tiffany, the heiress of Tiffany & Co. At Folly Point nearby, you'll find the dilapidated Folly Ruins, which Tiffany and her family had planned as a sixty-room Roman villa. Today it stands as a skeletal reminder of the whims of Jamaica's many wealthy expats.

The Royal Mall Village of St. George, a shopping center downtown that locals refer to as Fahmi, is illustrative of this sensibility. Created by the late German designer Baroness Sigi von Stephani Fahmi, the structure is an odd hodgepodge of various European architectural styles. Constructed as a tribute to Georgian, Tudor, art deco and Gothic design, the mall is a metaphor of sorts for the local spirit. For centuries, outsiders have tried to shape its way of living to their own liking—but not without resistance from local residents. Port Antonians have always taken what is brought to them, often by force, and made it their own.

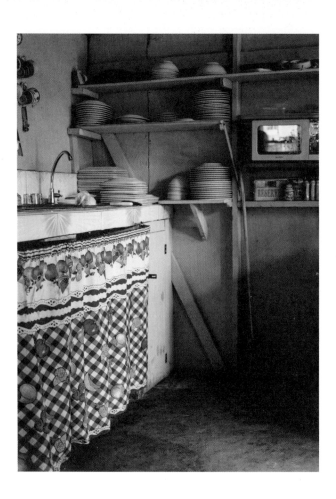

ABOVE & OPPOSITE

The kitchen at Soldier Camp
(pictured above), a twenty-seat
bolt-hole that makes some of the
best curries in Port Antonio. Try the
coconut shrimp curry, served with a
choice of rice or roti. For jerk, you'll
find numerous options along Boston
Beach. Little David's Jerk Centre
(pictured opposite) is one of the best.
Order the signature jerk-chicken
sausage and take it down to the
beach (entrance fee required)
for a picnic.

FOLLOWING PAGES, LEFT

A view from Errol Flynn Marina at
sunset. There are many beaches
and places to swim along Port
Antonio's stretch of coastline. The
jungle-hemmed Frenchman's Cove
(which charges an entrance fee) is
often hailed as the most beautiful
among them. At the Blue Lagoon,
a 200-foot-deep (61 m) cove about
7 miles (11 km) outside town, local
fishermen will take you out on a skiff
for the day so you can dive directly
into deep, turquoise waters.

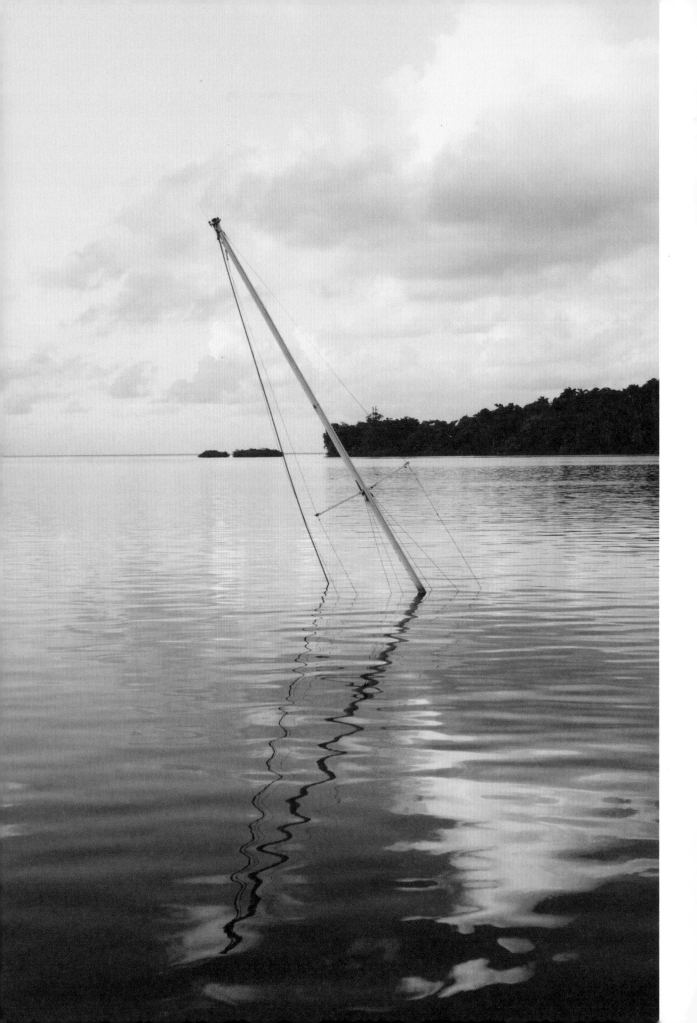

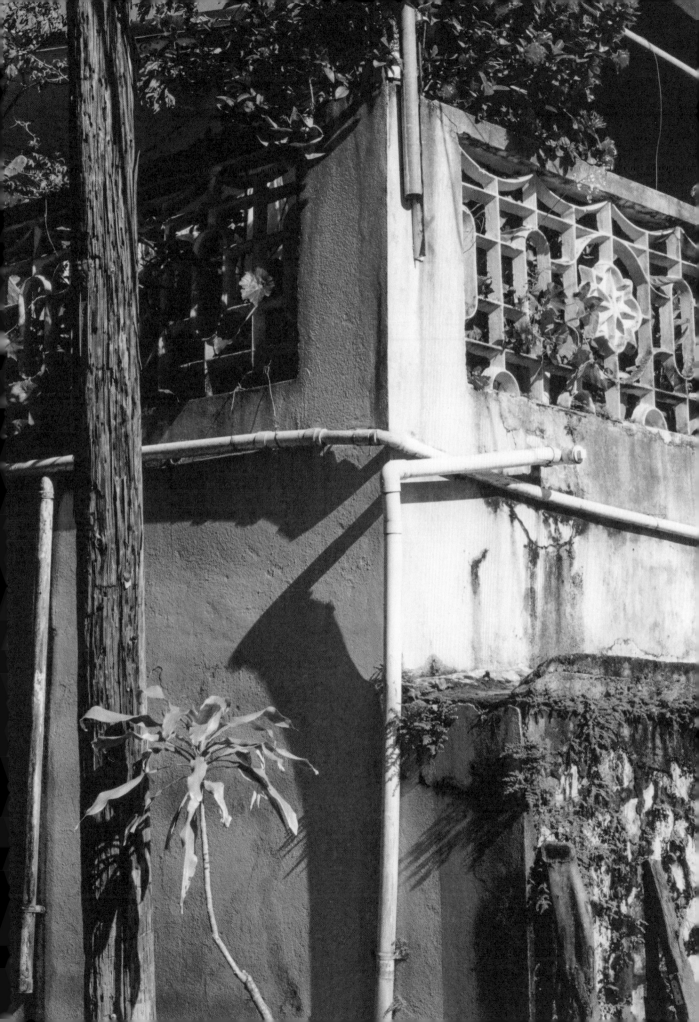

OPPOSITE

Trevor, a local resident, poses for
a portrait outside his home. There
are generally fewer tourists in Port
Antonio than at the all-inclusive
resort towns of Negril or Montego
Bay, making it an affordable, and
more adventurous, alternative.
The area is renowned for its lush
jungle and natural beauty. The
Rio Grande, which flows out of
the Blue Mountains, provides
beautiful rafting, hiking and
caving opportunities.

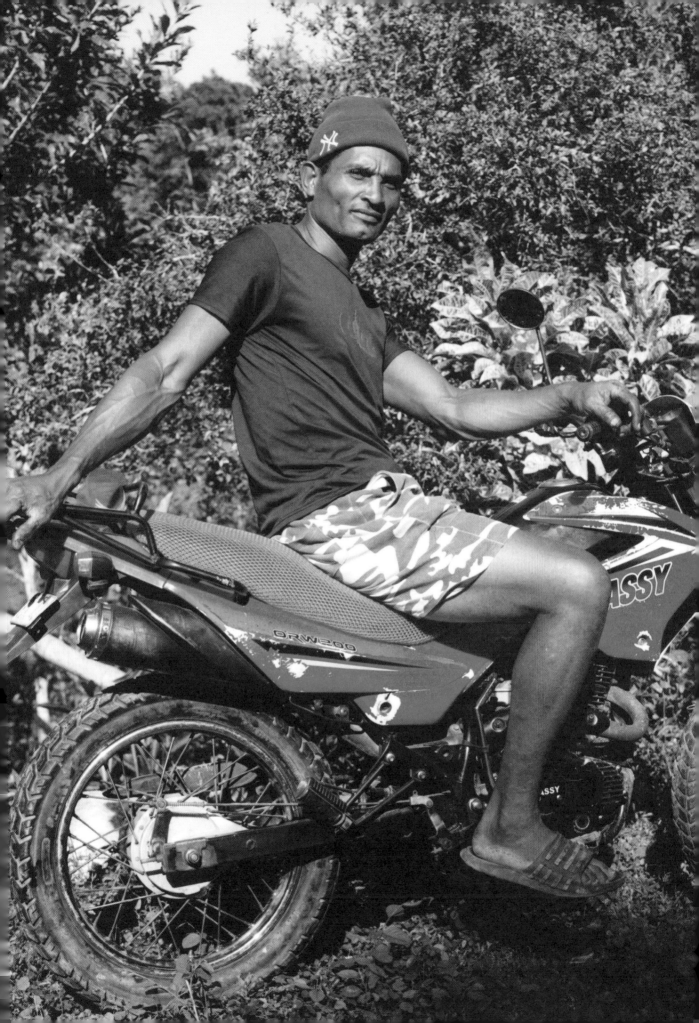

The
Siren Call

Words by Daphnée Denis

According to Homer's ancient poem *The Odyssey*, it took Odysseus ten years to return home to Ithaca after the Trojan War. The tale of his wanderings at sea has become a myth in Western culture, as have the islands he encountered along the way—each an obstacle capable of engulfing the Trojan hero and his crew in a fatal trap. In Aeaea, the enchantress Circe seduced Odysseus's men into forgetting their homes before turning them into pigs. Later, as the voyage takes the crew past another island, they must resist the mesmerizing call of Sirens, creatures whose song lures sailors to their doom.

It's difficult to pinpoint when exactly humans first felt the siren call of islands. As areas of land surrounded by water, both protected and isolated by the sea, they have seemingly always been equally alluring and daunting for adventurers, colonizers and, nowadays, travelers. Countless works of art and literature find inspiration in the idea of remoteness they embody and the fabled hospitality or threat of "island people." Think of the mythical "desert island" for which we've all mentally packed our most precious belongings. And of all the utopias that are islands, from Plato's Atlantis to Thomas More's Utopia—the first fictional place to be called that—all are conveniently hidden somewhere at sea, away from the mayhem of real life. It could well be that the many islands of our imagination have shaped a collective perception of island travel.

Yet, of course, it seems strange to speak of islands in general without acknowledging a simple fact: one island experience doesn't fit all. Traveling to Great Britain, for instance, hardly feels the same as visiting Hawaii. Though both are archipelagoes, only one *feels* like a group of islands. Richard Sharpley, a professor of tourism and development at the University of Central

Lancashire, argues it is nonsensical to speak of or analyze "island tourism" as a single unit, considering the vast range of places that may be described as islands. Yet, he says, one can long for, or indeed experience, "islandness," meaning "to be both physically and emotionally detached from your normal, day-to-day lives—a sense of isolation, which is enhanced by being geographically in the middle of the sea."

For Sharpley, that feeling of islandness may develop only on certain types of islands—perhaps smaller, and of the warm-water kind. "A lot of it is in the mind of the tourist," he says, adding that one may not experience the same sense of islandness when landing at Palma airport in Mallorca, where nine million other tourists travel every year, that one might feel when arriving in Fiji, which immediately grants travelers a sense of remoteness due to how geographically far and culturally distinct from North American and European cultures it is.

Arguably, some tourists may be unaware that their chosen destination is an island at all. "It's confusing to speak of tourists going to islands as if a lot of them are going because it's an island," says Richard Butler, a leading researcher into the evolution of tourist destinations and the ways to achieve sustainable tourism. "I think they're going because it's a destination that has been marketed to them, and they like what they see. Now that's obviously different if you're going somewhere like the Maldives, where the islands are very small, and it's very visible that you're flying into one island and then another," he says. "Islands cover a multitude of destinations, but when people know they're going to an island, it's an added attraction."

For Butler, the West's unconscious fascination for islands may trace back to times when they equaled protection: in the Middle Ages, he says, moats essentially turned castles into islands and made them safer insofar as they were harder for the enemy to access. Granted, islands also served as prisons, or places to quarantine immigrants, like New York's Ellis Island, or the Micronesian island of Nauru, where the Australian government detains refugees and asylum seekers to this day. Yet Butler believes it is the feeling of safety and seclusion that prevailed. In that vein, the boundedness of islands may be part of their appeal. The sense that they are finite and may be explored in a more total way than other places prompts tourists to develop their own local habits for the duration of their stay.

It may seem counterintuitive that islands could carry the notions of adventure and safety all at once. Still, what we perceive as islands could well be a creation of the mind. A small, isolated, fishing town could make us feel the same sense of islandness whether or not it is attached to the mainland. Likewise, a big city on an island could feel as continental as they come.

In the 1993 essay "Our Sea of Islands," Tongan writer and anthropologist Epeli Hauʻofa challenged Western views of the Pacific Islands, or Oceania as he preferred to refer to them, as "small," "poor" and "isolated." The peoples of Oceania, he argued, didn't conceive of their world as ending where the ocean began. "There is a world of difference between viewing the Pacific as 'islands in the far sea' and as 'a sea of islands,'" he wrote.

At the time, Hauʻofa was pushing back against the notion that Pacific island-states couldn't be self-reliant, yet his view also questions the West's longing for islandness and prompts us to keep an open mind. The islands in our heads are vastly different from the ones we may encounter in real life.

"One can long for, or indeed experience, 'islandness,' meaning 'to be both physically and emotionally detached from your normal, day-to-day lives.'"

III

UNWIND

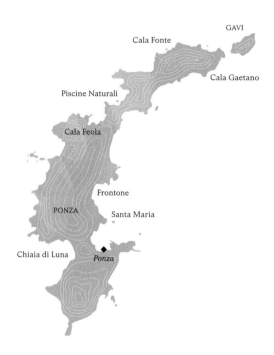

PONZA

Swimming and snacking along volcanic shores

LOCATION	Tyrrhenian Sea
COORDINATES	140.91° N, 12.96° E
AREA	4 sq. miles (10 sq. km)
POPULATION	3,339
MAIN TOWN	Ponza

Rising sharply from the topaz surface of the Tyrrhenian Sea, the Italian island of Ponza has never lost its primeval aura. Though its port towns today have tight clusters of confetti-colored houses, Ponza's beaches are backed by embankments of raw lava petrified into striking shapes—a natural monument to the earth in its formative years, and a reminder of how this outpost looked to the Etruscans and Greeks who arrived here on early explorations of the area.

"We're out here in the middle of the sea, following in the footsteps of Ulysses and reconnecting with the philosophy of the ancient Greeks," says eminent Roman artist (and protégé of Cy Twombly's) Alberto Di Fabio, who purchased a remote property on Ponza a decade ago, transforming the white stucco home over long summers into a refuge from urban life. "This place is where I go to dream of more analog times," he says with a smile.

Though Di Fabio has apartments and studios in Rome and New York, his "cave home" on Ponza is where the painter found he was able to settle into a contemplative frame of mind. "Visitors here are left enraptured by the purity of nature," he says. Di Fabio's neighbors are agriculturalists committed to

growing in harmony with the land, and whose ventures include the acclaimed vineyard of Antiche Cantine Migliaccio, where ancestral methods and the Biancolella grapes (for centuries grown only on the Pontine Islands, of which Ponza is the largest) produce wines redolent of hawthorn flowers and the terrain's igneous flavor.

The wine is a natural match for Ponza's culinary delicacies, including linguine c'o Fellone, which is made with the island's native spider crabs, local red shrimp (often eaten raw), fresh-caught anchovies served with cherry tomatoes, and cicerchie, a flat pea that grows wild here.

Di Fabio spends his summer months on Ponza "reading, writing and gathering energy for new ideas," even occasionally painting, but when he takes a break from his ruminations, he heads to the dockside Bar Tripoli for an aperitivo and views of sailboats bobbing in rows on the water nearby. He may also duck into Hotel Chiaia di Luna where, gazing from the poolside terrace at the rift between two hills opening to a stretch of sea, "the sunset is incomparable." Around the central Piazza Carlo Pisacane, dinner is best taken at Ristorante l'Aragosta, at

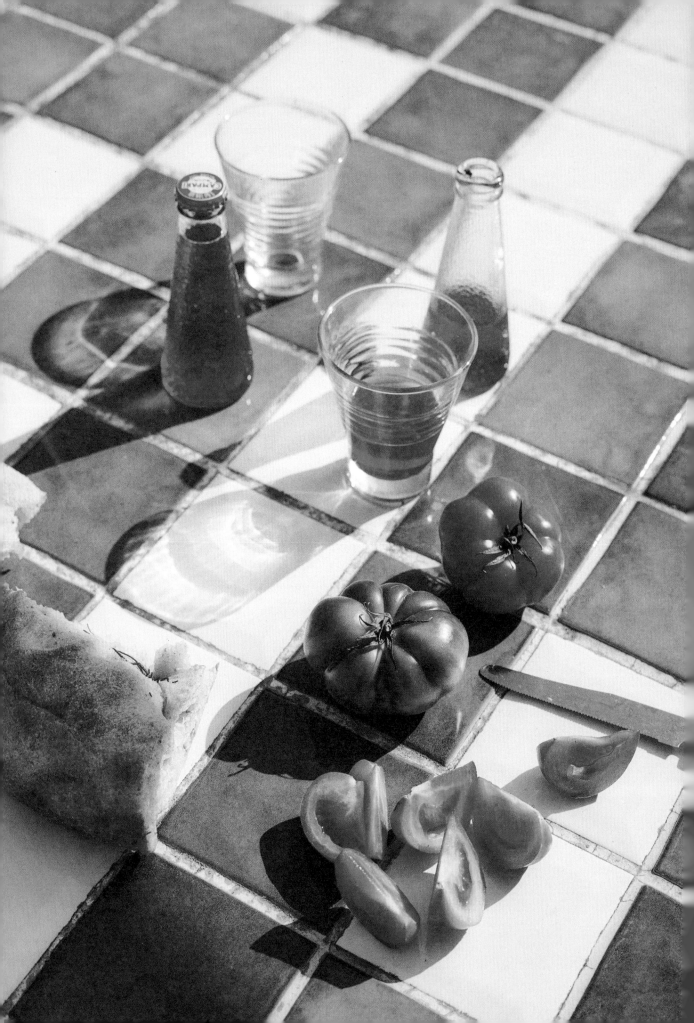

Most Italians visiting Ponza arrive from either Naples or Rome. From Naples, take the train to Formia and then the ferry. From Rome, board the train to Anzio or Formia and then the ferry. The crossing from Anzio will last just over an hour, while the crossing from Formia takes two and a half hours. A direct ferry from Naples to Ponza runs a few times a week; other ferries depart from Terracina and San Felice Circeo.

Rent a boat and duck in and out of the island's coves or travel to the smaller island of Palmarola. If you're lucky, the *barchino dei gelati* (ice cream boat) will catch you on the way. Alternatively, take a dip in the sheltered Piscine Naturali where you can rent sun beds and parasols. In the early evening, stop by the colorful harbor for aperitivo. Don't worry if you can't get a seat: the harbor wall is the best seat in the house.

Hotel Chiaia di Luna is head and shoulders above the other high-end hotels on the island. Its vast terraces are particularly spectacular in early summer when the bougainvillea is in bloom. Alternatively, there are several tastefully designed guesthouses. Villa Laetitia, owned by fashion royalty Anna Fendi, is a Bourbon-era building at the foot of Monte Guardia, renovated with Neapolitan tiles and antiques.

Between 1922 and 1943, when Italy was subjected to fascist rule, Ponza served as a prison for high-profile political opponents including Ras Imru Haile Selassie, a cousin of Ethiopian emperor Haile Selassie. After he fell from power in 1943, Benito Mussolini himself was also imprisoned here, although only for a couple of weeks—he was moved to Sardinia to keep his location secret from Germany.

Ristorante Eéa (Ponza is thought to be cited as Eéa in Homer's *Odyssey*) or at Gennarino a Mare, where the dining terrace is built right into the waters along the shore. For dinner with "vistas of faraway horizons," where the sea and sky can be appreciated in vast expanses, Di Fabio suggests the westward-facing Tramonto ("sunset") restaurant, situated high above the hills in the exact center of the island.

The artist also recommends visiting other regions on the island, engaging with the traditional atmosphere of its smaller towns. "If you want to experience Italy as it was in the 1950s and '60s, you have to go to Le Forna," he says of the area at the island's northern tip. Here he suggests Ristorante Punta Incenso, or Da Igino—"the absolute top, with fish served roasted or salt-baked that comes directly from the fishermen working in the Cala Fonte bay there." Di Fabio always stops to appreciate the view of the fishermen's old wooden boats sheltered by the dramatic rocks curving around the cove. Nearby, he likes to swim at the Cala Gaetano, a crystalline inlet with a rocky shore surrounded by prickly pears and blackberry brambles. It

can be reached only by the ambitious—the steep climb counts over three hundred stairs—but it keeps the beach uncrowded. At one of the few sandy beaches on the island, Cala Feola, the Ristorante La Marina is "unmissable," as are the natural pools that have formed along the shoreline. Di Fabio also makes the journey to Bar Zanzibar to enjoy a drink by the pebble beach of Santa Maria, encircled by the town's colorful houses.

At Frontone, a sandy cove surrounded by small verdant cliffs, Di Fabio likes to dine and stargaze at Da Enzo, where tables are set out on the rocks by the water—the owner transports guests to their table in a rowboat. In the daytime, the nearby Ristoro da Gerardo serves its homey dishes in a more rural setting, "a paradise on the hillside with chickens and goats wandering around you," as the artist describes it. The owner has even set up a self-made ethnographic museum in one room, laying out the antique tools and folk art of life in old Ponza, with the scythes and fishing nets they've used to collect their food and models of the boats they've used to sail around these remote waters—all glimpses of an analog time that feels much closer on Ponza's ancient shores.

Gamberi & Capperi—which translates as "shrimps and capers"—is one of the island's most celebrated restaurants, featuring innovative takes on island staples that chef Luigi Nasti delights in preparing directly at the table. From the whitewashed terrace outside, you can look down onto the town of Ponza and, beyond it, the harbor—where the fish on your plate likely came from.

OPPOSITE

Bar Nautilus sits next to the island's Piscine Naturali. These saltwater pools, formed by ancient volcanic activity, are perfect swimming holes— shallow and sheltered from the weather out at sea. The surrounding cliffs are dotted with sun loungers and bar shacks. If the heat gets to be too much, take a plunge off the pontoon slide or dip inside one of the surrounding caves.

Porto di Ponza will be most visitors'
entry point to the island. From here,
you can take a boat out to the tiny,
almost completely uninhabited
island of Palmarola, which features
extraordinary vaulted grottos
set back into high cliffs that you
can swim and snorkel into. Local
fishermen will happily complete the
twenty-minute journey and help you
catch your lunch along the way.

FOLLOWING PAGES, RIGHT
The striking Hotel Chiaia di Luna is
situated next to the beach that lends
it its name. Chiaia di Luna,
which translates to "Half-Moon
Beach," is a thin strip of white sand
surrounded by vertiginous cliffs. The
only land access to the beach—a
tunnel built by the Romans—has
been closed for several years now
due to the high risk of rockfall.
The area must be admired from
afar, either from the water or the
surrounding cliffs.

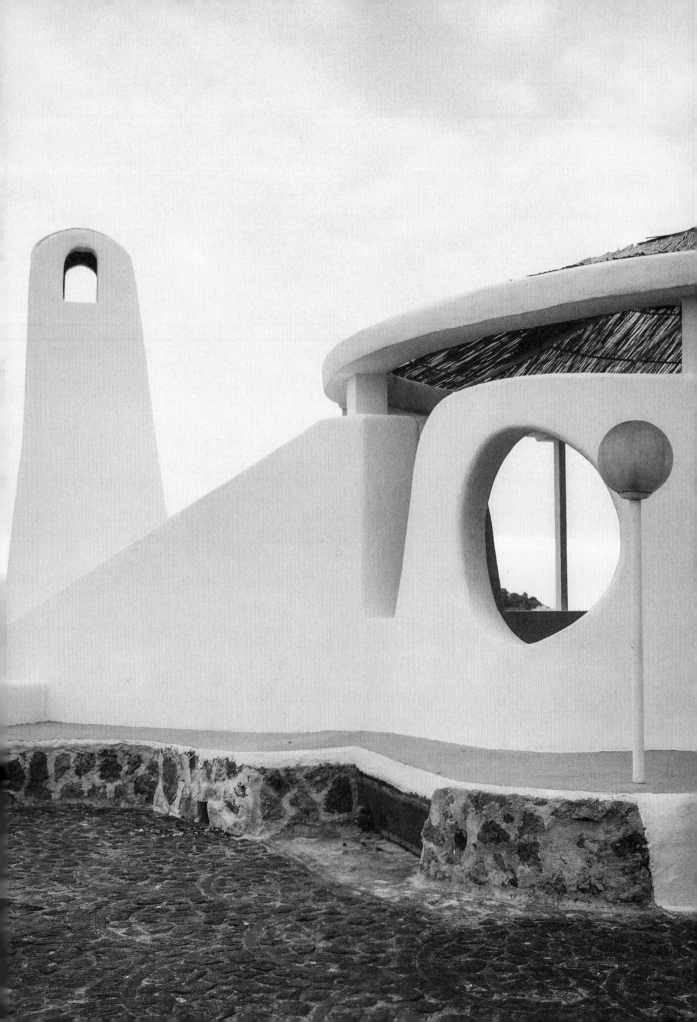

BELOW LEFT

Antonio Balzano, the former mayor of Ponza, outside his pizzeria Tartaruga Pub. Balzano was mayor between 1993 and 2001 and now says he enjoys the job of restaurateur because he's able to talk to people from all over the world. The small restaurant books up quickly, so it is worth making a reservation during the summer season.

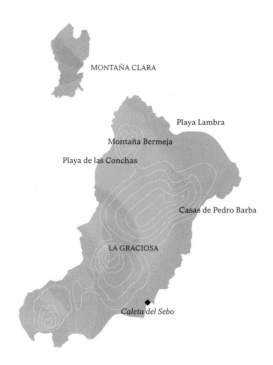

LA GRACIOSA

The last Canary Island

LOCATION	Atlantic Ocean
COORDINATES	129.25° N, 13.50° W
AREA	10 sq. miles (26 sq. km)
POPULATION	730
MAIN TOWN	Caleta del Sebo

La Graciosa is a 10-square-mile (26 sq. km) speck cut adrift in the Atlantic Ocean. Its seven-hundred-odd inhabitants owe nothing to the wider world. Theirs is an island where herons perch on boats, cats sleep on quays and dinner is fish, every night. In February, the weather is fiery. In September, it's scorching. There's no rainy season and no "tourist season." Time is marked by the ferry that chugs over from Lanzarote; there are just a few crossings each day.

Many islands develop a mode of transport dictated by society and topography. On the Caribbean island of Mustique, gas-powered golf buggies convey the jet set. On Sark, in Britain's Channel Islands, transport is horse and cart. Boipeba, off the coast of Brazil, is sandier, so carts are pulled by tractors. La Graciosa, for its part, has a fleet of vintage Land Rover Defenders. All are painted white to block the searing sun and are essential for an island tour.

There's no asphalt on La Graciosa, so the handful of daily visitors drive down sandy tracks toward the beaches. Bupleurum flowers grow in the dust and balsam spurge spreads wherever it finds morning dew, holding its moisture tight for the rest of the day. Out in the ocean, the red rock island of Montaña Clara—now an uninhabited nature reserve—glows atop an indigo Atlantic.

For the most part, visitors must make their own fun. Bird spotters, desert hikers and naturists will find that there is little to no signposting of the island's attractions. For surfers, however, the draw is simple: at Playa de las Conchas, waves curl with the languid regularity of a washing machine set to delicates, and shade is provided by a shipwrecked fishing boat.

La Graciosa's sole settlement is Caleta del Sebo. From here the sun sets over the far larger Canary Island of Lanzarote, which is separated from La Graciosa by a surging ½-mile (0.8 km) strait. This waterway is known as El Rio: the river. The two banks used to feel like they belonged to different centuries, but the gap is narrowing.

Carmen Dolores, who runs a local guesthouse, recalls the quality of life being quite different from the standard on the island today. "It was a very hard childhood on La Graciosa," she explains. "My father went to the African coasts and came home every three months." He cast his rod for bluefin tuna off Cabo

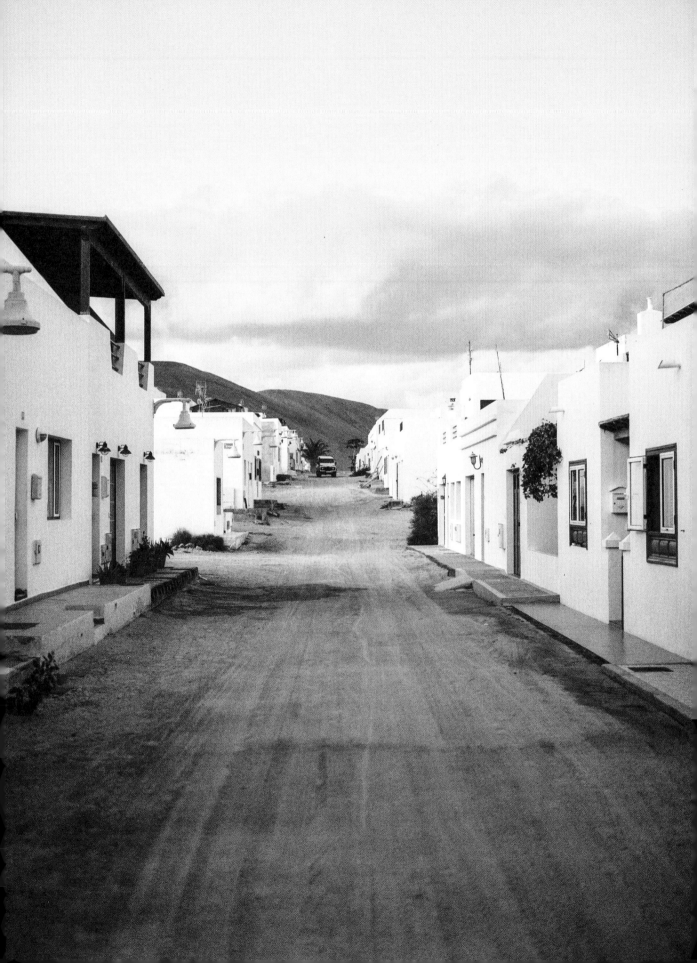

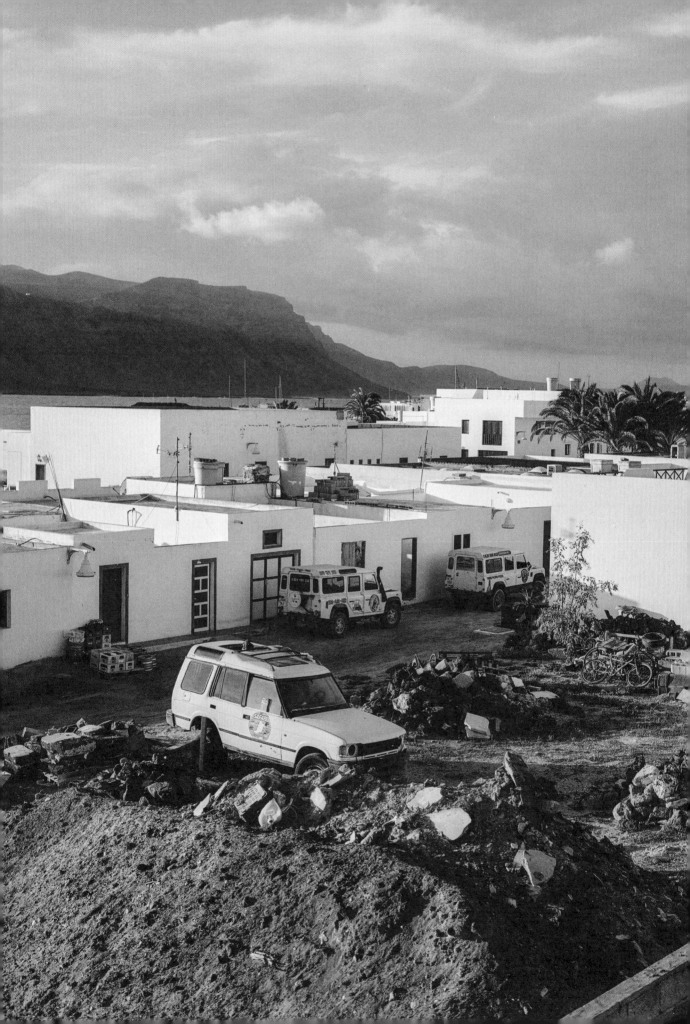

Biosfera Express operates the thirty-minute ferries that navigate La Rio several times each day. Land Rover taxis will take travelers to La Graciosa's three main beaches: Playa de las Conchas, Playa Lambra and Playa de Pedro Barba. The island is a ninety-minute walk from north to south.

Climb Montaña Bermeja near Playa de las Conchas for epic island views. Share a parrillada seafood grill at Restaurante El Mesón La Graciosa—the only non-fish order is salad. Hike from the ferry terminal at Caleta del Sebo to Playa de las Conchas beach and try scuba diving. Enjoy a sundowner at Bar El Saladero.

There are a handful of guesthouses in Caleta del Sebo, plus a host of simple rental properties. None is more than a few minutes' walk from the petite ferry port. Casa Carmen Dolores is a smart three-bedroom property with a barbecue out front (you can purchase a fish fresh from the pescadería).

In 2018, La Graciosa had its moment in the spotlight. Thanks to a citizen movement, it was officially declared the eighth Canary Island (rather than an islet administratively dependent on its bigger neighbor), joining Tenerife, Lanzarote, Gran Canaria. Its seven hundred residents partied into the night.

Blanco, a former Spanish fishing ground. "We barely had enough to eat," recalls Dolores.

Enriqueta Romero, who is now in her eighties, used to be dropped off on the "other side" by her father. As a girl, she would carry 65 pounds (29 kg) of fish in a basket on her head, up Lanzarote's sheer cliffs. The fish would be traded for potatoes, tomatoes and gofio, a Canary Islands flour made from starchy grains like rye and chickpeas. Romero would slide her purchases back down the cliff, then light a fire. Her smoke signals would alert her father that it was time to pick her up.

Today Romero and her family run a guesthouse and restaurant on La Graciosa. Dinner is octopus prepared four ways, squid prepared two ways, seafood paella, or—for the unadventurous—filete de pescado. The hotel is sited on Calle las Sirenas, a street named after the sirens who lured sailors to their rocky idyll. Other streets include Calle el Arpón (Harpoon Street) and Calle Hélice (Propeller Street). Spend a night on the island and you'll be welcomed like a local. Stay a week and you can help fishermen mend their nets.

A Land Rover Defender can take you to La Graciosa's ultimate reaches, like Playa Lambra, where you're almost guaranteed a beach to yourself, or Playa de Pedro Barba, a curving swoosh where endless sand is backed by whitewashed houses.

Yet for today's tourists, says island guide Miguel Ferrer, an empty beach just isn't enough. Ferrer has branched out from bike hire to offer fishing trips and scuba dives, guiding tourists on where to spot angel sharks and lobsters.

Ferrer has no fear for tomorrow. Time may slip, ferries might sail, but the new dawn on the island will be much like today. He is content here. "We have one pharmacy, one bakery, one church. What more do you want?" he says.

When the simple life all gets too much, Ferrer and his friends sail out to Montaña Clara island to grill sardines. It's like La Graciosa, before the people came.

Tourist Brigitte Rabus, like many Northern Europeans, visits the Canary Islands during winter, when the weather is guaranteed to be warm. Thanks to a subtropical climate, the islands feature more than three hundred days of sunshine annually, with average temperatures during the winter months of around 68°F (20°C). Rabus, visiting La Graciosa for the first time, extended her stay as soon as she arrived.

La Graciosa has no asphalted roads, which means all vehicles on the island must be authorized and geared for off-road driving. It is not possible to rent a car; the only way to tour the island is to hire a four-wheel-drive taxi. Alternatively, you can bike (there are plenty of rental shops) or walk.

OPPOSITE
White dominates the built landscape on La Graciosa, working as a mirror to reflect the sun's rays and keep home interiors cool. Traditionally, most houses were built using the island's volcanic stone with a technique similar to drystone walls; some stones are left exposed and unrendered to allow the wall to "breathe" during the winter, to avoid dampness.

FOLLOWING PAGES, RIGHT
Playa de las Conchas, the island's most popular beach, is around 3½ miles (6 km) from Caleta del Sebo. The sand stretches for almost 2,000 feet (600 m) at the foothills of Montaña Bermeja, the island's highest peak. A red flag means the current is too dangerous for bathing; the strong tides in the immense Atlantic Ocean often make swimming impossible on the north of the island.

KINALIADA

HEYBELIADA

BURGAZADA

Büyükada Pier

BÜYÜKADA

SEDEF

BÜYÜKADA

The crown jewel of the Princes' Islands

LOCATION	Sea of Marmara
COORDINATES	40.85° N, 29.11° E
LENGTH	2 sq. miles (5.4 sq. km)
POPULATION	7,499

When boarding the ferry to the Princes' Islands, you have a choice to make: either opt for the front seats facing the open sea, or sit at the back and watch Istanbul recede behind you. This journey is the beginning of a restorative day trip, and it can be satisfying to watch the concrete havoc of the city shrink to the horizon line. Ahead of you are nine green and hilly islands in the Sea of Marmara, often referred to by locals simply as Adalar ("the Islands").

Another decision is your destination, which must be chosen wisely. Büyükada, the largest island, heaves with tourists in summer but is pleasantly quiet from September until May. In fall, when the ferry docks at Büyükada's original nineteenth-century iskele (pier), the island is usually quiet; its 7,499 residents go about their daily business, not paying any mind to who gets on or off the boat. In these colder months, the seafood restaurants on the pier are almost empty and one can rent a bike or enjoy a stroll along Yirmiüç Nisan Avenue, which runs along the seafront. Büyükada is also beautiful on a gray fall or winter's day, when it is steeped in the kind of sweet melancholy that the Nobel Prize–winning author Orhan Pamuk, who has been known

to spend summers on the nearby island of Heybeliada, likes to write about.

If the summer season can't be avoided, escape to one of the smaller islands. Hike up to the Halki Seminary and its beautiful sea-view-blessed garden on Heybeliada; visit the former home (now museum) of the late Sait Faik Abasıyanık, one of Turkey's greatest short story writers, on Burgazada; or while away time at Jash, a classic Istanbul tavern, which now has two venues on the island of Kınalıada.

Once a place of exile for Byzantine royalty and, later, members of the Ottoman sultan's family, the Princes' Islands eventually transformed into a playground for the wealthy during the late nineteenth century. Timber resort houses, known locally as kosk, were fashioned in over-the-top style by Istanbul's wealthy Greek, Armenian and Jewish residents looking to escape the narrow streets of Pera and Galata for their summer breaks. Not much has changed since. On Büyükada, take your time walking down Çankaya and Nizam Avenues to examine some renovated examples of these neoclassical wooden mansions and their elaborate late baroque, rococo and art nouveau ornamentation.

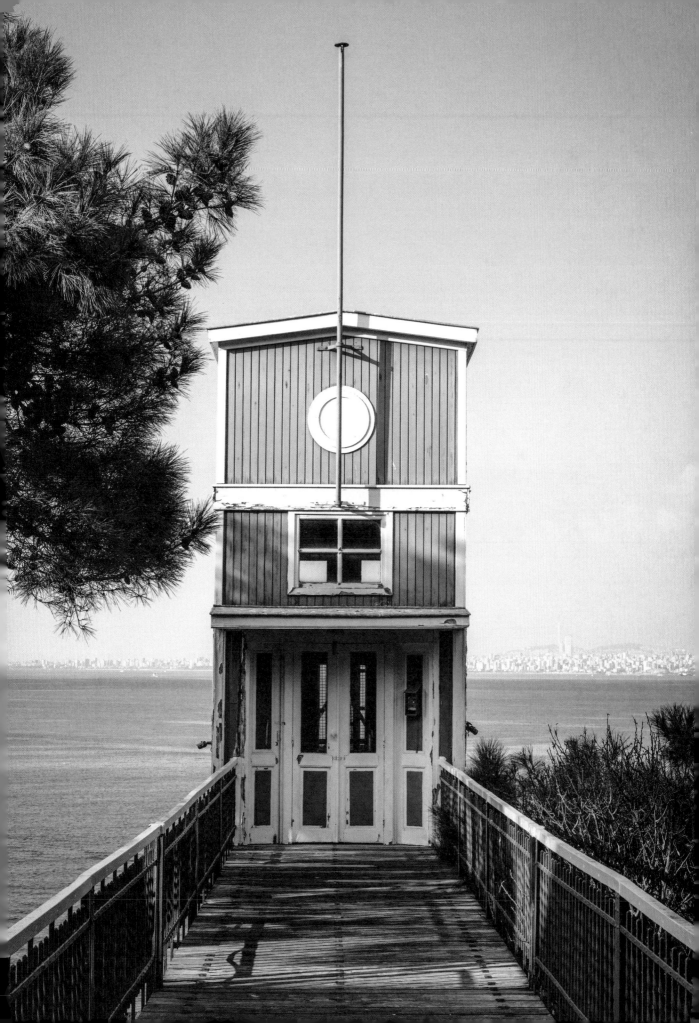

GETTING THERE

Mavi Marmara offers regular boat service to the islands from various ferry terminals in Istanbul, as does the Şehir Hatları Vapur service. Times vary depending on the seasons so check the schedules online; there are no private shuttle boats between the islands. Tour the islands using electric carts; you'll need to pay for these using an Istanbul Card (Akbil).

SEE & TOUR

Stop by Büyükada Pastanesi, a popular bakery and patisserie, to try one of Hüseyin Bey's classic sweet and savory pastries. Hike up to Büyükada's fire observation tower for a great view of neighboring Heybeliada and its highlight: the Halki Seminary, a former Greek Orthodox theology school. Admire the modernist architecture of the Anadolu Kulübü.

STAY

Airbnb rentals and rooms in boutique hotels are available on the island. A definite standout is the Splendid Palace Hotel near the port—an art nouveau beauty with silver domes, red window shutters and marble floors harking back to the island's more elegant past. Guests receive a full Turkish breakfast: half a dozen kinds of cheese, bread and jam and an omelet.

WORTH KNOWING

Leon Trotsky lived in exile on Büyükada between 1929 and 1933. While taking breaks from writing *History of the Russian Revolution*, it is said that he would row around the island's coves with a Greek fisherman, accompanied by bodyguards. An amateur naturalist, he identified a species of red rockfish in the Marmara waters that he named *Sebastes leninii*.

A brief detour down Hamlacı Street leads to the remnants of a redbrick mansion where communist revolutionary Leon Trotsky spent his days in exile between 1929 and 1933, working on his autobiography and the two-volume *History of the Russian Revolution* before France offered him asylum.

Away from the grand manors and up the ascending walkway on Asıklar Yolu Street (Lovers' Path), a thick pine forest begins to emerge, with sudden slices of sea bursting from between the branches. Sometimes, the retired horses that used to pull the island's decorated phaetons (carriages) can be seen roaming free. (The island's traditional horse and carriages were banned in 2020 due to animal rights protests and have been replaced with electric public transportation carts.) It is also up here that Prinkipo Palace—an abandoned Greek orphanage and one of Europe's largest wooden structures—sits in a forest clearing. The building is nearing collapse and decidedly spooky. Entering is prohibited, but it is worth a peek from behind the demarcations.

A visit to the Museum of the Princes' Islands is worth a visit for those looking to learn more about the islands' history. The permanent exhibition displays a visual and rich multicultural story through daily objects from islanders past and present, Ottoman archival documents and old photographs and films. All in all, the museum covers a period from ranging from prehistory to the present day.

At the end of the almost fifty-minute circular walk—starting at Büyükada Pier, alongside the grand mansions and back through the pine forest—awaits a glass of rakı (anise-flavored spirit) enjoyed with one of the best views the island can bestow. Ask for a table by the window at Eskibağ Teras, a simple restaurant set among the olive trees and bougainvillea bushes. It's open year-round and serves meze and grilled fish and meat—the kind of food that islanders have been clinking rakı glasses over for centuries, whether in their sprawling kosk gardens or at a simple wooden table, watching the sun set over the open sea.

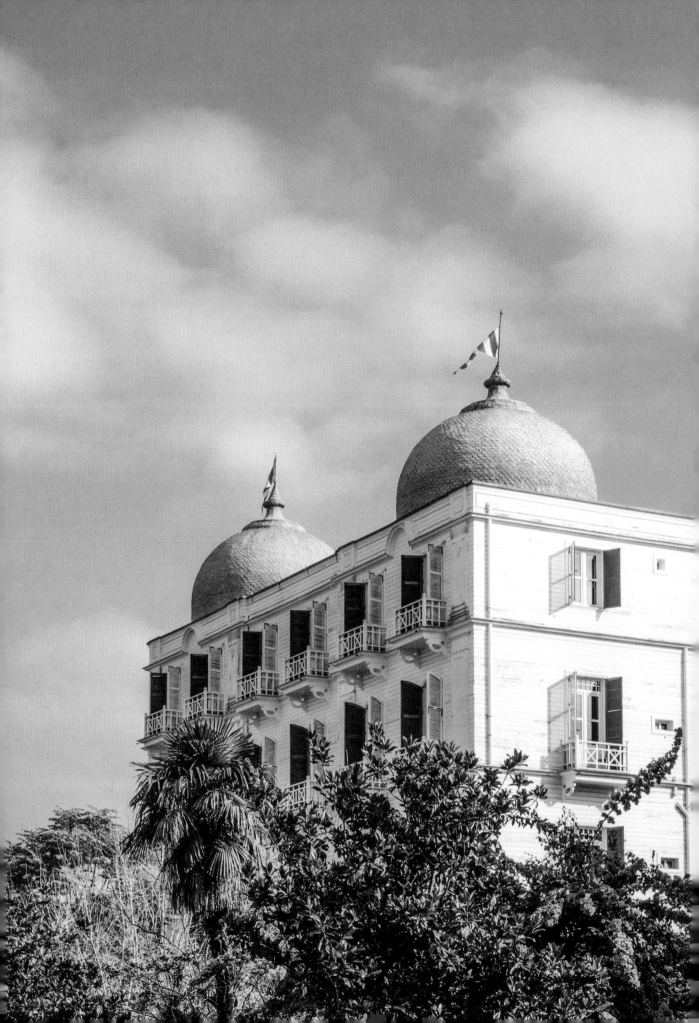

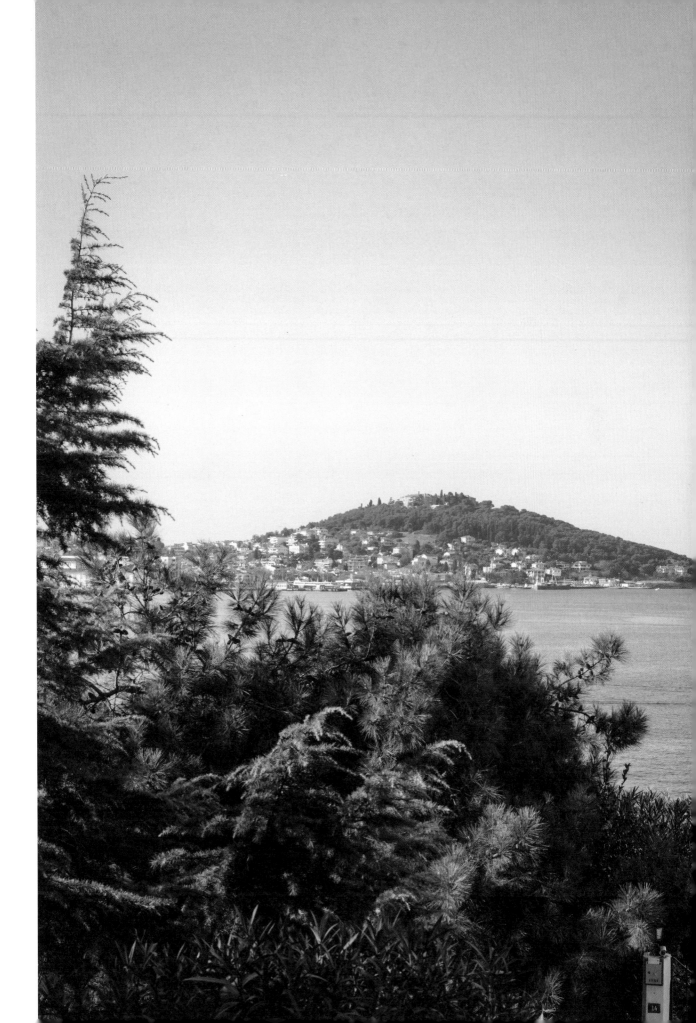

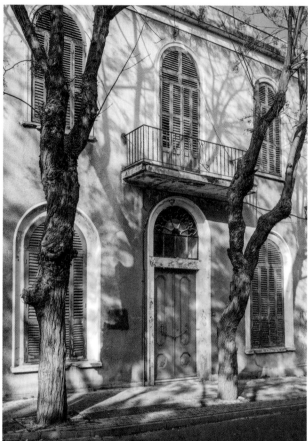

ABOVE LEFT

A table at the water's edge in Büyükada Loc'Ada restaurant on Yılmaztürk Avenue. The restaurant, which adjoins a hotel of the same name, serves seafood and offers views over the neighboring island of Sedef. Most restaurants on Büyükada serve Turkish meze such as grilled octopus, white bean salad and roasted eggplant. Choose your own fish to be grilled as a main course, and order a glass of local raki to accompany the meal.

OPPOSITE

Built in 1908, Splendid Palace Hotel on Büyükada has a faded Edwardian elegance—all art nouveau grandeur, crimson awnings and Ottoman-esque domes—that would not look out of place in a Wes Anderson movie. Today the hotel is managed by the sixth generation of the founding family. The building has been granted national monument status by the Turkish Ministry of Culture.

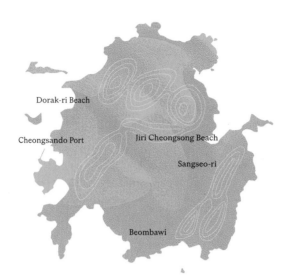

Dorak-ri Beach

Cheongsando Port

Jiri Cheongsong Beach

Sangseo-ri

Beombawi

CHEONGSANDO

A slow walk through Korea's countryside

LOCATION	Korea Strait
COORDINATES	34.18° N, 126.88° E
AREA	12 sq. miles (33 sq. km)
POPULATION	2,182

On the small island of Cheongsando, located off the southern coast of South Korea, residents live under the legend of a disobedient tiger.

According to myth, the tiger, acting on the command of a Taoist hermit, gathered up ten spirits to go to Cheongsando. They numbered as follows: the sun, the moon, the mountains, water, stones, pine trees, deer, cranes, turtles and, finally, a mythical herb for immortality. On this island, where sacred energies abounded, the spirits would live eternally. But sometime during his mission, the tiger grew angry that he himself was not among the chosen spirits. Giving in to his jealousy, the tiger harmed the deer and traveled to Cheongsando in its place. The hermit was furious and banished the tiger from the island, telling him that if he did not flee before the moonlight shone on the sea, he would turn into stone. The tiger was reluctant to leave. Visitors to Beombawi, or "Tiger Rock," on the southern tip of the island might, upon close inspection, notice a certain familiar feline frozen in the rock's outline.

Today life is slow on the island, so much so that it has earned official recognition for the leisureliness of its ways. In 2007,

Cheongsando was designated as an official slow city—the first of its kind in Asia—by Cittaslow, an Italian organization inspired by the slow food movement. Cittaslow's goals include improving the quality of life in towns by slowing down their overall pace, and it's easy to see why Cheongsando made the cut: the landscape stretches out like a blue-green watercolor painting of sky, mountains and fields. Here fishing and farming shape everyday life. Tiny villages dot the coastline and nestle in the valleys.

Though a short fifty-minute ferry ride from the mainland-connected island of Wando (boats run six times a day in winter, more frequently in summer), Cheongsando feels a world apart. A speck in the sea—it takes less than fifteen minutes to drive from one end to the other—the island is home to just over two thousand residents.

Visitors from hyperactive Seoul, removed from the capital's densely packed entertainment districts and shopping venues, might initially eye Cheongsando's relative lack of "things to do" as cause for concern. Beyond the island's famed TV and movie filming locations, there are few flashy attractions. But Cheongsando reveals itself to those who meander, rewarding

GETTING THERE

From Seoul's Central City Terminal, take a five-hour bus to Wando Terminal, then a five-minute taxi to Wando Port. From there, ride the ferry to Cheongsando Port, where most of the island's markets and restaurants are clustered. Explore by foot or taxi (or bus, which does run, but infrequently).

SEE & TOUR

At 1,263 feet (385 m) above sea level, Maebongsan is Cheongsando's tallest peak and presents a pleasant and easy two-hour hike. Hwarangpo Observatory (near Course One) is a popular panoramic spot. For food and drink, try hoe (pronounced "hwey"), Korean raw fish, at the He & She truck parked at Sinheung Beach.

STAY

Most Cheongsando accommodations are hanok-style pensions. While pensions can be found throughout the island, some of the most picturesque hanok-style accommodation is just south of the port in the village of Dorak-ri, which also makes for a good strategic base. Cheongsan Hanok Pension is highly recommended.

WORTH KNOWING

Translating to "blue mountain island," Cheongsando is known as a place of enigma and intrigue. So powerful are its spirits, lore has it, that they form a Bermuda Triangle–esque effect in the waters near Beombawi, where magnetic forces are rumored to cause compasses to malfunction.

the unhurried and unfussed visitor. And while travelers can bring a car with them by ferry, they might consider forgoing four wheels. The Cittaslow ethos is that a place becomes more beautiful when it is experienced slowly.

Travelers may stroll the 26-mile (42 km) Slow Road, a network of eleven routes that follow Cheongsando's coastline and cut inland across the island's fields. Adapted from the original transportation routes residents used to get from village to village, the road officially opened in 2010, and its web of signposted trails was recognized, again by Cittaslow, as one of the world's most beautiful walking vacations.

Casual hikers would be hard-pressed to walk the whole length of the Slow Road in a day, but it's possible to hire a driver to drop you off and pick you up at certain points, depending on your preferences for beaches or villages, for memorials of the past or testaments to life here and now. Heading counterclockwise from Cheongsando Port on the west side of the island, Course One traverses Dorak-ri Beach and the filming sites for the Korean drama *Spring Waltz* and the movie *Seopyeonje*, while Courses Two, Three and Four pass by tranquil parks, an old fortress and Bronze Age tombs. Course Five leads to Tiger Rock, where visitors might hear the whistling wind that locals say sounds like the cries of a tiger.

At Course Six, the Slow Road's only completely inland trail, Cheongsando's unique rice fields, *gudeuljangnon*, gradually unfurl.

Classified as a part of Korea's national agricultural heritage, *gudeuljangnon* are terraced rice paddies built with stone walls, designed to work with the island's naturally unfavorable farming environment of steep slopes and excessive drainage. This part of the trail also takes walkers through Sangseo-ri, a Joseon-era village where stone walls line the roads and wind around homes.

Continuing through Sangseo-ri, Course Seven crosses the white sands of Sinheung Beach, while Courses Eight and Nine lead walkers down Sunrise Road (named for its perfect view at dawn), then along the foliage-filled Maple Road (most striking, of course, in fall). Finally, Courses Ten and Eleven open onto Jiri Cheongsong Beach before reaching the narrow alleyways of the provincial port village and connecting back to the route's beginning.

Along the way, travelers can refuel at one of the seafood restaurants run by the island's female divers, *haenyeo*— Cheongsando is famous for fresh abalone—or at a seaside café or stone-wall teahouse. For an overnight stay, check in at a hanok-style pension, a traditional Korean home that welcomes guests.

While the island might be most stunning in spring, when the bright yellow canola and rapeseed flowers are in full bloom, it is lovely—and accessible—year-round. Even winter has its charms, when Cheongsando feels particularly quiet and serene. Visitors should take time to linger. There is no need to worry about overstaying one's welcome and turning into stone.

BELOW

Fresh eggs at a homestay in Cheongsando. Bo-kyung Lee, the owner (pictured on page 219), moved to the island twenty years ago from the mainland to begin a new life for herself at a slower pace. She spends her days raising chickens and making pastries with their eggs, along with growing her own vegetables and gardening for pleasure.

OPPOSITE

Hanoks, the tile-roofed residences seen on Cheongsando and throughout Korea, feature traditional architectural elements. The homestay pictured opposite belongs to Jong-chae Oh and Myung-im Kim, a couple who were both born on the island, and features doors screened with changhoji (paper made from mulberry bark).

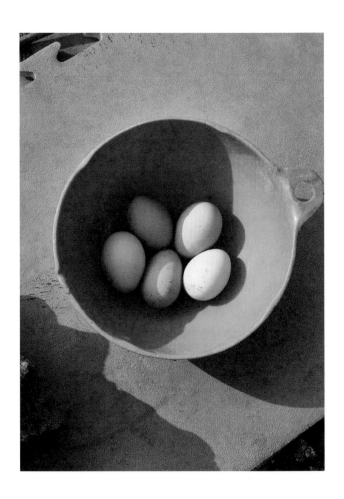

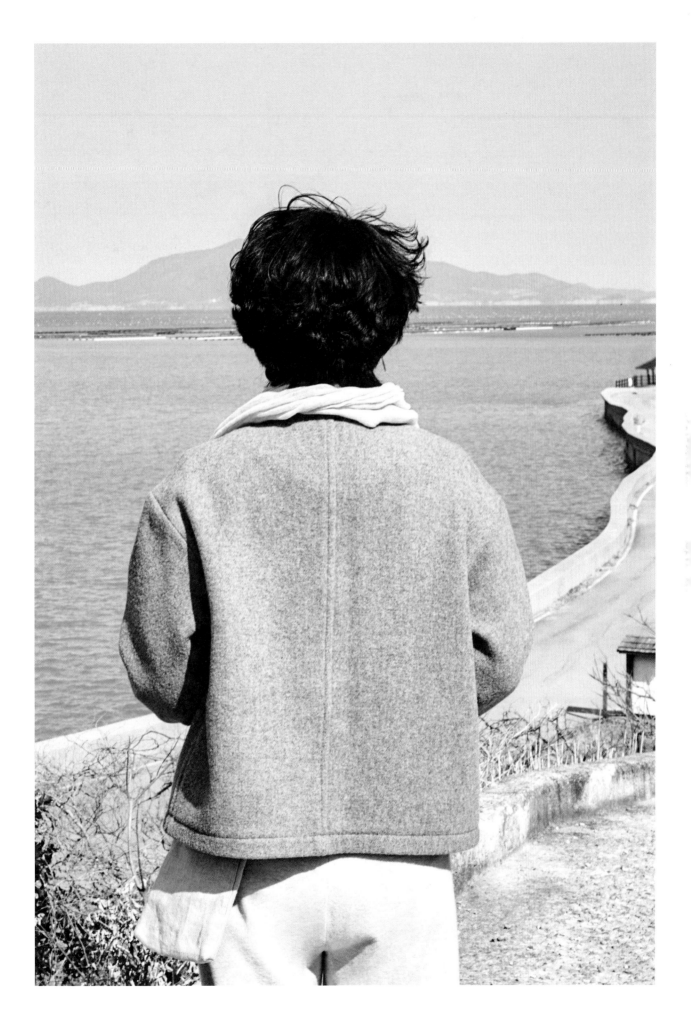

JURMO & UTÖ
A ferry to Finland's farthest reaches

LOCATION	Baltic Sea
COORDINATES	59.82° N, 21.60° E
AREA	2 sq. miles (5 sq. km)
POPULATION	52

Imagine a triangle in the middle of the Baltic Sea, its corners stretching to Turku, Tallinn and Stockholm. Right in the middle, there's a scattering of islands. Here, on Finland's southernmost archipelago, you'll find Jurmo and Utö.

"I always recommend that people watch the passing of the islands from the sun deck of the ferry when they travel here," says Hanna Kovanen, a second-generation islander who runs a guesthouse on Utö. "It's worth it even in the middle of the night. You move slowly enough that you can adjust to the changing scenery."

The adjustment is needed because life is lived differently on the outer rim of this isolated archipelago. The larger islands just off the coast of Turku are densely forested but become rockier the farther from the mainland you sail. By the time you get to Jurmo and Utö, the landmasses are small, weather-beaten and barren.

Jurmo (not to be confused with an island of the same name in the Åland Islands) boasts twelve year-round residents. Here little red buildings sit on rocky ground and alpacas graze the sweet nubby wildflower shoots growing between the pebbles.

The inhabitants of the island's one tiny hamlet are dwarfed by the number of rare migrating birds that visit the nature reserve at the north of the island each year.

There's a harshness to the landscape, which is part of the Salpausselkä ice age ridge, but a strange beauty to it too. In 2011, Aino-Maija Metsola, the lead artist for Finnish design brand Marimekko, was inspired to create a print named after the island featuring bold and imperfect circles that mimicked its boulders and pebbles. She called it one of the most magnificent places she has ever visited.

Utö, which means "outer island" in Swedish (the most-spoken language in the archipelago), is a forty-minute ferry ride onward from Jurmo. While this 200-acre (81 ha) island could feel like a forgotten frontier, it's home to a well-resourced community of some forty people. There is a school, lighthouse and cobblestone streets with streetlights. The internet is broadband. Here business runs in line with the timetable of the near-daily ferry that brings in supplies and visitors.

Retreating into the wilderness is a Finnish habit; slow living and treading gently on the ground come as second nature

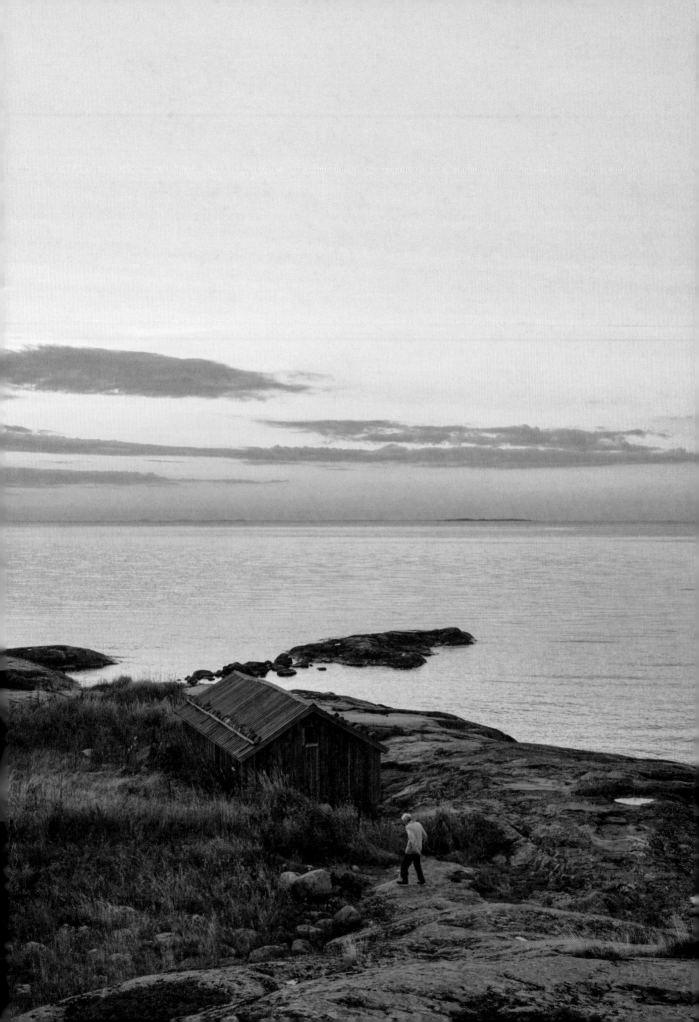

Take a coach from Turku to Pärnäs in Nagu, an island connected by roads and bridges to the mainland. Then take the free ferry to Utö via Jurmo (approximately three and a half hours); island hopping requires a bit of organizing. Ferries stop at the main islands and make request stops at smaller harbors. Cyclists pay just a few euros.

On Jurmo, don't miss the free-range alpacas, which are raised for their wool. A pleasant walk will take you to the munkringar, four stone circles in the eastern part of the island with mysterious origins and purpose. On Utö, walk to the oldest standing lighthouse in Finland, then keep on walking—it's a small island and best discovered on foot.

Options on both islands are extremely limited, so book in advance. The most comfortable choice is Jurmo Inn, with three rooms: one in a tower, one in a cottage and one in the main building. There are also cottages in the village, plus a basic (rocky) campsite. On Utö, consider the Hannas Hariport B and B.

Swedish is a common language on the islands. As a result of colonization during the Middle Ages, Finland gradually became part of Sweden and stayed under its rule for almost seven hundred years. Today, while the majority of Finland's population is familiar with Swedish, it is mostly spoken by those who live on the southern and western coasts.

(a fifth of Finns own a summer cottage where they can get back to nature as often as they like). On Jurmo and Utö, the slow life is the only life and it can be found in small moments: watching the distinctive orange legs of a redshank as it stalks the high tide line on a rocky beach, walking or cycling the hiking trails, or eating a Finnish-style picnic of smoked fish on the beach. Away from the main harbor, quiet walking paths along the coastline are soundtracked by the wind, the waves and calling birds. Many Finns travel here just to see the sun set into the ocean.

Winter brings storms that can halt the ferry and cut the islands off for days at a time. The waters in the inland areas of the archipelago freeze until early spring. At its edges—in Jurmo and Utö—the ice melts away first. Spring brings the first migratory birds, along with hardy bird-watchers, and early summer sees wildflowers in bloom in the meadows and between the stones on both islands.

For maximum tranquility, the period between midsummer and the middle of August—peak Finnish holiday season—is perhaps best avoided (despite Jurmo having only twelve year-round residents, it's estimated that an astonishing twenty thousand people visit annually). By late August, the harbors are emptied of day-tripping yachts but the water is still warm and the evenings long; there is no need to turn the lights on at home during the summer.

On the long ferry ride back to civilization, rocky islets slowly give way to occasional broad-leafed trees, then pine forests, and finally the mainland, where car alarms replace the cries of seagulls.

PREVIOUS PAGE
Ask Klas Mattsson, the owner of Jurmo's only shop, about the catch of the day as soon as you arrive on the island; it usually sells out within minutes. Along with supplying fresh fish, berries and vegetables, Mattsson operates a small café, serving warm drinks and freshly baked cinnamon buns.

OPPOSITE
The ferry to Jurmo and Utö departs from Pärnäinen harbor in Nauvo; a one-way trip takes four or five hours, depending on the weather and the number of stops on the way (usually, the islands of Berghamn, Nötö and Aspö).

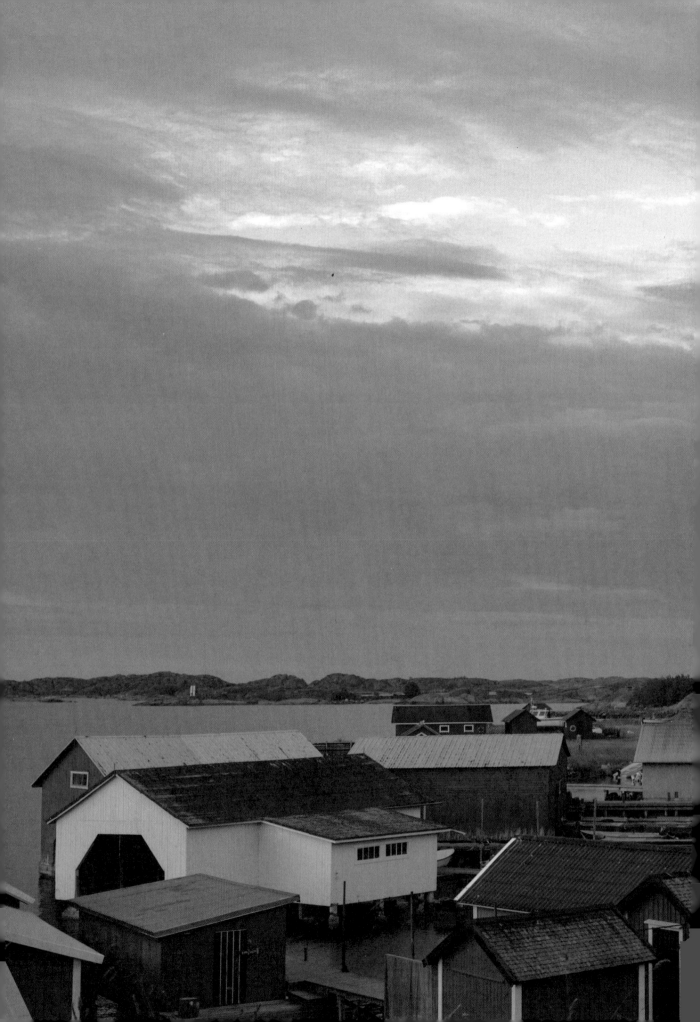

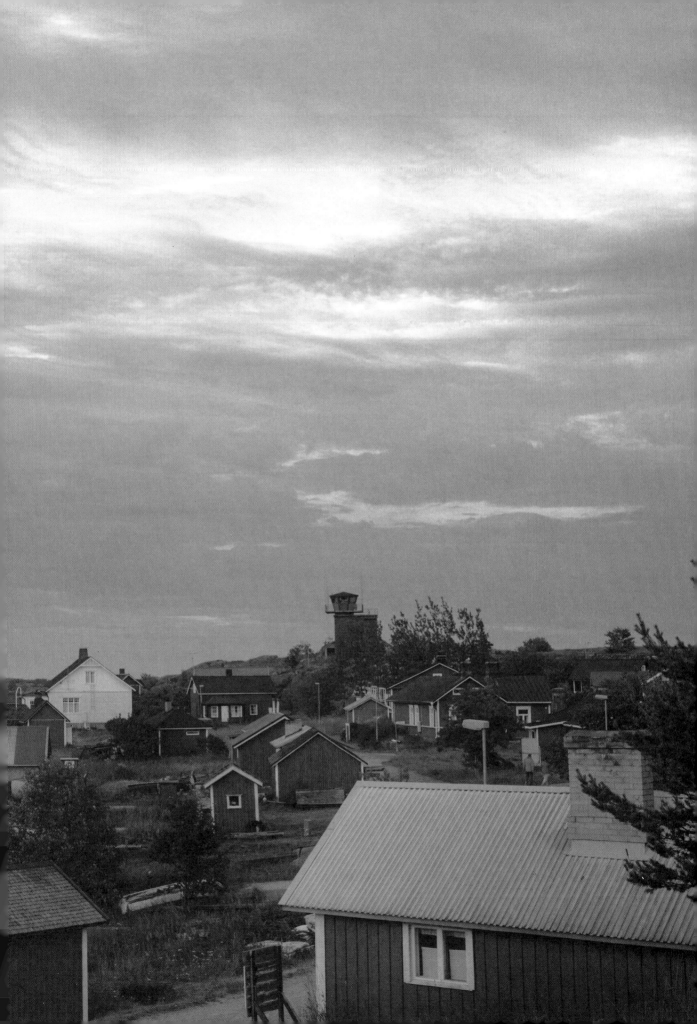

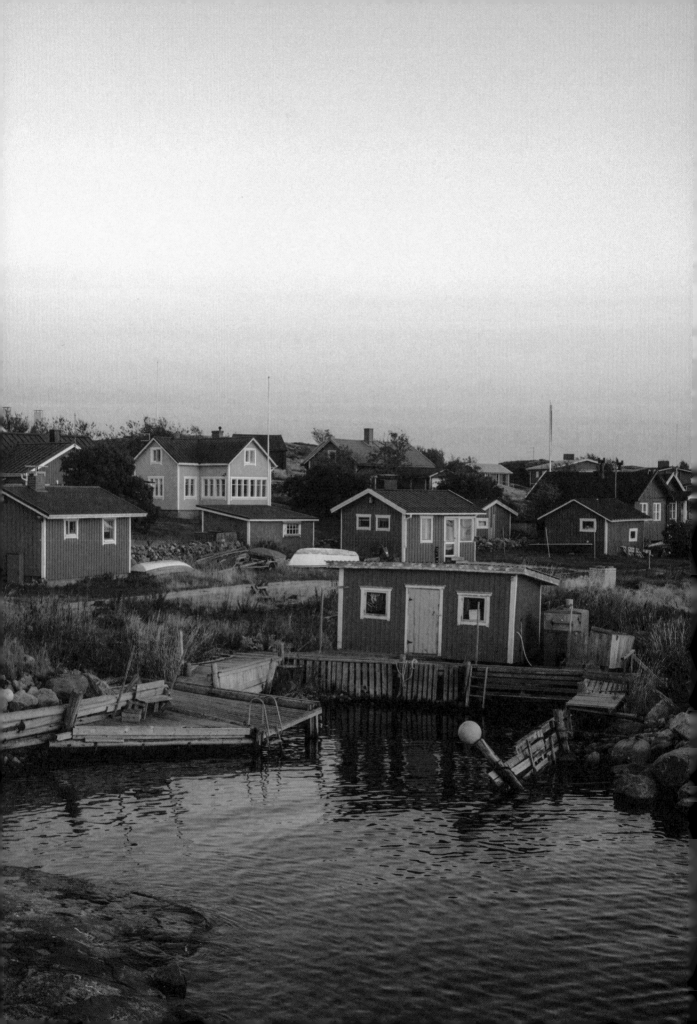

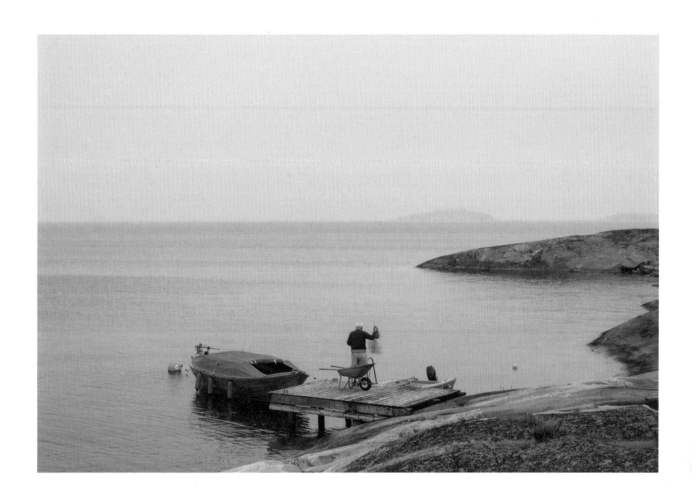

OPPOSITE

The main village on the island of
Jurmo. The island is particularly
beloved by bird-watchers; a total
of 318 species have been spotted
locally. Near the chapel in the
village, a bird observatory is staffed
by volunteers and offers seven
beds, a fridge, a stove and a sauna;
bring your own bedding and food.
Reservations can be made via the
Turku Ornithological Society.

OVERLEAF

The bell tower of the chapel and
cemetery on the island of Jurmo,
founded in 1846. Inside the chapel
are historical artifacts, such as a
fifteenth-a wooden statue of Saint
Anna and a model tall ship, strung
from the ceiling. It's thought that
the earliest church on the island was
built in the twelfth century.

Miyanoura

Shiratani Unsuikyo Ravine

Jōmon Sugi

Yakushima National Park

Anbo

YAKUSHIMA

Into a lost world of old-growth

LOCATION	East China Sea
COORDINATES	30.34° N, 130.51° E
AREA	195 sq. miles (504 sq. km)
POPULATION	13,600
MAIN TOWN	Miyanoura

The mountains begin their irresistible pull as soon as you arrive on Yakushima, a small island on the southern tip of the Japanese archipelago. Wreathed in cloud cover, the towering jade-gray peaks present an impenetrable wall, one guarding some parallel world conjured from the imagination of a fantasy novelist. Venturing within is not for the faint of heart.

The airport, ferry ports and the two-lane road that rings the island are deceptively mundane. This edge world is home to the island's 13,600 people, but Yakushima's real majesty lies at the heart of the island, in its ancient nature. The island is only 15 miles (25 km) across, but it's home to almost two thousand species and subspecies of vegetation, 16 kinds of mammals and 150 types of birds. It is the island's legendary forest and wildlife that make Yakushima one of Japan's premier hiking destinations.

To get to the deep, green heart of Yakushima, on public transport, you must rise before the sun. A bus ride starting at Miyanoura, the main port, will get you to the trailhead, still shrouded in darkness. From there, an abandoned logging railroad leads off into the gloom. At this point, you enter a primeval rain forest, and a realm of ancient *sugi* (cedar-like trees).

Found above 3,900 feet (1,200 m), the sugi are like mighty rivers of wood flowing up from the ground. Seen from a distance, they shine blood-red in the mist. Some are 65 feet (20 m) tall, 26 feet (8 m) around and thousands of years old. Others fell long ago, leaving hollow stumps the size of small houses. These colossal plants populate a world of emerald-colored moss and thick roots webbing over great glistening rocks, all shot through with torrents gushing from the mountains of Miyanoura-dake and Nagata-dake.

"The unique combination of ancient granite, tectonic movement and the water-laden airflow from the equatorial region has created a dense forest here," says Cameron Joyce, a resident guide with Yakushima Experience. "The moss bed that covers much of the forest floor has enabled the multitude of plant and tree species to prosper. It is truly like walking through the set of *Jurassic Park*."

The oldest sugi trees on Yakushima, those over a thousand years old, are known as *yakusugi*. They are *Cryptomeria japonica*, a kind of conifer in the cypress family. Because the abundant water here is pure but poor in nutrients, the cedars grow slowly

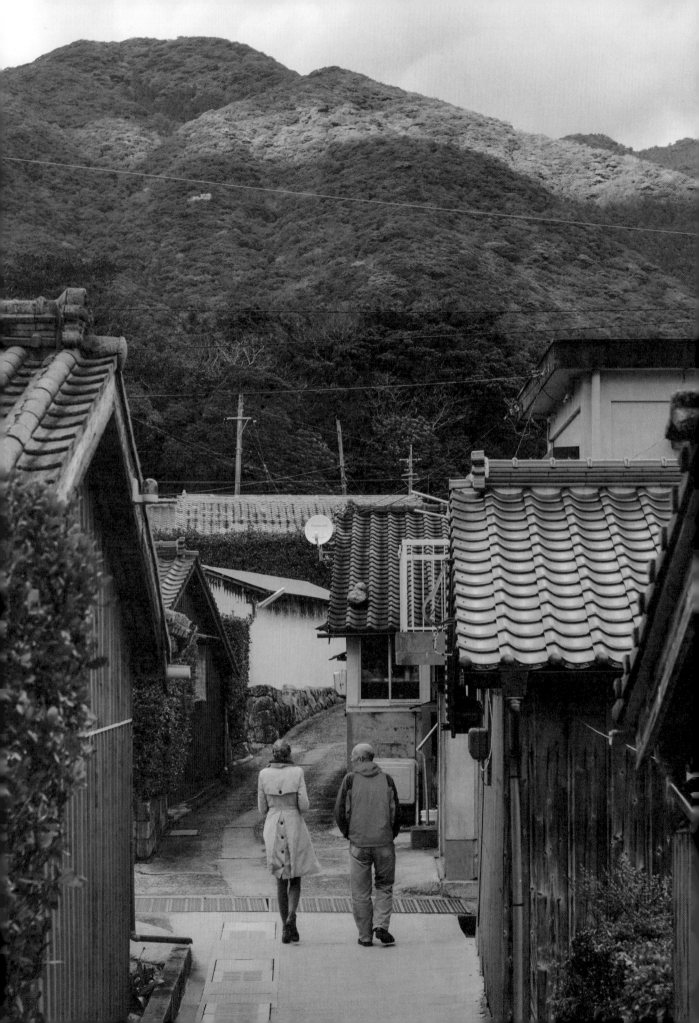

GETTING THERE

Although there are ferry services, the quickest way to reach Yakushima is on a Japan Air commuter flight from Osaka, Fukuoka or Kagoshima. To get around the island quickly, rent a car or scooter in Miyanoura, the main link to the rest of Japan.

SEE & TOUR

Yakushima has some fine onsen hot springs, including Hirauchi Kaichu Onsen, a collection of rocky pools on the seafront. Yakushima venison is a tasty, sustainable meat available in restaurants in various forms, including as a ramen topping.

STAY

There are hotels, guesthouses, youth hostels and campsites on Yakushima. It's best to use Miyanoura as a strategic base, but Anbo and other points on the eastern and southern coasts can also serve well. The west coast is wilder, with fewer facilities.

WORTH KNOWING

Yakushima is the wettest place in Japan, and one of the wettest on earth. It's especially soggy during the rainy season in June, when the creeks can become dangerously swollen. The local joke is that it rains thirty-five days a month.

over the granite bedrock. They have a high resin content, making them less susceptible to rot, allowing them to live for centuries (or millennia). In samurai times, timber from Yakushima was prized for its dense grain and oil content, and was used to build Shinto shrines and Buddhist temples. Over half of all yakusugi were felled, but they are now protected as part of Yakushima National Park and the island's UNESCO World Heritage status.

Walking through the rich tapestry of Yakushima's forest can produce an almost electric sensation. Indeed, Yakushima can impart new meaning to *shinrinyoku*, a Japanese ecotherapy term coined in the 1980s that translates as "forest bathing." Said to increase energy and immune strength while melting away stress, shinrinyoku is a way of reconnecting with nature and reawakening the senses; all it takes is slowing down, breathing deeply and using all your senses to soak up the woods. Joyce chooses quieter trails for this, and asks guests to find spots they want to connect with more deeply.

Whatever path one takes, there are many hiking options on Yakushima, from a few hours to full days to multiday island traverses. One of the most popular is the trek to Jōmon Sugi, the oldest of all yakusugi. For an experienced hiker, the route is not particularly arduous—if the weather cooperates. If it doesn't, you may face an eight-hour drenching that feels like marching under a moving showerhead. The journey culminates at Jōmon Sugi, a titan of wood. A staggering 52 feet (16 m) in circumference and more than 82 feet (25 m) high, it towers over the surrounding camphor trees. Estimates of its age range from two thousand to seven thousand years.

If your schedule permits, Yakushima's other attractions are well worth the time. With a rented car or scooter, you can zip out to the relatively untamed west coast and see Ohko-no-taki, a 288-foot (88 m) magnificent double waterfall surrounded by lush greenery. On the way, you may encounter some of the island's unique fauna: the Yakushima macaque, a more compact, hairier subspecies of the Japanese macaque; and Yakushima deer, also smaller than the sika deer found on larger islands. On the way back to the port, a dip in the coastal hot springs, including seawater pools, is almost as invigorating as traversing the interior rain forest. Here you can watch the sun go down over the East China Sea, providing you can turn your back on this enchanted island.

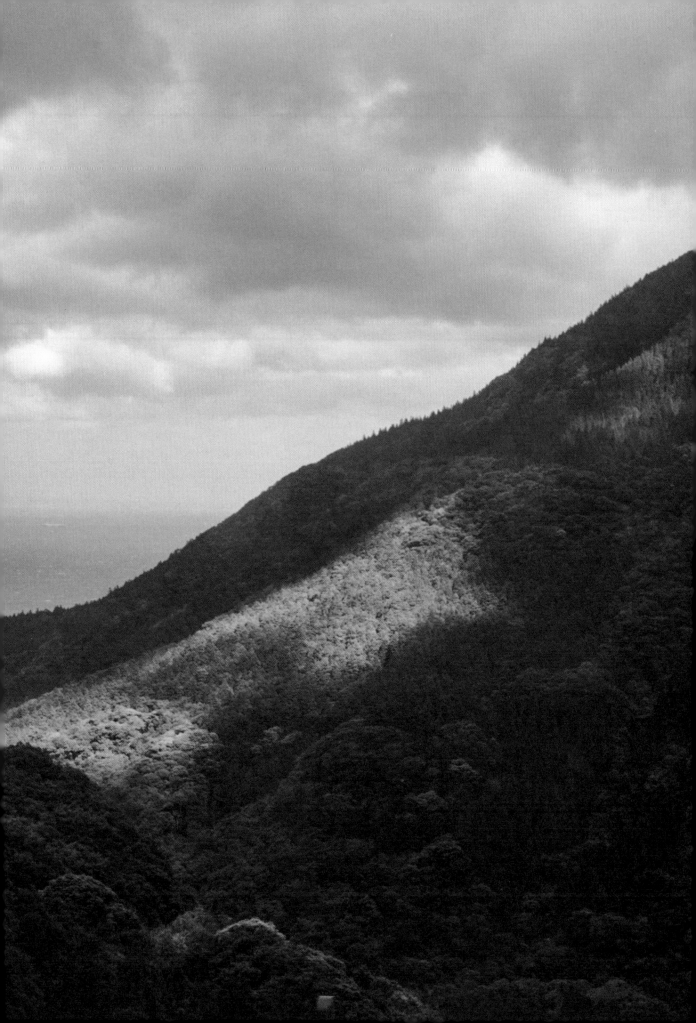

Most of the forested interior is protected, so to navigate the island by car, you must take a single road that laps around its perimeter.

OPPOSITE

Deep inside the 1,000-acre (405 ha) Shiratani Unsuikyo Ravine are various hiking paths through the forest, some dating back to Japan's Edo period (the seventeenth through mid-nineteenth centuries). The longest trail takes four hours and the shortest takes just one. The forest's enchanting effect on those who visit inspired Studio Ghibli's classic anime movie *Princess Mononoke*.

Island Time

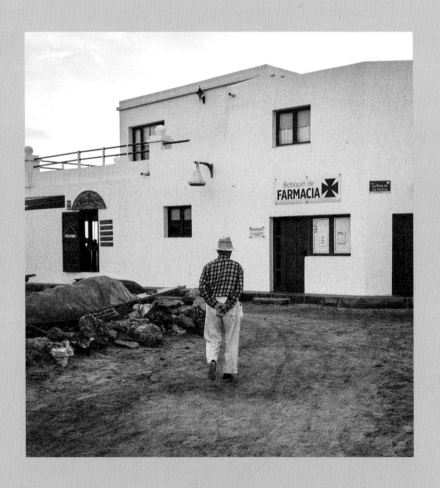

Words by Alex Anderson

Every traveler knows that time is fickle. It slows in the months before departure, spins forward recklessly during the short days of vacation, and settles back to its regular, steady pace for the routines of work and home that follow. But a mindful tourist can take control of time, reshaping it to harness the possibilities of travel. To fashion an unhurried, calming pace, the key is to step willingly into "island time."

Island time, which is a term sometimes disparagingly affixed to islanders' relaxed approach to timekeeping, follows the melodic lines of the days and seasons rather than the beat of the clock.

Daniel Defoe offers one of the earliest, and perhaps unhappiest, travel accounts of island time in his eighteenth-century novel *Robinson Crusoe*. A lone survivor of a shipwreck off the coast of Venezuela, Crusoe begins his years on "the Island of Despair" by first building a shelter and assiduously marking the days on a wooden post, so he won't lose his "reckoning of time." After a while, though, the unfortunate traveler slips into looser habits. As Dewey Ganzel, a scholar of English, pointed out in his 1961 essay "Chronology in *Robinson Crusoe*," the castaway gradually begins to adopt "island time," characterized by languorous spans punctuated with singular events—the year he built a canoe, or the year he finally toured the island (his sixth), and so on for another twenty years until his rescue and return to England.

For travelers today, there is no need to spend decades on an island to feel the benefits of its casual rhythms. The key is to develop a sense for "island-ness," a term Philip Conkling, founder of the Island Institute in Maine, uses to describe "a deeply held feeling of a sacred connectedness to place that blurs the sense of time." For island residents, this is the background to a lifestyle in

which, he wrote in the *Geographical Review*, "the rhythms of tides, wind and storms determine what you do and will not do." Visitors don't have a lifetime to synchronize with these patterns, but islandness can be "earned," he writes, "by accepting the values and perspectives that island life imposes."

The first moments you experience in island time can be frustrating. Heading to the hotel, the loquacious driver might take the long way, cheerfully pointing out landmarks and beaches. On arriving in the breezy, open lobby, the front-of-house staff may invite the arriving guests to lounge nearby until the room is ready. *When?* Soon. But this loose itinerary quickly replaces the more rigorous and reliable schedule of home. In island time, punctuality loses its sharp definition. Deadlines and appointments become open time spans— sometime around noon rather than twelve o'clock on the dot. Waiting isn't an inconvenience; it's an opportunity to kick back and watch the clouds, the waving palms, the gently lapping turquoise water on golden sand. Island time also connects travelers to the flow of the tropical day, where it makes sense to move in the cool morning hours, slow down with the rising heat of afternoon, and emerge again in the evening.

This pattern can take some adjustment for the traveler, since the sun comes up early in the tropics and the heat builds quickly. Vacationers at the Song Saa Private Island in Cambodia would normally need to get up by five thirty if they wanted to watch the sunrise. To avoid a martial wake-up call, managers at the "eco-luxe" sanctuary decided about ten years ago to simply move the clocks back and give their early-rising guests an extra hour of rest, essentially creating its own time zone. Other resorts have followed its lead. Hotels in the Maldives and on small islands off Belize, Costa Rica and Mexico have also adjusted the clocks to help visitors glide more easily into island time.

In the far north, island time takes on a different cast. Arctic archipelagoes experience patterns of day and night unlike elsewhere in the world. Residents on Norway's Sommarøy Island, for example, watch the sun rise in mid-May and don't see it set again until the end of July. Visitors to the island in summer enjoy constant daylight altered only by gradual shifts in the color of the sky, as the sun dips toward the horizon around midnight. In 2019, citizens of the island—and government-funded tourist agencies—launched a campaign to become the world's first time-free zone. "We do what we want when we want," declared Kjell Ove Hveding, a resident and campaign organizer. Time doesn't dictate the pace of life on the island, he points out, so vacationers can forget about schedules. Why hurry when there's no time at all?

Whether it keeps pace with the drift of tropical clouds or the subtle variations in perpetual daylight, island time invites travelers to slow down and savor whatever the day offers.

"Waiting isn't an inconvenience; it's an opportunity to kick back and watch the clouds, the waving palms, the gently lapping turquoise water on golden sand."

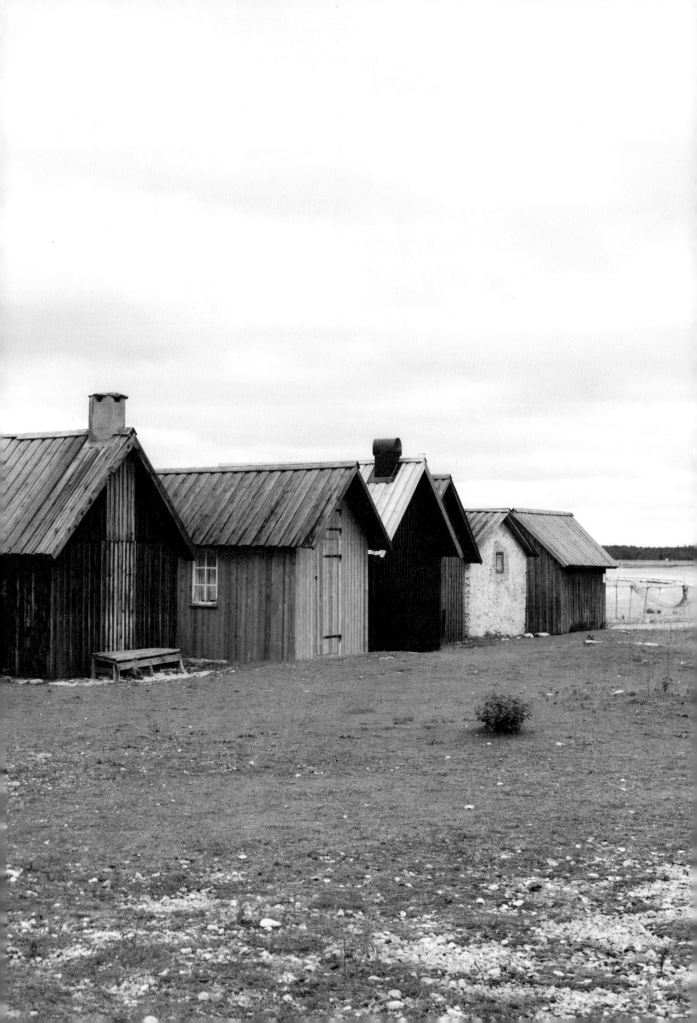

THANK YOU

No brand is an island, and the *Kinfolk* team would like to extend a heartfelt thank you to the many talented people who have helped us create this publication.

We would like to sincerely thank all the distinguished writers, photographers and illustrators around the world whose talents have brought these stories to life so beautifully. Thank you for contributing your creative energy to *Kinfolk*; it's an honor and a privilege to publish your work.

The *Kinfolk Islands* creative team in Copenhagen is made up of John Burns, Staffan Sundström and Harriet Fitch Little. Staffan has both designed this book and selected each beautiful image within its pages; thank you for your hard work and dedication, and for pushing the brand forward with your ideas and creativity.

To Lia Ronnen at Artisan and our colleague Edward Mannering at *Kinfolk*: This book simply wouldn't exist without you both. Thank you for always believing in the series and expanding its horizons. Thanks also to our Kinfolk colleague Susanne Buch Petersen for keeping track of in-house production on the title and offering moral support, and to the rest of our colleagues at *Kinfolk* for their input, inspiration and patience: Alex Hunting, Cecilie Jegsen and Christian Møller Anderson. Thanks also to Chul-Joon Park, Seongtaek Jang and the rest of the team in Seoul for their support.

At Artisan, we'd like to extend an enormous thank-you to Bridget Monroe Itkin for her guidance and diligence during the editing process. The same gratitude is due also to Artisan team members Donna G. Brown, Maggie Byrd, Suet Chong, Theresa Collier, Zach Greenwald, Erica Huang, Sibylle Kazeroid, Allison McGeehon, Amy Michelson, Nancy Murray and Fiona Winch. Thank you all for lending your expertise and hard work to *Kinfolk*.

Finally, we'd like to thank you, dear reader, for your continued support of *Kinfolk*. We hope this book will put wind in your sails.

CREDITS

WRITERS

Alex Anderson
244–247

Samia Qaiyum
140–143

Amira Asad
112–115

Zinara Rathnayake
126–129

Ann Babe
208–211

Asher Ross
86–89

Oliver Berry
52–55

Tristan Rutherford
186–189

Stephanie D'Arc Taylor
60–63

Laura Rysman
104–107, 170–173

Daphnée Denis
164–167

Alex Shams
74–77

Tom Faber
14–17

Sharine Taylor
152–155

Laura Hall
40-43, 220–223

Sumiko Wilson
92–95

Timothy Hornyak
232–235

Feride Yalav-Heckeroth
198–201

Gabriel Leigh
26–29

PHOTOGRAPHERS

Dayyan Armstrong
52–59

Staffan Sundström
26–39, 248, 250, 252–253, 255

Cayce Clifford
60–73

Sophie Tajan
5, 104–111

Louise Desnos
7, 92–103

Colby Tarsitano
112–125

Jeano Edwards
152–163

Charles Thiefaine
14–25

Richard Gaston
40–51

Ville Varumo
220–231, 232–243

Jae-An Lee
208–219

Constantin Mirbach
86, 164, 170–185, 186–197, 244

Anna Nielsen
126–139, 140–151

Ekin Özbiçer
198–207

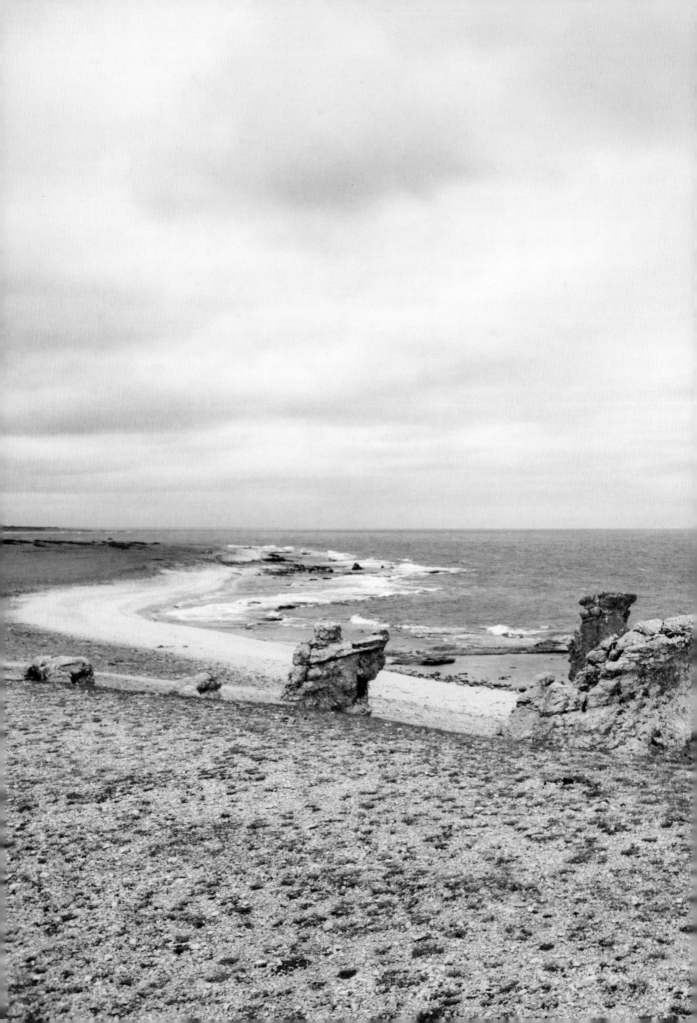

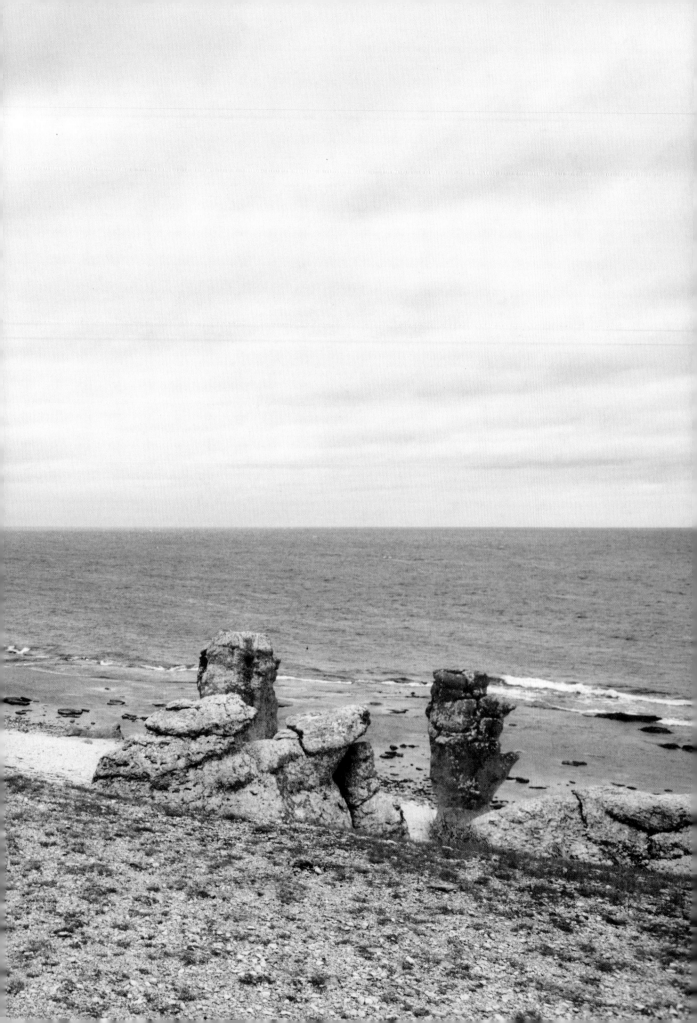

Library of Congress Cataloging-in-Publication Data

Names: Burns, John Clifford, author. | Kinfolk (Art publisher)
Title: Kinfolk islands / John Burns.
Description: New York, NY : Artisan, [2022]
Identifiers: LCCN 2022010976 | ISBN 9781648291524
Subjects: LCSH: Islands—Guidebooks. | Travel—Psychological aspects. |
 Slow life movement.
Classification: LCC G500 .B87 2022 | DDC 910.914/2—dc23/
 eng20220519
LC record available at https://lccn.loc.gov/2022010976

Artisan books are available at special discounts when purchased in
bulk for premiums and sales promotions as well as for fund-raising or
educational use. Special editions or book excerpts also can be created
to specification. For details, contact the Special Sales Director at the
address below, or send an e-mail to specialmarkets@workman.com.

For speaking engagements, contact speakersbureau@workman.com.

Published by Artisan
A division of Workman Publishing Co., Inc.
225 Varick Street
New York, NY 10014-4381
artisanbooks.com

Artisan is a registered trademark of Workman Publishing Co., Inc.

Printed in China on responsibly sourced paper
First printing, October 2022

10 9 8 7 6 5 4 3 2 1